T0294530

Museum Branding

Museum Branding
Reimagining the Museum

Third Edition

Margot Wallace

ROWMAN & LITTLEFIELD
Lanham • Boulder • New York • London

Published by Rowman & Littlefield
An imprint of The Rowman & Littlefield Publishing Group, Inc.
4501 Forbes Boulevard, Suite 200, Lanham, Maryland 20706
www.rowman.com

86-90 Paul Street, London EC2A 4NE

British Library Cataloguing in Publication Information Available

Library of Congress Cataloging-in-Publication Data

Names: Wallace, Margot A., 1941- author.
Title: Museum branding : reimagining the museum / Margot Wallace.
Other titles: Reimagining the museum
Description: Third edition. | Lanham : Rowman & Littlefield, [2024] | Includes bibliographical references and index. | Summary: "The challenge for all museum is sustaining their brand as audiences change. Museum Branding: Reimagining the Museum surveys museums of all sizes, genres, and geography—over three hundred of them—that exemplify audience-centered practices" —Provided by publisher.
Identifiers: LCCN 2024013233 (print) | LCCN 2024013234 (ebook) | ISBN 9781538185506 (cloth ; alk. paper) | ISBN 9781538185513 (pbk. ; alk. paper) | ISBN 9781538185520 (electronic)
Subjects: LCSH: Museums—United States—Management. | Museums—Public relations—United States. | Branding (Marketing)—United States. | Museum attendance—United States.
Classification: LCC AM11 .W35 2024 (print) | LCC AM11 (ebook) | DDC 069/.0688—dc23/eng/20240509
LC record available at https://lccn.loc.gov/2024013233
LC ebook record available at https://lccn.loc.gov/2024013234

♾️™ The paper used in this publication meets the minimum requirements of American National Standard for Information Sciences—Permanence of Paper for Printed Library Materials, ANSI/NISO Z39.48-1992.

Contents

Preface

In a 150-year-old tenement building, walls were broken through and the basement dug up in a search for treasure.

In a sunny vacation city, striking architecture joined palm trees in the skyline.

In the Old West, a modern community was speaking its hereditary language.

Re-imagined museums are emerging with bold, old brands blazing. All over the museum world, re-engineering, re-thinking, and re-aligning are taking place. And the miracle of all the re-inventing was that brand identities weren't changed but, rather, stronger than ever.

The twenty chapters of this book, in surveying museums of every description, reveal the great depth of a good brand. It is not linear. It wanders through the institution, taking ideas from every department, every staffer. Branding likes to make the acquaintance of every visitor, on-site and virtual. It pauses to chat with guards and store personnel, docents, and board members. Then it moves from the museum itself to other platforms.

Museums have given themselves distinctive identities. What lies ahead is keeping them.

This book looks eyes wide open at museums large and small, of all genres, and of all ages and geographies; there is no mistaking the damn-the-torpedoes fearlessness of many. In all cases, one can see creative exhibitions, reexamination of collections, new ways to conduct tours, professional attitudes in volunteers, strategic use of platforms, and mastery in videos.

When surveying the state of museum brands in the 2020s, one might expect advances of scale—that is, growth in existing initiatives. The revelation was different. There was *change*. Inventive, risk-taking groundbreaking change. Museum people honor legacy and respect reputation. They flock to a good challenge. And then they dearly love sledge-hammering walls.

A minor suggestion for using this book; scan the Index. It's full of provocative topics that chapter titles can't convey. Chapters come from the organized side of the brain. But the Index! That's where limitless thought starters spill out. And they come from the museums themselves.

Forward-looking is a through line of this book. Each of the following chapters reveal the brilliance in today's museums, which see the future and set their sights on it. Museums' challenges continue to be owning their distinctiveness and maintaining brand identity, loyalty, and support as they script their

particular forward path. The museums in this book think forward, aim forward, and head forward. It's a good direction and should be added to every description of "brand."

Throughout the research that led to these pages, not to mention the writing of them, museums have demonstrated virtuosity for which writers lack words. No amount of theory can match a good example. There are over three hundred of them here. Thanks everlasting goes to museums everywhere.

Margot Wallace
March 2024

1

Collection and Exhibits

Your collection, exhibits, and exhibitions are the tangibles that represent your brand. They are what the public perceives. Behind the scenes is your mission, guiding all activity, present and future. At the forefront, the fruits of your mission are seen by uncountable eyes, ears, and minds of visitors, members, donors, scholars, suppliers, funders, businesses, educators, and government entities of your community.

Here's what your audiences might take away from your collection, exhibits, and exhibitions:

- Trending and consequential ideas
- Knowledge and satisfaction
- Appreciation of heritage, from roots to branches
- On target for the way we live today
- Tomorrow, it's only a day away
- Celebrity ready
- A broadening (borrowing a phrase from Toledo Museum of Art)

TRENDING AND CONSEQUENTIAL IDEAS

TREND: INTERSECTION OF THE ARTS AND SCIENCE

Franklin Institute complements its broad exhibition schedule with digital learning programs that "explore the world of music through the lens of science." Its "So Curious!" podcasts built a 12-part podcast including topics such as The Science Behind Music Taste, The Origins of Music: From Evolution to Acoustics, and Music in Athletic Performance and Healthcare.

Museum of Contemporary Photography at Columbia College Chicago offers:

> "A new exhibition at Columbia College's Museum of Contemporary Photography is also exploring the constantly changing role of

music, asking visitors to think about how music relates and inter-acts with everyday life." —*NBC News*

TREND: WOMEN BEHIND THE THRONE

It's well known that many celebrated male artists—Lord Byron, Vincent Van Gogh, Pablo Picasso, and Jackson Pollock, to name a few— had talented women in their lives, and Chicago's Driehaus Museum explored the critical role played by Adeline Oppenheim Guimard, wife and collaborator of Hector Guimard, art nouveau architect and designer. Driehaus presents new scholarship that underscores Adeline's critical role as her husband's creative partner during his lifetime and ardent steward of his legacy.

And many women hold the power alone. Museum of Women in the Arts, Washington, D.C., is the only museum to collect and display only works by women artists. As it notes on its home page:

> "Just 11% of all acquisitions at prominent American museums over the past decade were of work by women artists."

And—

> "Our rotating special exhibitions showcase historic and contemporary artwork . . . programs and events foster conversations and connections that inspire change."

The museum places women in the flow of history, part of the art conver-sation. That is inherent in the name and brand of the museum. This is not inclusiveness. This is fact.

TREND: THE WORLD AROUND US

Beginning in 2022, the Ukrainian National Museum of Chicago became a bul-wark, a monument whose heritage suddenly became its present. The museum didn't have to communicate any message except its existence, through strong, vibrant, alive exhibitions. Its e-newsletter contained notice of an exhibit whose title and message were clear:

> "Un-issued Diplomas: when your classroom turns into a battlefield, your major becomes bravery."

There are times in life when museums fill a void that other institutions cannot. Sometimes, all that is required is being there. At these times, consider repeating your credo, what you stand for:

- Email to mailing list with letter from the Director
- Informal event with a talk from the Director

- Sign at the Information Desk with a statement of values
- Avoid social platforms this time; they reach many but encourage many interpretations that don't emanate from the museum

In 2016, Eiteljorg Museum in Indianapolis, Indiana, launched a capital campaign that included a new vision for exhibitions:

> "Focus intently on the Indigenous peoples of the Great Lakes region . . .[tell] the amazing stories of the West and Native Americans in more significant and impactful ways."

With a redefined vision, museums put their cards on the table and, often, their money. This is important because a vision is a promise; it has objectives that are tangible and can be proven. Visitors and stakeholders at every level will hear the promise and see the results. Then they will write, post, and talk about them.

In the age of instant sharing, when allocating funds and time to a vision, here are some pointers for communicating:

- Vet your vision internally; get everyone's input
- Ascertain the stakeholders key to implementing the vision—management, staff, volunteers, major donors, and community participants
- Understand your timeline and what each step entails
- Prepare for contingencies
- Communicate your vision regularly

When you're able to proclaim Vision Accomplished, you've earned your brand all over again.

In listing its docent training schedule, Museums on the Green in Falmouth, Massachusetts, reveals an important aspect of any brand: relevance for even the youngest visitor, in this case, third graders:

> "This class . . . delves into the life here in Falmouth after the American Revolution and explores the 1790 Dr. Francis Wicks House's collection, architecture, and social history. . . During this class, participants can . . . pick a special object to learn more about. During the last class . . . participants . . . may . . . share their research . . . with their classmates in a five-minute story.

The classmates are discovering that new ideas learned, not taught, and shared with their peers make new ideas easier to grasp and fun, too.

TRENDING: MULTI-NESS

Inclusive, multicultural, open-minded, open-hearted. Say it often and prove it with an exhibition like "The American Library by Yinka Shonibare CBE RA,

October 21, 2023-November 24,2024" at Skirball Cultural Center in Los Angeles. Shonibare is world-recognized, multiculturalism personified. The exhibition is a master class in multi-ness. The library of the title is 6,000 books, whose covers are made of Dutch wax-printed cotton; the stories are of enslaved persons transported from Africa and the Great Migration. Another set of books "features the names of people who have spoken against immigration, equality, or diversity in America." Visitors are encouraged to enter their own stories at interactive stations. There's an animated short film designed by the artist for children. It's immersive, structurally and emotionally.

Lessons for smaller museums:

- Show diversity in exhibitions
- Honor multicultural creators
- Invite the participation of multi-cultured visitors
- Engage children

KNOWLEDGE AND SATISFACTION

Museums are based on knowledge. Good museum management requires visitor satisfaction. It is wise to regularly remember that knowledge in itself is satisfying.

Behind the labels and wall panels of a museum is a wealth of knowledge. At Halim Time and Glass Museum in Evanston, Illinois, the history of the object and the era are combined. It's knowledge broadened, answering questions viewers haven't asked. What makes this rich survey possible is renovation; the collection is being archived online so visitors can become viewers—they may select a work that appeals, look, read, and look again, learning on their own. They can compare and interpret on their own. They can see:

> "intricate details up close and watch videos of our clocks move and chime . . . read the . . . stories behind pieces . . . in Stained Glass Masters, Treasures of Louis Comfort Tiffany, and Clocks of the World collections."

It's a big challenge to create a comprehensive look at your collection, for online visits, but even a small sample, with expanded labels, demonstrates continuity and a trying out of new ideas.

Here's a promise worth copying, courtesy of Verendrye Museum in Fort Pierre, South Dakota, whose exhibits include an original telephone operator's station, horse-drawn carriages, saddles and cowboy hats, homestead tools, Native American artifacts, guns, and wardrobe items:

> "Walking through the museum retains all the charm and excitement of discovering treasures in your grandmother's attic."

HERITAGE: ROOTS AND BRANCHES

Heritage usually starts small, with roots that are deep, not broad. Watch the branches, though! Every museum with a history follows this single root to a multi-branched shape, and it is exciting to build exhibitions around them.

Other museums can follow the root to branch collection, exhibit, and exhibition format:

- Include other cultures that shared an earlier history.
- Profile the people who live in the area.
- Conduct oral history projects—small-scale is fine—to tease out new threads.
- Build around subjects not covered by your collection goals: food, music, performing arts, architecture, and sports are evergreen.

Many exhibits and full exhibitions flow from a museum's archive, an invaluable resource too little opened to the public. The Pueblo Papers at History San Jose is a virtual collection of life in what is now San Jose, California, from 1780 to the admission of California as a State in 1850. The documents reveal municipal activities, the patriarchal concern of officialdom, and the magistrate as "town father." The archived Pueblo Papers function as exhibits, chronicling the relationships between Spanish and Indians, children and parents, missions, presidios and pueblos, elections, the local economy, and military discipline.

These accredited and widely known virtual archives are toured by scholars and researchers, much as other re-created societies are enjoyed by vacationing families.

To tour the online exhibits of an early pueblo, one follows the link online and touches "Read."

It's not often that a visitor is asked to read an exhibition. Sometimes, though, words are the only remaining artifacts of a heritage.

The Getty Center in Los Angeles says that Jean-Paul Millet's painting "A Man with a Hoe" may be "the most historically significant painting" in its collection. It is shown in a 2023 dossier exhibition that focuses on one work, this one reflecting on California's role in the painting's provenance and the State's heritage of agriculture labor and "beleaguered rural worker."

The concept of a dossier exhibition—focusing on all the archived material related to one work—is adaptable by any museum interested in highlighting its scholarly bona fides. You don't need the world's largest dinosaur fossil or an Egyptian pharaoh to mount a dossier exhibition. Look in a few drawers!

At History Museum at the Castle, in Appleton, Wisconsin, the name of the exhibition is "Perspectives." It has its own top-tier tab. It is subtitled a Visual Anthology, in this case the Fox Valley environs of Appleton, Wisconsin. Here's what the rigorous root and branches online curriculum includes:

1. "Seeing" History
2. Native Nations and Their Native Lands
3. Mapping the New United States
4. Surveys of the Land, the Native Land
5. The Making of a City, Appleton
6. Urban Life and a Focus on Fire
7. The Automobile and Building of Roads
8. Industry and Leisure on the Fox River
9. Urban Sprawl: History Moves Beyond the Map

If one knows where and how to look—and museums do—history can be found on maps and in photographs. Every piece of History Museum's "evidence" represents a unique perspective:

"History has always been told by varieties of tellers: winners and losers, rulers and the ruled, historians and poets, battlefields and hearths. Maps and photographs, like artifacts and archives, take on new meanings when viewed in different ways."

Using these documents of the past presents today as well. Visitors will lean in, see connections, note adaptations, and perceive growth: the whole brand package.

Newport Mansions in Newport, Rhode Island, has a brand commitment to both Newport and regional history. Its brand is not just the Gilded Age's grand mansions. Grander still are the stories of the people who lived in town. For example:

"Since Newport's beginnings as a colonial seaport, generations of its citizens have looked to China for knowledge, beauty, fortune and freedom. In turn, many different people of Chinese heritage, including artists, merchants, immigrant entrepreneurs and women suffragists, shaped all aspects of life in Newport. Their stories are at the heart of this exhibition."

ON TARGET FOR THE WAY WE LIVE TODAY

Exhibition acquires new meaning with Museums on the Green: They put the exhibits into one web page, "Untold Tales of Falmouth," with loads of articles and videos all in one place. This archive, full of stories plus 4- to 7-minute videos, spotlights lives of an earlier era, told by those who lived them. The people featured reflect slices and segments of an era. Their activities are unique to a time and place. The museum acquires a singular history by association with them, as do all museums that include their community in their story.

When a museum is absolutely sure about its mission, totally comfortable with its brand identity, and brimming with pride in its values, that museum flaunts it. Case in point: Bruce Museum in Greenwich, Connecticut, where

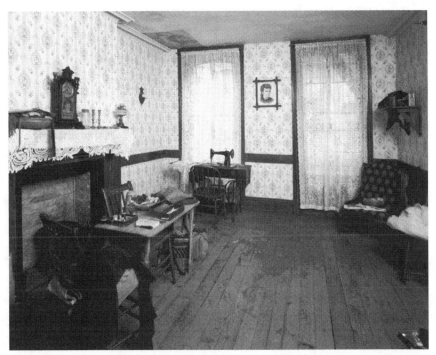

Room in Tenement Museum tells a story. The lives of immigrants to the Lower East Side of New York, collected and interpreted by the museum, are its collection. These reconstructed rooms are its exhibits. *Wikimedia Commons*

art meets science. The intertwining of these two disciplines is contemporary, especially with younger audiences. Fun with language is another imperative. So in addition to "Where Art Meets Science" welcoming the visitor to its home page, and mentioning it on the History page, it is echoed next to the box for entering one's email to sign up for the newsletter: "Your monthly dose of art and science."

A seventy-year-old outrage, with long-lasting echoes, was revisited in a 2023 exhibition at Skirball Cultural Center in Los Angeles. This survey of the 1950s Hollywood Red Scare, sometimes known as the Blacklist era, spotlighted its implications today.

Museums face multiple challenges with "issues," doubtless the reason they're put in quotes. Contemporary debates are part of history, significant for culture, and essential for learning—all areas of museum expertise. Then the donors get involved! More issues issue forth. Some guidelines:

- Take plenty of time to form and write your position and stick with it.
- Continue to stick with it.
- Create a timely discussion session, ticketed.
- Select the moderator for their diplomatic and discussion-leading skills; this is not an amateur performance.
- Avoid social media, which invites misinterpretation of your carefully crafted script.

TOMORROW, IT'S ONLY A DAY AWAY

Meeting the challenge of diverse audiences, collection management, budgets, and relevance today and tomorrow, museums also direct their attention to the artists. The arts, of course, are on display, in the workshops, described on labels, addressed in lectures, posted unlimitedly, and performed in programs. Then there are the artists. More and more, museums take up the challenge of nurturing the people who create an important part of society and the economy, at home and in the world. Sandwich Glass Museum in Sandwich, Massachusetts, in its statement of values places:

> "particular emphasis on the unique contribution of the glass industry to the local community, the region, the nation, and the world."

It reminds the visitor:

> "The Sandwich Glass Museum continues to be relevant today as an institution honoring the history and artistry of Glass Art . . . [and] development and practice of the craft and art of glass in contemporary society."

The world of work shifts dramatically every day, and museums are prepared.

Another future project, occasionally tried and revisited: Visitors never see your real collection, the multitude of small objects that hide in storage. You've acquired them for a reason; they tell meaningful stories in the mosaic of history, and yet they're not reachable.

Berkshire Museum in Pittsfield, Massachusetts, reaches into the lockers and pulls them out into view. One at a time. That's a treasure in the Berkshires. A hidden holding, brought into the gallery, where "visitors will discover distinct aspects of human history . . . a rotating mix of items and ideas" These new connections between fine art, natural science, and historic artifacts represent a shift in all areas of learning; learners like to follow their own interests, investigate where links take them, click and wander, and avoid people telling them what to do.

This approach is also good training for scholars, current and rising, in interdisciplinary studies.

For all audiences, looking at exhibits, even ones accompanied by labels and docent tours, takes practice, if not skill. Figge Art Museum in Davenport, Iowa, doesn't just show; it explains how to see. The museum's Learn to Look Gallery features one or two works by an artist, and uses guided questions to explore the artist's subjects and techniques. The display also encourages the viewer to invent new meanings for familiar symbols. Then, as if viewers were academics proposing a scholarly paper, it notes that the exhibits "are designed to help the viewer build art vocabulary and learn to construct meaning for works of art."

Are museum audiences as sophisticated as writers of scholarly papers? Why not? Museums with a strong brand have good relationships with visitors, and it's worth a try to teach up.

For any museum, whatever its size or resources, close examination of new information goes with the territory of a forward-thinking institution. Here are some ways to navigate challenging ideas:

- Take one discrete, digestible concept at a time, a contemporary step instead of a tired slog.
- Make relevant connections, the *why* today's children and adults demand.
- Use a forward-facing new slant on existing knowledge.
- Adopt a risk-taking attitude toward new approaches.

Collections, mostly hidden from view, unceremoniously stored, and languishing without labels, can confound the viewer. An enterprising curator/naturalist at Cable Natural History Museum in Cable, Wisconsin, leveraged a stored butterfly collection into a new kind of exhibit: a one-day workshop demonstrating how to preserve objects and how to admire them: "Scientific wisdom guides our preservation practices; the magic of artistry tells the specimen's

story." Helping the museum "be a good steward of specimens throughout their lifetime with us."

Even a small, limited exhibition of a collection can help brand it. It's a concept with many possibilities for museums of any genre:

- Objects + acquisition goals
- Objects + photographs of the era that produced them
- Artifacts + tools used to assess and preserve them
- Objects + strategy for an upcoming exhibition

The focus is on the collection; the branding comes from connecting them to the museum's collecting philosophy and plans for their stewardship.

Exhibits become interactive, focused-learning spaces at Indianapolis Motor Speedway Museum. This re-imagined museum does more than show and tell; it calls its galleries learning spaces. It motivates. This is tomorrow thinking. Indianapolis Motor Speedway Museum quickly communicated its implementation of the future: Tangible exhibits such as the "pit-stop challenge" space, for example, will include digital exhibits, a STEAM classroom, and immersive experiences.

Of course, it's easier to leap into the future with a large capital campaign and generous donations from industry, as Indianapolis Motor Speedway Museum has. But all museums can redirect their exhibits with these Share and Motivate principles:

- Wall panels in a gallery that ask visitors: How would you describe these objects?
- Labels that ask: Which two objects in this room would you like to use for your own projects?
- Tour guides that ask the group: Which exhibits did you like the most? Why?
- Store buyers ask themselves: What part of the museum would visitors like to take home with them? Let me see what I can find.
- Curators that analyze past exhibitions—their own and other museums'—to ascertain what inspires interest, what motivates discussion.

That adds up to many laps of questions. The process breaks down silos, encourages collaboration, and gathers information interactively. And then Indianapolis Motor Speedway Museum puts its promise on the line: "To learn more about our plans for the future, visit imsmuseum.org."

A BROADENING: FROM MISSION TO VISION

Every exhibit, wall panel, and label shows what you stand for; each has the opportunity to expand on the meaning of your collection, mission, and vision. It takes only two lines in a 2023 Jacob Lawrence exhibition description to show

how Toledo Museum of Art in Toledo, Ohio, connected mission and vision. The museum:

"will chronicle Jacob Lawrence's extended stay in Nigeria and present vibrant works by international artists . . . to broaden our understanding of . . . the history of modernism as a transcontinental phenomenon . . . [aligning with our] belief that a more inclusive narrative of art history is a truer one."

The following examples may also start the discussion of broadening mission and vision:

Labels at the Museum of the American Arts and Crafts Movement in St. Petersburg, Florida, describe the aesthetics of the object, whether it's a piece of furniture, pottery, tiles, lighting, or architectural elements. They:

- Describe the use of the object, because the Arts and Crafts Movement placed utility equal with beauty.
- Describe the studio, workshop, or colony that manufactured and marketed the piece, emphasizing that these were hand-made pieces, crafted by individual craftsmen who signed each piece.
- Explain that selling these pieces to like-minded buyers was also essential for the craft to endure. Many ceased to exist—failing is not a term used in this museum—after the Depression.
- Include the location, city, town, and state of the workshop. These were local enterprises; hand-made, crafted objects started in small shops within like-minded communities.
- Emphasize collaboration between artisans, craftsmen, and manufacturers of components like metalworks.

The honoring of partnerships is important and underlies many museum exhibits. It expands museum interpretations and gives shoutouts to all the people who nurture the growth of a community. As an example, The Mariners' Museum and Park in Newport News, Virginia, ensconces its mission on its home page:

"Our Collections-based, Community-focused strategy is impossible to execute without ensuring the preservation of our Museum Collections, including the Living Collection . . . so that generation after generation of mariners can connect to our shared maritime heritage."

The thinking of this museum is instructional. It uncovers the traditions of many cultures, not just those of war—even a war as storied as America's Civil War. Conserving the artifacts of a collection conserves the culture they came from. When the artifacts come from the USS *Monitor*, a Civil War iron-clad

warship sunk for 150 years, it's possible many cultures were on board, many traditions, many stories beyond just the war.

Every rope and bolt, gun turret, and coat button reveals the culture that needed it, and then made it. Who made the ropes? What pattern was used for the coats? In a young country, comprising dozens of older cultures, these artifacts on the USS *Monitor* represent generations of cultures from around the world.

CELEBRITY AND FAME

Famous citizens are a challenging exhibition target for museums. How do you separate the museum's identity and reputation from the personality's—and enlarge the museum's brand in so doing. Take Massillon, Ohio's beloved, much-honored football coach:

> "Paul Brown invented the modern game of football. So we built a whole museum about it."

Massillon Museum started the exhibition—soon to be museum—with facts the museum could relate to:

> "Paul Brown was not just a coach. He was THE coach. His historic credentials formed the future of football. He started teams, revitalized others and broke records. He also invented much of what we now take for granted in football."

These accomplishments form the basis of exhibits. Research will expand on their importance. The museum benefits from the interpretation.

Not all personages are so germinal. However, with good research and excellent interpretation, important people in every community will prove consequential. Here are some nuggets to be uncovered by scholarly research and interpretation:

- What did the person accomplish?
- Why was it significant at the time, and for the future?
- How did they affect the success of the community, or their field, or contemporary researchers?
- What endures of the great person's life? Don't forget relatives.
- How do important people still inform your museum's vision?

Your museum can also bask in the halo effect of other nearby stars. Massillon Museum boasts that it is "only 8 miles away from the Pro Football Hall of Fame in Canton."

For museums that mount a world-celebrated exhibition, it might be tempting to just state the spectacular exhibition title and sit back and enjoy the

crowds. Two American museums took a more singular approach and tied the Pablo Picasso 50th Anniversary of His Death commemoration to their values. For example, Mint Museum in Charlotte, North Carolina, interpreted its exhibition of "Picasso Landscapes: Out of Bounds" this way:

"Showing the genre through which Picasso . . . shaped his own creative evolution [and] exploring urban modernity."

And at Cincinnati Art Museum:

"With the works assembled for this exhibition, we are finally able to appreciate how significant landscape was for Picasso throughout his life."

It's the same Pablo Picasso, the same exhibition, but presented with museological objectives unique to each museum brand, not just Picasso's.

Every museum can claim a unique approach to a much-heralded topic. For small or local museums, if you're within the orbit of a larger museum, don't be shy about offering programs that expand the focus of their exhibitions; build them around your own area of expertise. That's putting your brand to the service of your audiences who want to know more about a big exhibition topic but can't make it to a big-museum city.

Offer programs centered on:

- Interpretations by speakers from local arts organizations
- School projects
- Learning activities inside the museum
- Partnering with local libraries to read and discuss the topic
- Providing links to topic-specific videos
- Field trips

Before the visitor sees your exhibits, before your curators plan an exhibition, generations of committees have converged on your mission. A truism worth repeating says: There is no more difficult writing assignment than a mission statement.

Dacotah Prairie Museum in Aberdeen, South Dakota, uses the word "conversation" in its mission statement, suggesting a wise and collegial committee:

The Dacotah Prairie Museum's mission is to facilitate conversation of the prairie and its people, cultivate insight, and curate its collections as a catalyst for inter-generational exchanges . . . to inspire children, connect families, and build community through education, programming, exhibits, and its collections.

Adding to the challenge of nailing a mission statement is placing a vision statement next to it on the web page. Here's how Dakotah Prairie Museum states its vision:

> "The Dakotah Prairie Museum . . . is committed to the continued growth of its collection of material evidence representing the ongoing history of its region . . . [that it] be used by present and future generations to study and interpret the lives and accomplishments of previous generations inhabiting the Dakota Prairie."

Mission is theory and hope. Vision is promise and tangibility. Side by side, mission and vision construct a template for full branding of any ambitious museum.

BRANDING CHECKLIST

First know this: You don't have to re-create your brand. You already have an identity in your collection, exhibits, and exhibitions—current, past, and future. Rediscover your identity by answering a few prompts:

- What's your favorite object in the museum? Take time to wander around and report back.
- What have you overheard from a visitor?
- What do the guards notice? Guards, paid or volunteer, are positioned somewhere between staff and public, and their viewpoints come from all points of the compass.
- What do people say at the store checkout? They're putting their money where their thoughts are.
- In your own memory—root deep here—what do you remember that bears on the DNA of your museum? Search for a new memory, not a usual one.

REFERENCES

"2023 Falmouth Museums on the Green Docent Training Schedule," Volunteer, Join & Support, https://museumsonthegreen.org/get-involved/volunteering/ [accessed September 16, 2023]

"The American Library by Yinka Shonibare CBE RA, October 21, 2023–November 24,2024," https://www.skirball.org/museum/american-library-yinka-shonibare-cbe-ra [accessed September 9, 2023]

"Blacklist: The Hollywood Red Scare," May 4–September 3, 2023, Skirball Cultural Center, https://www.skirball.org/museum/blacklist-hollywood-red-scare [accessed July 25, 2023]

"Celebrate Culture. Preserve History. Join the Conversation," The Museum Minute, Ukrainian National Museum, https://myemail.constantcontact .com/Who-is-Yevgeniy-Prokopov--.html?soid=1134152416755&aid=EGW_ HiuCo_U [accessed June 28, 2023]

"The Celestial City: Newport and China," https://www.newportmansions .org/events/the-celestial-city-newport-and-china/ [accessed September 9, 2023]

"Champion Women Through the Arts," National Museum of Women in the Arts, https://nmwa.org/ [accessed October 23, 2023]

"Cultural Heritage," Areas of Conservation, The Mariners' Museum and Park, www.marinersmuseum.org/conservation/ [accessed March 5, 2023]

"Digital Archive," Halim Time and Glass Museum, www.halimmuseum.org/ digital-archive [accessed October 22, 2023]

The Franklin Institute, "So Curious!," Podcast Index, June 6–September 5, 2023, The Franklin Institute, https://podcastindex.org/podcast/4789728?episode =15567714645 [accessed October 17, 2023]

Genshaft, Lindsay. "Stay Cool This Summer at the DAM," Blogs, June 13, 2023, Denver Art Museum, www.denverartmuseum.org/en/blog/stay-cool -summer-dam [accessed July 18, 2023]

"Hector Guimard: Art Nouveau to Modernism Explores the Life and Work of the French Art Nouveau Architect and Designer," Driehaus Museum, May 3–November 5, 2023, Press, Driehaus Museum, https://driehausmuseum .org/press/view/hector-guimard-art-nouveau-to-modernism-explores -the-life-and-work-of-the-french-art-nouveau-architect-and-designer?mc _cid=9649d490fc&mc_eid=b97d54fadb [accessed October 17, 2023]

"Inspiring the Next Generation," The Stories Behind the Spectacle, Indianapolis Motor Speedway Museum, https://imsmuseum.org/support-the-museum/ the-stories-behind-the-spectacle/ [accessed October 18, 2023]

Kreb-Mertig, Mollie. "Butterfly Pinning," Cabinet of Curiosities, E-Newsletter, mailing list, October 13, 2023, Cable Museum of Natural History Museum [accessed October 15, 2023]

Kreb-Mertig, Mollie. "Butterfly Pinning," Cabinet of Curiosities, Programs & Events, October 21, 2023, Cable Museum of Natural History, www.cable museum.org/event/butterfly-pinning/ [accessed October 15, 2023]

"Learn to Look Gallery," Art, Figge Art Museum, https://figgeartmuseum.org/art/exhibitions/view/learn-to-look-gallery/166 [accessed September 6, 2023]

Levine, Adam, quoted in "Toledo Museum of Art Presents Jacob Lawrence's Nigeria Series in Summer Exhibition," About, Toledo Museum of Art, www.toledomuseum.org/about/news/toledo-museum-art-presents-jacob-lawrence's-nigeria-series-summer-exhibition [accessed March 21, 2023]

Lewis, Mary Tompkins. "'Man With a Hoe': Common Laborer, Uncommon Artistry," Masterpiece, *The Wall Street Journal*, September 22, 2023, www.wsj.com/arts-culture/fine-art/man-with-a-hoe-jean-francois-millet-paris-realism-getty-e58fdd3c?st=yzletpeijxj8zvc&reflink=article_copyURL_share [accessed September 24, 2023]

"Mission Statement," About, Dakotah Prairie Museum, Brown County, South Dakota, www.brown.sd.us/dacotah-prairie-museum/about/mission-statement [accessed October 22, 2023]

"Objects and Their Stories," What's On, Events & Exhibits, Berkshire Museum, https://berkshiremuseum.org/events-exhibits/objects-and-their-stories/ [accessed September 4, 2023]

"Paul Brown Invented the Modern Game of Football. So We Built a Whole Museum about It," Paul Brown Museum, Massillon Museum. https://paulbrownmuseum.org [accessed October 16, 2023]

"Picasso Landscapes: Out of Bounds," Mint Museum, www.mintmuseum.org/exhibition/picasso-landscapes-out-of-bounds/ [accessed April 18, 2023]

Sandwich Glass Museum, About, https://sandwichglassmuseum.org/about/ [accessed October 22, 2023]

"See History in New Ways," History Museum at the Castle, www.myhistorymuseum.org/perspectives.html [accessed August 1, 2023]

"Shift: Music, Meaning, Context, Apr 13–Aug 6, 2023," Exhibitions & Events, www.mocp.org/exhibition/shift/?mc_cid=490141f183&mc_eid=b45a811ec4 [accessed October 17, 2023]

"The Stories Behind the Spectacle," Featured Video, Indianapolis Motor Speedway Museum, https://imsmuseum.org/ [accessed October 18, 2023]

"'Untold Tales of Falmouth' Archives," Archives, Museums on the Green https://museumsonthegreen.org/untold-tales-the-archives/ [accessed October 8, 2023]

Verendrye Museum, "About the Museum," www.verendryemuseum.com/about-the-museum/ [accessed October 8, 2023]

Wallace, Margot, visit to Museum of the American Arts and Crafts Movement, February 21, 2024.

Weiter, Taylor. "Cincinnati Art Museum to present Pablo Picasso exhibit," April 17, 2023, www.wcpo.com/entertainment/local-a-e/local-arts/cincinnati-art-museum-to-present-pablo-picasso-exhibit/ [accessed April 18, 2023]

"Welcome to Project 2021," Eiteljorg Museum. https://eiteljorg.org/project-2021/ [accessed October 16, 2023]

"Where Art Meets Science, Bruce Museum," https://brucemuseum.org/about-the-museum/our-history/ [accessed June 14, 2023]

"A Year in the Life of a Spanish Colonial Pueblo: San Jose Guadeloupe in 1809," Online Exhibit, The Pueblo Papers, History San Jose, https://sites.google.com/historysanjose.org/spanishmexicanarchives/online-exhibit [accessed July 31, 2023]

2

Audiences

People haven't changed; their slots and categories have. The word "parents" once perfectly described the adults who accompanied children; now those adults are part of a larger, more inclusive guardian and caregiver segment. Expanded hours for working people now expand for newly defined work schedules of gig workers, shift workers, flex-time workers, people who work from home, and the self-employed. Communities have been shapeshifted into neighborhoods, towns, surrounding areas, organizations, main streets, districts, school groups, and softball groups. Into what category do you slot grandparents, businesspeople, or kayakers?

In this chapter we will identify, but not typify, some changed audiences. We'll see how museums are addressing their transmogrified audiences. And we'll give pointers for recognizing change when it's right in front of our eyes but invisible.

There are no categories here; they're signposts:

1. Families Redefined
2. Working Restructured
3. Destination Visitors
4. Creators/Scholars
5. Visiting Rebels
6. Community

FAMILIES REDEFINED

Multigenerational events are trending, and the grandparent market is huge in many leisure sectors. Grandparents with grandchildren in tow love museums with memories and tradition. If your museum has a traditional event or program, build it up and shout it out. It enhances your brand with several audiences that cut across all demographic segments.

The challenge is choosing an event that evokes your brand, without sacrificing a large potential audience. Whether you own a longtime favorite event, or are starting a new tradition, take a new look at connecting event to brand.

Locust Grove Estate in Poughkeepsie, New York, promotes its gardens. The museum's identity is heavily invested in its fulsome wooded and flowering grounds. Once a year, nature embraces the supernatural: Fairy House Hunt in the Garden. It is a traditional favorite, not a botanical one. For this audience, the museum event:

- Promotes a beloved museum feature: "Discover fabulous, one-of-a-kind Fairy Houses hidden among the aromatic, blooming flowers and historic majestic trees!"
- Reappears with reliable consistency: "Delight in finding your old favorites and spying some wonderfully whimsical new ones, too!"
- Makes memories: "We'll supply a map and instructions; you should bring your imagination (costumes and fairy wings encouraged!)."

Look at the parts of a family tradition. The photo opportunities and a take-home treasure map suggest at-home family projects. Grandparents aren't new, and their presence in museums isn't unusual. What's powerful is recognizing them as a market segment with distinct characteristics that support your brand:

- A large and growing group—demographics and health have given the arts a group with deep roots in visitation, membership, and, lately, big support
- Cultural interests such as symphony and theater that connect with other arts
- Travel intensive
- Youthfulness

At McKinley Presidential Library & Museum in Canton, Ohio, two membership categories encourage the grandparent audience to pay $70-90 a year. These new members, it is hoped, will be regulars who use their membership to return frequently, eat at the cafe, and shop at the store for more than souvenirs. And they'll continue to donate.

At any museum, any size or genre, the grandparent member can access free or discounted programs and activities, building loyalty. Most important, this group brings the next generations with them. That's development. And it's brand building.

Grandparents, as a segment, contribute financially for other under-recognized reasons:

- Bringing young grandchildren to museums creates an extended period to inculcate the love of museums to younger generations.

- Many grandparents are still working-age—full time, part time, or gig—and have a large circle of contacts.
- They have many years of contributions ahead of them.
- Thanks to reciprocity, they visit other museums in the area or travel to your museum from all over the country.

Connecting the generations produces more than good promotion. Generational traditions keep membership alive and thriving. San Francisco Museum of Modern Art makes that marketing advantage clear with special days that include free admission for up to four adults accompanying one guest who must be eighteen or younger.

Note that this program, designed to cultivate and engage the next generation of art lovers, doesn't require that the young person be a family member. Talk about redefining "family."

WORKING REDEFINED

The trend toward working at home has far-reaching effects. According to *The Wall Street Journal*, beyond the workers themselves are the blue-collar workers who serve them food, drink, public transportation, and all the other city center amenities built on daily 9-to-5 customers. Salaries, tips, work hours, and changing flexibility influence how a large potential audience for museums will structure leisure time. And as for the absent white collars? If they aren't in the central business district, will they still find your museum?

Gig, shift, work from home, hybrid, and virtual—more than a new vocabulary, these job categories auger the new realities of audiences who used to visit on weekdays, weekends, and evenings. Without altering your mission, or even your open hours, do alter how you define your audiences.

The website for Eiteljorg Museum in Indianapolis gives some clues to today's audiences in its volunteer application form by acknowledging the new working person in these questions:

- Telephone: Home/Cell/Work
- Occupation
- Employer
- Volunteer & Employment Experience
- Days available to work: Weekdays . . . Evenings . . . Weekends . . . Morning . . . Afternoon . . . Evenings . . .

By asking for the applicant's work experience, Eiteljorg shows that volunteers aren't just retired people. As for the prospect's employer, they could be in any city in the world. And the worker? Perhaps new in town, as a work-anywhere employee. Audiences, of which volunteers are a part, have already changed.

Volunteers are unpaid workers who likely have worked somewhere else in their careers, their work ethic coming from a job that significantly defines them. Just like your visitor audiences. Owls Head Transportation Museum, in coastal Maine, describes its volunteers corps, which might include: "retired clam diggers to the vice chairman of a Fortune 500 Company" and ranging "from experienced industry retirees to youth seeking skills." Your audiences, of course, come from jobs other than museumgoer.

All museums are cautioned to be aware that not all retired people are over 60, and that their jobs are part of their background and culture.

Audiences can often be understood by their available time. Scheduling programs with compassion for your audiences' changing work hours demonstrates a brand prepared for the future in many ways.

The Barnes Foundation recognizes that audience preference goes beyond topics of their courses. It expertly categorizes its learning programs by credit and non-credit, as well as lecture and workshop, a nod to jobs like educator. The Barnes goes further by offering a wealth of time choices: day of the week, time of day, one-day or six-week, virtual or on-site; there's a slot for everyone. This is a luxury of options, and not all museums can manage it. However, look at the diversity of audiences served by:

Introduction to Color Theory - Thursday, 10am - 4pm

Great French Paintings at the Barnes - Wednesdays, September 6 - September 27, 12 - 2pm

Graphic Design: An Unruly History - Tuesdays, October 3 - October 24, 6 - 8pm

Thursday people, six-week people, and morning, noon, and nighttime people—so many different kinds of habits, each one delineating a specific audience.

DESTINATION VISITORS

Where a museum lives is defining. Its audiences that head there could be defined as fans, traveling from anywhere in the world because they ardently support the brand. People visit Cooperstown (fans know where it is) because they love baseball. "It was the best day of my life," said a 40-year-old mother of two boys, with only slight exaggeration.

Likewise, fans come from all over the world to visit Queens, New York, because the Louis Armstrong House Museum is there. Global reach is in the brand vision, which informs the museum, the man, and all the people who remember him:

"to not only preserve Armstrong's legacy, but to live the Armstrong values of Artistic Excellence, Education and Community . . . for local neighbors, city, national, and international visitors. . . [a] legacy as one of the most influential figures in American and Global History."

Louis Armstrong is demonstrably a destination for all visitors. However, a legacy that one can currently see and hear on multiple platforms, from vinyl to television to YouTube, is not necessary to attract destination audiences. Smaller museums everywhere are experiencing a well-trod path to their doors, especially if they have an identity that is:

* Singular
* Manifested in a collection
* Interpreted in exhibits
* Enhanced with programs
* Communicated consistently in ways that stay on brand, all the time

You know this, but it bears repeating.

Destinations say a lot about a museum, especially if there are two of them vying for the same famous person. Two Susan B. Anthony museums, one in western New York, the other in eastern Massachusetts, are separated by branding as well as geography.

"This is the home of one of the world's great revolutionary sites," headlines Rochester, New York.

"Organize, agitate, educate," implores Adams, Massachusetts.

One museum website pictures a cradle, hearth, and home as the warm, pastel birthplace of suffrage's fight. The other one uses campaign buttons, bunting, and red and black backgrounds for suffrage emphasis.

An urban museum and a small-town museum tell similar stories in totally different colors. The audiences for each are somewhat defined by distance from the museum, time available for a visit, family structure, education programs, and tourist interests. When it comes to donor support, the subtle audience differences might matter more. By the way, the Empire State museum disclaims "affiliation with other organizations bearing Anthony's name."

How do time, the valley, and a logo that's a stopwatch with water pictured on its face fit together. At Time and the Valley Museum, it's all about a natural resource that's been glistening through the Catskill Mountains for centuries. The museum's name and home page indicate the breadth and commitment of its brand to the Catskills region and its rivers, which have supplied New York City with water for centuries. It serves tourists to and from the Catskill Mountains, and nature explorers at all levels, not to mention environmentalists studying water security, and students writing papers. The museum envisions

being "a leading resource for exploring the history and future of access to clean water." It knows its brand and its audiences.

An inventive, and effective, vehicle for spreading its mission is a traditional, folded road map—marked with the time-and-water stopwatch logo—to the region. Useful for tourists of all interests, the map secures the museum as a knowledgeable guide.

On another map, across the country, the Columbia River looks like a connector. It winds through several states, starting in a port and passing scenic wonders and small towns, farms, and highways. It's easy to grasp that the river is a map of history, enterprise, industry, and growth and that it comprises every vocation and avocation from engineering and navigation to transportation and tourism.

This maritime museum, unlike many that are on coastlines of oceans or lakes, overlooks a great river. The Columbia River Maritime Museum interprets the river as a thoroughfare, a network of trade routes for Native Americans, a salmon fishing paradise, and historic shipping channel. The museum's home page visual is a wide swath of the Columbia River, the museum, and ships, looking purposeful. It previews the brand. People who like natural beauty, ships, American industrial history, and water will visit for information on the business of a great American river.

CREATORS AND SCHOLARS

Once a museum expands its definition of audience, the brand doesn't change but its brand mission expands. In the case of Newberry Library in Chicago, the collection philosophy also expanded, as happens when acquisitions grow over generations.

Newberry Library includes, as part of its audiences, the people who write the books (and read the books):

> "Today, the Newberry collection extends across 27.5 miles of shelving in the library stacks. And it's still growing. We acquire and preserve materials that represent a range of perspectives and experiences—including those that historically have been marginalized, misrepresented, or silenced."

Programs for creative people are charged with being creative, and Mark Twain rises to the occasion with a program for scribblers. Says the Mark Twain House, in Hartford, Connecticut:

> "Not a writing class, not a writing workshop, just three hours of uninterrupted writing time in Mark Twain's own library. Join a handful of fellow scribblers to write, reflect, and plot whatever piece of literature you're working on. The space is quiet, except for the burbling fountain in the nearby conservatory, and infused with Mark Twain's spirit. Laptops are welcome, but make sure you

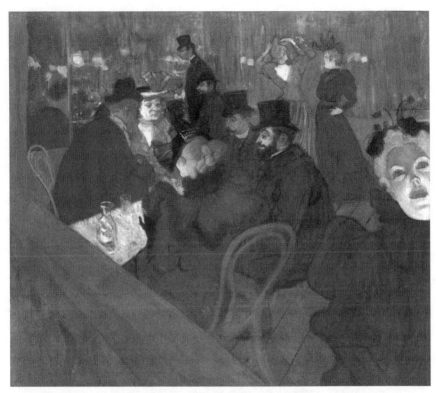

The new museum audience is plural. Strong brands constantly redefine their visitors and supporters. Can you pick out the first-time visitors, members, and donors in this audience? *Helen Birch Bartlett Memorial Collection, Art Institute of Chicago*

charge up before you come as we have no power outlets to offer. Pencils only, please; no pens permitted!"

Admission is $50. Each session is limited to eight participants and runs from 6 p.m. to 9 p.m. This is a specially priced and scheduled program, not for everyone. But for the brand of the man who immortalized river-boating and racial understanding and even Joan of Arc, all manner of diversity is acceptable.

The Metropolitan Museum of Art in New York City has a Met Copyist Program, and interested artists with accessibility needs are acknowledged and welcomed. The program's application askes the applicant what galleries they are interested in—American, Asian, Egyptian, Greek and Roman art, and multiple galleries of European art—and what medium they would like to use: oil paint, acrylic paint, oil-based clay, or other medium. And then the application asks for the disability requirements:

- A wheelchair route
- Sign Language interpreters
- Accomodation for blind or partially sighted visitors
- Assisted listening devices
- Assistance carrying easels

So many kinds of artists. Look at the variety of audiences represented by the art they create, their areas of expertise, their use of traditional art methods like copying. Such diverse—but not divisive—accessibility issues. So many audiences to be aware of.

Don't forget the creative people in your area. Art conservators, writers, and researchers all need resources, so find out what they need to do their job, whether at your own museum or another institution. Tell the world how they do their job. They'll spread the word, too.

At the Guggenheim in New York City, an art conservator and her blog gave voice to many careers that go unknown and under-publicized to audiences of young people who are unaware of career possibilities in museums:

"Behind the scenes. Many don't know it's there. Certainly they don't know what conservators do ... [how museums can] provide young people with opportunities to channel their interests into a profession to which they might otherwise never be exposed"

The Guggenheim also prospects for a new employee class with its "Art Detective" summer course for teens. New workers, new audiences.

By attending to that segment of the population that doesn't see behind the scenes, all museums will augment their brand.

VISITING REBELS

Museums attract more rebels than one might imagine. Where else could a person see something outside-the-usual, rub shoulders with strangers, and commit an act others don't?

Des Moines Art Center welcomes such venturers with My Museum Monday, available to members. It's a member perk fronting a museum's peek at the secret motivations of its audiences. My Museum Monday offers three hours' exclusive use for any member who wants to do their own thing inside a museum. Within reason, of course. One wish-fulfilled visitor spent time in contemplation, then after the peace and quiet, "decided to fill the Art Center galleries with music. He brought his flute and played pieces in different gallery spaces, testing out the differing acoustics in each space."

Another brought her daughter, and they were able to observe a behind-the-scenes operation: the de-installation of an artwork. "Art Center staff members shared information on the fascinating process of carefully dissembling and re-packing every piece, a special treat" usually unseen by the public, which installation crews typically do on Mondays when the museum is closed.

Another visitor visited a work by Mark Rothko, an artist he had seen only once at the Rothko Chapel in Houston, where he grew up.

With My Museum Monday, Des Moines Art Center has insights into who accompanies members, what their other arts interests are, and the panoramic backgrounds of their members. And isn't it illuminating to see the creativity deployed in what is sometimes called spare time?

Your visitor might be a traditional 25- to 40-year-old, traveling on a work-from-anywhere schedule, college educated, with an urban, cosmopolitan outlook. However, if their individual interests show a rebellious side—say an unexpected interest in wildlife and bugs—"Animals and Insects" in the arts, might be just the appeal for this specific audience.

Museum of Fine Arts, St. Petersburg, segmented their many-faceted visitors' individual interests with a long single shelf of brochures. Each was titled to intrigue different interests:

- Animals & Insects
- Wild Creations & Women Artists
- The Divine & Belief
- It's All in the Details
- Becoming an Artist
- Death & Remembrance

These certainly differ from segmenting by age, zip code, and education level!

An exercise: Show this list to museum colleagues. Which brochure would they reach for? Why? Once you ask those questions, you know a little more about museumgoers' motivations and gain new insights into your audiences.

And now, a shout-out to Goat Yoga, stretching some preconceptions at Shaker Village of Pleasant Hill, Kentucky. This one-day event was sold out weeks in advance, demonstrating an assured risk-taking audience. Visitors rely on museums for something new and different. The same-old, same-old does not entice the young, and never did. Are Nigerian Dwarf goats on brand for a museum that, in the same newsletter, features fall hay-wagon rides and Equinox walks? Shaker Hill is still pitching the joy of nature to audiences very much at peace with expanding nature's geography. Global goats are part of that.

COMMUNITY

"Community," as a word, has a homey, neighborhood aura, which can be limiting to communities with more complex identities. Newport, Rhode Island, claims large, grand mansions as part of its community's deep roots in American history (though the original residents called these homes "cottages"). The Preservation Society of Newport County is proud to support "the oldest intact city, Newport, RI, in America."

The Newport Mansions website clarifies that, in addition to Gilded Age mansions and decorative arts, the museum offers historic information on Gilded Age technology, architecture, work life, landscapes, and American history from the past 250 years. Entrepreneurial America, sometimes baronial, always innovative and hard-working, offers too much to be marginalized as an age of rich people.

Take a refocused look at your museum today. Does it:

- Communicate grandeur, or large size for big families?
- Interpret science as advances, or as something fun?
- Educate about history, or tell stories?

"Growing organically" is a popular term for anything that flourishes and expands without outside tinkering or imposition. It's a good thought, but doesn't help identify the root.

Many museums need to find their roots—their origin, purpose, and identity. The Knight Museum and Sandhills Center in Alliance, Nebraska, looked at the history of the area and found five reasons to be the core of the Sandhills. Any of them could be a template for any museum defining its unique place in the world. The Knight is inclusive when it describes its audiences' roots:

"five areas of local history: Life in the Sandhills, Native American Life, Life in the Country, Life in the Town, and The Railroad, which is the last piece of the puzzle to tie these wildly different lifestyles together. The secondary theme

of Rogues, Rascals, and Visionaries gives you a look at the personalities that settled the area . . . who is what!"

Pioneer memorabilia, Native American artifacts, and railroad history are some of the highlights of the museum's vast collection—glimpses of the life lived by the diverse people who settled in the Nebraska Sandhills. Genealogy research is another place to search for an area's beginnings. At the Knight, that includes "the majority of the city and county records . . . many Western Nebraska records . . . a digital database . . . collection of microfilmed local newspapers, original photos, and genealogical files."

Many museums have similar research available to them.

For museums that have access to archived local authors, listen to those writers. A writer's perspective is wide and inclusive, seeing into the personalities who make the community. Journalists, especially, are accustomed to ferreting out small details with large consequences; they tell history with insight and verve.

Just when it seems that audience demographics have been sliced, segmented, and charted in every imaginable way, a new segment comes along. All-age Girl Scouts. Of course, audiences are changing, and predicting them would take more artificial intelligence (AI) than most museums can afford. Just keep your eyes—and your doors—open, and let's see what the Girl Scouts bring to the mix. Most of them are young, hard-working, and striving for badges. The Scouts also comprise people who like a challenge, mastering the skills that earn a badge. There's a healthy dynamic at work here—with no age or background limits to earning a badge—and new ways to approach important subjects such as science, technology, engineering, and math (STEM), financial literacy, and global action.

Older Scouts also love earning badges that are "retired," supposedly no longer so important to tomorrow's world. How about that? Learning something that isn't required!

If your museum wants to expand its brand of learning, Eiteljorg Museum in Indianapolis provides an example: a badge program on a topic that aligns with its diverse audience and its brand. The badge-earning skill it is teaching is Jewelry Making, drawing on the historic craft skills of Native Americans in the Midwest. Native American history and culture is the soul of Eiteljorg's brand, and it's honored by young girls, with the help of an old organization, who will learn something just for the pleasure of learning—and then take some bracelets and necklaces home. That's important branding, too: Take your project home and show family and friends what's happening at the museum.

New badges enter, less relevant ones get retired; all are viable. There's an analogy here for audiences.

EMOTIONAL COMMUNITIES

Veterans of American wars comprise an audience that's practically a sub-culture. Like their counterparts all over the world, these audiences cross every possible demographic, geographic, economic, political, professional, and behavioral segment. Many veterans visit with their children—young and grown—a cohort of indestructible solidarity, and they'll cross time zones to visit a favorite museum.

New England Civil War Museum in Rockville, Connecticut, is one. Home of Alden Skinner Camp #45, Sons of Union Soldiers in the Civil War was chartered in May 1890 and has met in the same building, the same room, on the first Thursday of every month since 1890, not long after the Sons of Union Veterans of the Civil War (SUVCW) was sanctioned and established by the Grand Army of the Republic (GAR) in 1883.

Alden Skinner Camp #45 "owns, maintains and operates the New England Civil War Museum." It manages a research library, a collection of relics, books, and documents. It awards a scholarship to a graduating high school student every year. Each brand—museum and camp—is a fixture in the community and reinforces the other. They evince consistency, reputation, and stability, proven by 130 years of weekly meetings.

Veterans and their families are an identifiable market, albeit a complex one, that all museums can learn more about. Start by:

- Offering military discounts
- Remembering that "military people" comprise women, parents, and children
- Developing targeted services and hours for this audience with such different work and assignment schedules
- Programming discussion groups on military issues

Communities aren't just the visitors, staff, volunteers, and partners who come to the Anoka County Historical Society in Anoka, Minnesota. They're embedded in the museum's mission statement: "Our mission is to gather, preserve and share the stories of all the people and communities that are part of Anoka County." More than promising inclusiveness, it starts with inclusiveness. As an example, the historical society's podcasts give voice to memories of homesteaders to archeologists to high school coaches. The executive director says, "We have to know who communicates with us and in what way."

When discovering new audiences and how your brand communicates to them, hearing from them is a good starting point!

Your brand is your audiences. When they visit, it's because they like it. When they attend a lecture, buy merchandise for a gift, or volunteer, it's because they respect it. When they donate, support, or partner, they trust it.

BRANDING CHECKLIST

Audiences are so diverse, each day another segment segments again. For branding to stay relevant, check these new people:

- Newcomers to the community
- Immigrants, often industry recruits, sometimes without families
- Job transfers
- "Weekday, weekend, it's all the same to me" people
- Drama-lovers, concert-goers, or anyone who reads a program in a theater
- The over-70 bracket (the new middle age)

If the people in the lobby were shown your mission statement, would they see the museum in it?

REFERENCES

"Alden Skinner Camp #45," Museum, New England Civil War Museum and Research Center, www.newenglandcivilwarmuseum.com/copy-of-library [accessed July 22, 2023]

"Discovery the History of an Artwork in a Speck of Paint" (blogs, online resources), Museum of Modern Art, www.guggenheim.org/blogs [accessed July 17, 2023]

Esmay, Francesca. "Discovering the Story of an Artwork in a Speck of Paint" (blog), December 30, 2021, Guggenheim, www.guggenheim.org/blogs/checklist/discovering-the-story-of-an-artwork-in-a-speck-of-paint [accessed August 11, 2023]

"Fairy House Hunt at Locust Grove" (email), Locust Grove Estate, www.event brite.com/e/homeschool-fairy-house-hunt-in-the-garden-tickets-577 663756847?aff=erellivmlt [accessed April 19, 2023]

"First Thursdays + Free Days at SFMOMA," San Francisco Museum of Modern Art, www.sfmoma.org/free-days/?sid=23644&utm_source=mkt_news&utm_medium=email&utm_campaign=MKT_FY23_NL_BowlingKin shipPress_060723_SG_CRM-KC&utm_content=button#free-family-days [accessed August 15, 2023]

"Girl Scouts Junior Jeweler Badge Workshop and Tour, August 27, 2023" (events), Eiteljorg Museum, https://eiteljorg.org/eiteljorg-events/girl-scouts -jeweler-badge-workshop-and-tour/2023-08-27/ [accessed July 20, 2023]

"Goat Yoga" (events calendar), Shaker Village of Pleasant Hill, August 26, 2023, https://shakervillageky.org/events/goat-yoga-2/ [accessed August 8, 2023]

"Grandparent Membership," Getting Involved, McKinley Presidential Library & Museum, https://mckinleymuseum.org/join/grandparent-membership/ [accessed July 24, 2023]"

"Here to Stay," The Louis Armstrong Center Opens July 6 [2023], Louis Armstrong House Museum, www.louisarmstronghouse.org/our-new-center/ [accessed August 3, 2023]

"History," Columbia River Maritime Museum, www.crmm.org/history.html [accessed August 13, 2023]

"Girl Scouts Junior Badge Workshop and Tour," Girl Scouts of Central Indiana, https://eiteljorg.org/eiteljorg-events/girl-scouts-jeweler-badge-workshop-and-tour/2023-08-27/ [accessed July 20, 2023]

"Individual Met Copyist Application," The Metropolitan Museum of Art, https://metmuseum.wufoo.com/forms/z6lzkal0uuv7sm/ [accessed August 15, 2023]

"Introduction," Home, Knight Museum and Sandhills Center, https://knightmuseum.com [accessed March 30, 2023]

"My Museum Monday," Membership, Support, Des Moines Art Center, https://desmoinesartcenter.org/support/membership/my-museum-monday/ [accessed July 30, 2023]

"New Badges," Girl Scouts, www.girlscouts.org/en/members/for-girl-scouts/badges-journeys-awards/new-badges.html [accessed July 20, 2023]

Newport Mansions, The Preservation Society of Newport County, www.newportmansions.org [accessed August 7, 2023]

"Organize, Agitate, Educate," The Susan B. Anthony Birthplace Museum, www.susanbanthonybirthplace.org/ [accessed August 1, 2023]

"Our History," About Us, The Newberry, www.newberry.org/about/ [accessed March 18, 2023]

"Our Vision," About Us, The Time and the Valley Museum, www.timeandthe valleysmuseum.org/about-us/ [accessed August 4, 2023]

"Reminding You the Present Is the Past of the Future," Anoka County Historical Society, https://anokacountyhistory.org/ [accessed March 10, 2023]

"Take a Class," Barnes Foundation, www.barnesfoundation.org/classes [accessed July 9, 2023]

"This Is the Home of One of the World's Great Revolutionaries," National Susan B. Anthony Museum & House," https://susanb.org/ [accessed August 7, 2023]

"Volunteer," Support, Owls Head Transportation Museum, https://owlshead .org/page/volunteer [accessed June 29, 2023]

"Volunteer Application," Volunteers, Give & Join, https://eiteljorg.org/give-and -join/volunteer/ [accessed April 19, 2023]

Wallace, Margot, visit to Museum of Fine Arts, St. Petersburg, February 20, 2024.

Weber, Lauren. "Burned Out, More Americans Want to Work Part Time," Exchange, *The Wall Street Journal*, February 25, 2023, www.wsj.com/arti cles/as-americans-work-from-home-europeans-and-asians-head-back-to -the-office-db6981e1 [accessed February 28, 2023]

"Writing in Mark Twain's Library" (events), https://marktwainhouse.org/pro grams-events/writing-programs/writing-in-mark-twains-library/ [accessed July 28, 2023]

3

Learning

Note the subject of this chapter: Learning. When an educator passes information to a student, it becomes learning. This is a long process, and the burden to learn is on the student. This chapter helps museums lighten the burden and shorten the transfer time. It all starts with the idea of *learning*, rather than *being taught*. It focuses on the "learner," because "student" has connotations of old systems and only young recipients. In admiration of museums' flexibility and venturesomeness, the following concepts aim to smooth the transition from educating place to learning wonderland with new perspectives, enduring capabilities, and obvious strengths. That's what good brands are made of.

COMPONENTS OF LEARNING

The following are components of learning that we'll discuss in this chapter:

Discovery. People discover what's interesting to them. What they learn at your museum reflects their interests, their personal ideas, them. They've found kinship with you. Connecting reinforces branding.

Curiosity. This most personal trait needs more respect. Ask any human being what they're curious about and they will likely answer, "I'll have to think about that." Bingo! You've just made someone learn about something they believe in. Now you are an ally. Common cause builds branding.

Agency and satisfaction. Power to experiment, choose, discard, try again, all on one's own. And then enjoy the satisfaction that comes with the doing, not only the achieving.

Family. Learning is a family matter, for all families. If ever there was a common denominator among cultures and ages and backgrounds, it's the family; everyone finds a comfortable space for learning. For families, the museum that fosters education, the grail of the world's families, earns enduring support.

Empathy. Understanding others is a good knack to have. Museums of all sizes and all genres nurture empathy.

Conversational sharing. Museumgoers talk to each other about what they're seeing. The more they talk, the more they boost your brand.

Advancement. Museumgoers say they want to learn. That's the phrase they use. It's a proxy statement for wanting to be better, to get ahead. It's emotional, and that's good branding.

All these components exist right now, in your museum. Leverage them into fresh original approaches. Innovate your brand.

DISCOVERY

Discoverers have such great adventures. They go looking for things they covet, they enjoy the thrill of the hunt, and then, wow, they find something wondrous. Can this be learning? Yes! Museums make this kind of learning possible, with a helping hand from X (formerly Twitter). X is designed for explorers of an idea, as well as followers. And when a museum like Zanesville Art Museum in Ohio sends out jigsaw puzzles of paintings, art lovers and puzzlers like that museum brand more.

Online involvement is smart for museums with "irregular hours," occasional closings, or a location not always accessible to their loyal visitors. X posts involve many audiences, and learners should rise to the top of that list. Learners at any age, of any learning style, are a promising investment; they learn to love the museum all their life. That's good branding.

Here's how Zanesville Art Museum writes its discovery learning tool, ZMA Puzzler: "Today's online puzzle is Down Wick Avenue by Clyde Singer. Share it with your friends and give it a try bit.ly/3JMhE6k #puzzle #artoftheday #museumfromhome."

While looking for the Puzzler, visitors will see a scrolling of all activities, exhibits, announcements of the museum. It is a steady infusion of not just what museums do, but what they do for you—because X targets doers, not just seekers.

Also note that the post identifies the author of the puzzle. Sharing credit is good learning and good branding.

CURIOSITY

Curiosity is a slippery thing, and it eludes many. Accolades to Connor Prairie, a restored village in heartland Indiana, for defining curiosity for anyone who has forgotten how to find it. Try:

- Purposefully noticing something you haven't before or seeing something from a different perspective

- Taking the time to explore what you are interested in
- Noticing what you have overlooked

Connor Prairie shows how curiosity is accomplished with Curious Conversations involving everything from transient art to seasonality to Ossabaw Hogs. Not clear on what these mean? That's the whole idea behind curiosity. Find out with Connor Prairie.

Milwaukee Public Museum, with its Community of Curiosity program, fully realizes its branding with:

- A continuing program, scheduled monthly
- A special club, open to anyone, defined not by age or education but by a love of following their curiosity
- A name that identifies that special club: Community of Curiosity
- A singular program offered only by the Milwaukee Public Museum

This is not a new program. It's been tried and proven successful as an at-home video series. Now it has been elevated to a museum-owned learning program.

Any museum, of whatever size or genre, can take ownership of curiosity:

- Use the word "curiosity" in children's open art programs or story hours.
- Ask children, of all ages, to identify one topic they're curious about; then show where in the museum they can investigate further.
- Involve adults and caregivers in sharing what they're curious about; make it a family exercise.
- Encourage interns in following their curiosity when conducting research.
- Invite speakers to talk about curiosity; most communicators welcome the challenge.
- Launch a Curiosity Contest—on the platform of your choice, or a touch screen in the galleries.
- Ask docents to listen on their tours for what visitors are curious about, then discuss their findings.

Everyone is curious about something; it's amazing how few are ever asked, *What are you curious about?* Milwaukee Public Museum makes the viewer ponder the point: "Tap into your curiosity and have fun!"

CONVERSATION AND SHARING

Of all the ways to hold a conversation or share information—meetings, internal posts and message boards, a friendly break room, a large coffee pot—one format especially effective in sharing ideas and burnishing a museum's image

is the conference. Large or small, one-day or a weekend, on-site or at a brand-reflective other venue, conferences use the sharing mode to:

- Nurture creativity—offering individuals from multiple disciplines a thought-provoking environment in which to produce works and present them to your community
- Expand interpretation of your site through active solicitation of diverse perspectives and voices
- Provide audiences across racial, ethnic, and economic lines an opportunity to discover and engage more fully with the museum and its focus
- Strengthen the museum's community, perhaps the entire region, as a center for exploration and learning

Look at all the audiences that learn something new:

- Creative people of all disciplines
- The museum itself—curators, docents, researchers, board, fundraising, volunteers
- Visitors who enjoy newly imagined interpretations of the museum
- The community: it's strengthened and established as a center for culture and the arts

Symposium is another name that connotes a meeting of many focused minds. The education value of multiple brains and their singular contributions is well known. Put it into practice, even on a small scale, it adds to your brand's credentials. Here are a few tips:

- Give your symposium a name that relates to your collection or area of specialization
- Be mindful of length of gathering; it need not be two days
- Offer at least five different topics for each day
- During meals, add a Topic for Discussion card to the centerpiece of each table—a good conversation starter for people trying to meet each other
- Inform each speaker of your museum's mission; speakers want to relate appropriately

Some thoughts on a learning symposium that reinforces your brand: Focus clearly at the concept, planning, and execution stages. Stand for something. Show the scholarly side of your museum and its serious attention to advancing toward the future.

Whatever your size and genre, extend invitations to speakers from as many disciplines as possible. They needn't be academic to talk knowledgeably and insightfully. Search beyond the expected categories for serious ideas from

Curiosity is the new learning. Museums don't tell; visitors discover. They've been using their curiosity for a long time. *This file is licensed under the Creative Commons Attribution-Share Alike 3.0 Unported license.*

cooks and carpenters, farmers and game developers, grammar school science teachers and the mayor.

Instruct speakers that you're expecting their specialty to offer unusual perspectives.

At Locust Grove Estate's Historic Architecture Symposium (June 16-17, 2023, in Poughkeepsie, New York), the first speaker was a photographer who documents buildings. The eye of a photographer provides a unique perspective of history and its structures.

You can bring this multidiscipline concept into all museum learning programs by redefining what makes a teacher. At Tellus Science Museum in Cartersville, Georgia, an Educator program words it like this: "The Tellus education department understands the needs of teachers—public, private or home school—scout leaders and other educators."

Museums open quite a few new doors when they enlist other "educators." Call them learning experts. In addition to their own learning experts, museums have access to expertise in their community—scientists such as broadcast meteorologists, environmental experts such as farmers, engineering pros such as mechanics, or music experts such as piano teachers. You can be creative with other teachers. It is all new territory.

Museums with a reputation for identifying and engaging professionals—people who earn a living practicing their expertise—reinforce their brand. It is not rebranding, it's expanding. And when you can expand in the community, it is highly visible branding.

EMPATHY

"The past is not over . . . our ancestors are not relics." With that avowal, Door County Maritime Museum in Wisconsin, in the manner of generations of traditional boatbuilders, offers a 25-week program to learn about, and then build, a wooden boat. This museum sees the people of the past and their occupations as forerunners of today's industries. For the museum's learners, this is an "opportunity to learn firsthand skills of the age-old craft of building wooden boats."

The Museum of Work & Culture in Woonsocket, Rhode Island, exemplifies empathy up front, as forward as possible. In its "About the Museum" it says: "Guests explore the lives of immigrants at home, work, and school through nine immersive exhibits." You can't teach a person's life and experiences, but exploring their homes, workplaces, and schools gives you entree to them.

Connor Prairie extends this awareness of other lives to the natural and man-built world around us: "The White River runs through the heart of Conner Prairie. This water brought together seemingly disparate groups of people to this place."

And: "one way to look at history [is] through human experiences . . . how individuals [responded to] . . . larger historical events."

Museums are exceptional schools for empathy. So many different kinds of people mix among their objects and along their pathways. Think of the many ages and backgrounds sharing the line at the ticket counter, sitting together in a program space, or learning together on a tour. How can learning from others not happen?

AGENCY AND SATISFACTION

Look at the layout of any museum. There are so many directions one could take. At Grohmann Museum in Milwaukee, one could be tempted to spend the entire visit in the roof garden with its dozen statues of workmen of old. Inside, the galleries are rectangular and walkways are wide, and one can see ahead to where they might go next. Most historic houses have odd-shaped rooms where visitors wander in and out. In all museums, wandering hither and thither is expected; visitors are free agents to go, stop, or move on as they please.

Museums are places where people have agency: freedom to decide on their own what is worth further observing, and then to compare, analyze, and form opinions. This is great learning! No multiple-choice questions. It's satisfying to learn on your own schedule and itinerary.

Today, museums are bringing that freedom of looking and learning to many activities, such as:

- Tours where guides ask for comments before making their own
- Labels suggesting that the visitor compare one object with others in the room
- Mixing eras and genres in one galley, encouraging the viewer to make connections
- No labels at all in painting and sculpture galleries, other than the artist's name on the painting, frame, or podium

Learners don't lean back and wait for bolts of knowledge. Today's learners explore endlessly, armed with digital advice and their own trail-breaking ideas.

Cherokee Strip Regional Heritage Center in Enid, Oklahoma, gives learners agency to explore in this way: "A Townsperson will greet students and take them through the daily chores of homesteading in the Cherokee Outlet. Students are encouraged to wear period clothing and bring their lunch pails filled with a typical 1893 Oklahoma Territory lunch."

New Mexico History Museum in Santa Fe has a Making History program, which dedicates venues throughout the museum where visitors can gather at worktables loaded with tools, supplies, and instructions to put together

history-related projects. Making things intrigues learners of all ages and backgrounds; they explore, exchange ideas, master some skills, and gain confidence in new technologies, all the while working together across generations and cultures. The worktables, ready for today's new ideas, are next to historical objects—the traditional and the future, helping the present learner figure it all out on their own. Based on a heritage's "long tradition of problem-solving, invention, and actually making things," this is how a fine museum that knows its brand renews its history.

FAMILY

Bauxite in your pots and pans. Feldspar on the tile floor. Barite in tennis balls and kaolin in the toothpaste. Tellus Science Museum directs families to science activities around the house in its scavenger hunts: "Minerals in your house! How many of these items can you find around your house?"

How many small-town museums in rural areas could benefit from family programs like this? The At-Home Science Activities kit includes pictures of the mineral, a list of where they're found around the house, and a checklist of the ones the learners find.

The project is devised for young people and adult caregivers, whose input is essential to proper learning. Museums long ago discovered their unique advantage in being able to invite parents into the schoolroom. Tellus Science Museum helps families enter that space at home. They've expanded into new territory, at a time when borders are changing. Good going! Good way to recharge your brand.

Cooper-Hewitt in New York City gives families an assignment to complete as a family. Its Places for Peace Family Program involves a one-day workshop that asks participants to work as a family to imagine and design a space for peace in the community. Family—revisit that concept regularly. A brand that endures across the generations is a powerful brand.

Family learning gains in value when you think in terms of learners. At Flint Hills Discovery Center in Manhattan, Kansas, the Learning Objectives are refreshingly relevant: targeted to audiences at 18 months to 3.5 years, so parents can learn how to raise a nature lover and how to model good outdoor behavior. Reframed as a family initiative, this solidifies the museum brand, marking it as generational, thus enduring,

ADVANCEMENT

Learning holds an exalted place in the plans of many museum audiences. Those who want to advance themselves, their families, and their community are legion; and the legions are growing as museums expand their tent.

Historically, museums have served as educators. As they revisit their brands, they will be a bold resource for learners and an avatar for the future of learning.

Embodying advancement, museums will:

- Clearly state program credentials
- Indicate program goals
- Help learners plan the proper—or not appropriate—programs to select
- Explain how the learning program reflects the museum's mission and collection philosophy
- Identify outside resources, where possible
- Select properly credentialed, trained facilitators

The following three programs, out of many, give examples of museums' roles in advancing learning.

High School in a Museum, in Cleveland, has evolved a partnership with Great Lakes Science Center to offer a high school STEM curriculum. The partnership's MC2 STEM High School offers a year-round schedule of 10-week classes. Focusing on science, technology, engineering, and math, the school benefits science-eager high schoolers with expertise from two learning organizations. The program is project-based using implementation practices that scientists and engineers use. It's meant for advancement. It's high level. It's how a trusted brand re-earns trust. The best partnerships benefit more than two partners. In this case, the Cleveland Metropolitan School District, the Science Center, and the students can all shake hands on a stellar learning model.

Since learners enter your doors at all ages and from all backgrounds, remember the ones who come looking for scholarly research. Good researchers leave no book unturned, and your library may already have what they need. Feature your library prominently on your website.

The Museum of the American Arts and Crafts Movement, in St. Petersburg, Florida, states that its mission is "commitment to education and furthering the scholarship of the Arts and Crafts Movement." The library plays a visible role. This resource is discreetly located but easily found on the first floor. It's prominent on the website for all to access, though its on-site location is available by appointment only. Museums should be proud of and attentive to their libraries. They signal scholarship and learning without boundaries.

Remembering the financial needs of those wanting advancement, Conde-Charlotte Historic House, in Mobile, Alabama offers the American Indian Medical Scholarship Program for students of American Indian descent. Designed for nursing, healthcare, and health education careers, students are expected to return to work on reservations or hospitals in areas largely populated by American Indians.

Advancement is a goal for all visitors, and museums can honor success by putting it within reach. Good branding demands outstanding attributes—yours and your customers'. When the latter are also outstanding, you deserve the brand.

ALL THE SENSES

Within the building and out, a museum has access to all the senses that sentient people use. Senses are emotional and vivid. Sound and taste, smell and touch, they make for a world of avid, enthusiastic learners. Beyond food trucks and summer concerts, museums are putting senses on display.

Norton Simon Art Museum in Los Angeles teamed with Los Angeles Opera and Maestro James Conlon to pair works from the production of Debussy's *Pelléas et Mélisande* (March 25–April 16, 2023) with nine paintings selected by Conlon from the museum's 19th-century galleries, and narrated by him. Consider all the learning styles involved:

- Looking at images
- Listening to music
- Comparing the two kinds of communication
- Moving around while listening and looking
- Using online resources for more choices of time and place
- Benefiting from collaboration with several cultural resources
- Learning from a legend in the music world
- Experiencing the museum version of a master class

Now consider the joy of scent. Institute of Texan Cultures, at University of Texas Austin, found that new learning language as an unintended consequence of a series of videos aimed at introducing the museum's volunteers. One docent talked about visitors' enthusiasm for Texas history, and she spoke wholeheartedly about children's need to know about their past: "They need to touch it [the past] and smell it if need be."

Every time your museum discusses learning with a new language—like smelling—you bolster your reputation as a learning place. Conversely, of course, every time you fall into a learning cliche, you diminish your status.

And then, there's food. Glorious food. In "The Art of Food," Jordan Schnitzer Museum of Art at Portland State University in Eugene, Oregon, exhibited more than 100 works, in many media, depicting food. Visitors were encouraged to "consider your own relationship with food" in ways beyond just consuming it as fuel.

The following ways the museum suggested thinking of food is a template for all learners when looking at museum exhibits:

- How is this object integral to our communities?
- How does it affect our relationships?
- What does it say about cultures, ours and others?
- How has it entered our languages?

With food specifically:

- How do you interact with food?
- Do you grow it, gather it, or buy it?
- How do your transform it, cut, cook, spice, or garnish it?
- When and where does food enter your days with other people? Think about holiday meals, business lunches, dates, and other appointments.
- What are the ethical implications of food in our world?

Exploration and curiosity blaze bright at museums. Museum professionals constantly reinvigorate all aspects of their learning. As innovators, look around; your brand mission is everywhere, implementing and updating learning. With these revitalizing ideas, you have the tools to make it even stronger.

BRANDING CHECKLIST

Do your learning programs:

- Invite all ages, reflecting broader audiences?
- Have distinctive, ownable names?
- Employ new, perhaps proprietary, techniques?
- Bring in speakers from a wide spectrum of disciplines?
- Use different spaces in and around the museum?

REFERENCES

About the Museum, Museum of Work & Culture, www.rihs.org/locations/museum-of-work-culture/ [accessed March 28, 2023]

"American Indian Medical Scholarship Program," Scholarships, Education, Conde-Charlotte Museum House, www.condecharlotte.com [accessed June 15, 2023], https://nscda.org/?page_id=150&state=AL&prop=199 [accessed June 15, 2023]

"The Art of Food: From the Collections of Jordan D. Schnitzer and His Family Foundation" (exhibitions), Museum of Art at Portland State University, Oregon, www.pdx.edu/museum-of-art/exhibitions and www.pdx.edu/museum-of-art/events/art-food-collections-jordan-d-schnitzer-and-his-family-foundation [accessed June 14, 2023]

"Community of Curiosity," Programs, Milwaukee Public Museum, www.mpm.edu/programs/community-curiosity [accessed May 17, 2023]

"Curious Conversations: Ossabaw Hogs with Dr. Michael Sturek," Learning Portal, Connor Prairie, May 15, 2023, https://cp-ecommerce.amesite.net/index.php/product/curious-conversations-ossabaw-hogs-with-dr-michael-sturek/ [accessed May 8, 2023]

"Field Trip and Group Tour Programs," Educator Programs, Education, Tellus Science Museum, https://tellusmuseum.org/explore/education/programs/ [accessed April 19, 2023]

"ITC Docent Judy Toscano," TexanCultures, Institute of Texan Cultures, https://youtu.be/bv0-DX1QnPs [accessed June 15, 2023]

"Learning Portal" (website), Connor Prairie, www.connerprairie.org/conner-prairie-learning-portal/ [accessed April 5, 2023]

"The MAACM Library," Museum of the American Arts and Crafts Movement, www.museumaacm.org/librarysearch.php?ver=71079201 [accessed June 15, 2023]

"Making History Program," Education, New Mexico History Museum, www.nmhistorymuseum.org/education/makerspace-and-learning-lab.html [accessed June 14, 2023]

"Musical Audio Tour," Exhibitions, Norton Simon Museum, www.nortonsimon.org/exhibitions/virtual-exhibitions/claude-debussy-refracting-his-music-through-art/ [accessed April 28, 2023]

"Nature Together," Register for a Class, Youth Programs, https://secure.rec1.com/KS/manhattan-ks/catalog/group/4501/122324/905ac13be7965738db62ae4f99443440 [accessed April 9, 2023]

"Pioneer Live Homesteading," Cherokee Strip Regional Heritage Center, https://csrhc.org/pioneer-life-homesteading/ [accessed April 10, 2023]

"Places for Peace Family Program" (event, April 8, 2023), www.cooperhewitt.org/event-category/family-programs/?utm_source=wordfly&utm_medium=email&utm_campaign=DesignNews040623&utm_content=version_ [accessed April 6, 2023]

"Puzzler," Programs Online Anytime, Zanesville Museum, www.zanesvilleart.org/ [accessed March 31, 2023]

"Rural Residences, etc., The Architecture of Alexander Jackson Davis," Historic Architecture Symposium, June 16, 2023, Locust Grove Estate e-newsletter, www.eventbrite.com/e/cancer-research-symposium-tickets-6285983 03447 [accessed June 9, 2023]

"Scavenger Hunt: Minerals in Your House," At-Home Science Activities, Tellus Science Museum, https://tellusmuseum.org/wp-content/uploads/2021/11/Tellus-Scavenger_Minerals-1.pdf [accessed June 14, 2023]

"School Is in Session at the Science Center," About, STEM MC2, https://greatscience.com/about/mc2-stem-high-school [accessed March 30, 2023]

Wallace, Margot, visit to Grohmann Museum, July 21, 2022.

"Win a Handcrafted Wooden Boat!" Door County Maritime Museum e-newsletter, November 3, 2022, https://dcmm.org/homepage-featured/win-a-handcrafted-wooden-boat/ [accessed March 27, 2023]

4
Talks, Speakers, and Stages

Whenever a museum sets up a podium, microphone, and, perhaps, a screen, that's a stage. Surround them with a few chairs and you expect an audience. At this point decide whether the ensuing talk, speech, or performance will be an entertainment or a branding event.

The goal of this chapter is to ensure that stage and audience combine to strengthen your museum's brand. It's a fertile opportunity. Talks and performances attract all manner of audiences, often quite different from your usual museum visitors. Your brand gains new meaning with these new adherents. It is hoped they'll enjoy the experience, even be entertained.

Know the difference before you make it brand appropriate:

• Entertainment is common/generic; branding is particular to your museum.
• Entertainment comes and goes; branding is deep-rooted and lasting.
• Entertainment is hired, paid, and leaves when the gig is over; branding is earned and endures.

There are many ways a museum can transform a talk or performance to a signature event:

• Leverage the museum's spaces, architecture, and displays
• Connect what happens on the stage with the mission
• Target new audience segments from industry, academia, and other time zones
• Reveal and revel in local history
• Invite experts on topics that relate to the museum's focus
• Collaborate with other organizations for broader viewpoints

Here's an event that doesn't talk much; no speechifying, no lecturing. All the noise comes from heavy machinery like helicopters whirring to ground, big rigs roaring their engines, military equipment exuding power. Kids love it. The

Heavy Metal in Motion fall event at Tellus Science Museum in Cartersville, Georgia, lets kids climb and peek into the big ideas that stir imagination. The stage at Tellus is the broad landscape around its building, where on other days nature drops in.

The well-engineered vehicles connect smartly to this science museum whose mission states: "Because science matters, we engage, educate, and inspire visitors to make scientific connections through dynamic exhibits and enriching experiences."

The set for Newport Mansions, in Newport, Rhode Island, is a podium on a stage in one of its historic houses, The Breakers, for a talk on Gilded Age architecture. The talk featured Gilded Age mansions in New York City and showed how society owners and architects moved their tastes to and from late-nineteenth-century Newport and a more recent television adaptation. An expert talk, complemented with professional slides, shines a scholarly light on an already gilded brand.

Goat Yoga at Shaker Village! Who could resist this? With the lawn as its stage, Goat Yoga surpasses Shaker Village's usual visitor expectations by attracting young fit-followers, parents in search of an adult hour to themselves, outdoor types, and animal lovers. It attracts return visits by locals. It's enough of a head-scratcher to make one realize: This museum is more than I thought. Relevance sometimes means upturning usual expectations and reconfiguring them—to the times, the culture, and its ongoing dedication to the community.

CONNECT WHAT HAPPENS ON STAGE TO YOUR MISSION

Louis Armstrong House Museum in Corona, New York, sponsors jazz programs. Of course! Armstrong's music imbues the brand now and forever. And the museum connects the performance with goals and mission:

> "Each [musician] . . . shares a personal connection to Armstrong and . . . how artists approach, how listeners appreciate, and how audiences interact with music . . . Louis Armstrong House Museum . . . brings together world class artists to create new works inspired by museum archives."

Connecting speakers or performers to a museum mission transforms entertainment into branding. When first talking to the people who will hold a mic and inspire an audience, set the stage:

- Tell them your museum's mission and goals
- Explain how their performance interprets your museum's exhibits
- Thank them for their talent that enhances your museum's standing

You can't tell a speaker, or a jazz musician, how to perform, but you can share with them how your values intertwine.

The most important architectural detail of this paneled auditorium in the Oriental Institute (now Institute for the Study of Ancient Cultures, West Asia & North Africa) at the University of Chicago is the drop-down screen showing who owns it. A respected speaker will surely deliver an informed talk, because of the brand name of the museum. *Photo Daderot © Daderot, CC0, via Wikimedia Commons*

Awards ceremonies combine information with dazzle. When the main speaker, award, and honoree all match the museum's mission, it's a brand winner. The Mark Twain American Voice in Literature Award accomplishes that. The event and celebrity speaker are sparkly. The award winner will be: "an exemplary work of fiction from the previous year that speaks with an 'American Voice' about American experiences, much like Twain's masterwork, *Adventures of Huckleberry Finn*."

The museum mission is stated on the same page:

"Mark Twain changed the way the world sees America and the way Americans see themselves. We carry on this legacy to foster an appreciation of Twain as one of our nation's defining cultural figures, and to demonstrate the continuing relevance of his work, life, and times."

Note the inclusion of the world, and the continuum of legacy to continuing relevance. This is a museum conscious of its place and agency in a changing world. This is a visionary template.

With a clear eye on the intended audience, children eighteen months to five years, Briscoe Museum of Western Art in San Antonio, Texas, delightfully puts its brand on Storytime Stampede. The speaker for each monthly program is a storyteller who tells stories and also leads movement activities, reading out loud, and making art. "We believe in the power of engaging and educating children through art," says the web page, and the list of monthly topics artfully combines a Western ethos with artmaking of:

- Maracas to enjoy the sounds of the West
- Native American pinch pots to celebrate Native American Heritage Month
- Cactus art while learning about the desert
- Rhythm instruments while learning about Bill "Bojangles" Robinson, African American tap dancer, marking Black History Month

Storytellers started the speaker business eons ago, and the popularity of talks has never been higher. Give them a microphone and an audience and they'll enrich your brand joyfully. For a brand-conscious museum attuned to its diverse audiences, it pays to remember the children with their sharp ears and lifelong memories.

One thing about writers: They observe everything, live by the credo of unique insights, and listen carefully. If they're journalists, they talk to everybody. So expect a sportswriter to give a purposeful talk at Georgia Writers Museum. In the "Meet the Author" program about integrating the Greene County (Georgia) football team in 1970, the speaker was a former team member, college coach, multi-decade journalist and TV sports analyst, and author. He revisited

the era of Georgia sports integration and his teammates today and wrote a book about them.

When a museum speaker combines history and sociology, issues enormous and personal, it's not just entertainment. It brings the brand scope—Georgia writers—from past to present toward the future. With important issues needing to be discussed, this topic found the right museum and a brand-perfect speaker.

Where does a museum look for speakers? Are there speakers bureaus? Are there requirements?

"It's a hodgepodge," says Molly Schoenherr, Adult Services Librarian at an adjacent institution, the Winnetka-Northfield public library in Illinois. Hodge-podges are good, because your audience is a hodgepodge. "Sometimes we get [speaker recommendations] from community members who have filled out our Propose a Program form on our website."

The Jewish Heritage Museum of Monmouth County (New Jersey) has a speakers bureau, based on slide and video presentations. While this museum's offerings are focused on Jewish history and culture, the topics can be adapted by all museums. There's often a speaker nearby for any topic you're curious about. This sample of the Jewish Heritage Museum's talks demonstrates the importance of widening the range of ideas when planning talks. They appeal to more audiences and make it easier to find speakers:

- 18th-Century Monmouth County Jews: Colonial and Revolutionary Times
- Faces of Genius: Jewish American Nobel Prize Laureates in Science and Medicine
- Journey to Monmouth: From the Iberian Peninsula (Spain and Portugal) to the New World
- Louise Nevelson: Grand Dame of American Sculpture

The Jewish Heritage Museum also makes its presentations available to other organizations in the community; it's a collaboration in the making.

Here's where other nonprofit organizations look for speakers:

- Among members. They may not be professional speakers, or experts, but they have deep knowledge of topics, such as opera, seamanship, the Constitution, National Parks, or the history of railroads.
- The local bookstore—which, in many places, is singular. You won't find them on every corner, and the people who work there know how unique they are. Knowledgeable, too.
- Local college and university professors
- Commercial photographers (they see a lot from behind the lens!)
- Local bands and orchestras
- The Propose a Program page on your website

- Some speakers have YouTube channels, so you search that platform and assess specific speakers' topics and presentation styles.
- In Illinois there's the Illinois Humanities Speaker Bureau, and the Great Lakes Museum Speakers Bureau.

NEW AUDIENCE SEGMENTS

Many new audiences will come from Europe, Asia, Africa, or South America. They start the migration with virtual programming and often find a way to your real ticket counter. They have similar demographics and interests as your customary audiences—history and science, art and culture, design and technology—and a world of differences after that. Be alert to these unintended mistakes:

- Saying "we Americans," which only applies to Canada, and Central and South America. A corollary is anything that assumes the audience is United States American.
- In virtual programming, alluding to ET, CT, MT, or PT. "Thanks for spending an hour this evening with us," means something diffferent to people watching at midnight their time.
- On-site, many time zone groups vary in their comfort with personal distance, questioning the expert, or breakout sessions. A culture handbook may become required reading.
- Museum hours in many countries differ from American museum hours.

More commonplace time problems concern hybrid work schedules that alter individual schedules well beyond 9-5 and weekends. What's a weekend these days?

Cedar Rapids Museum of Art in Iowa has set its clock for people-standard time. Three series are timed for audiences with different interests and schedules. Perhaps the same people who traditionally visited museums and enjoyed learning programs could be targeted a different way by:

- Time of day
- Length in minutes
- Subject matter
- Time: late afternoon-early evening
- Program length: 20-60 minutes in length
- Platform: on-site, Zoom, or site in community

Time awareness reinforces your brand in many other ways:

- Novel, distinctive
- Attuned to the lives of current and new audiences

- Conducive to a range of topics more specific to new segments in your market

Museums that want broader audiences don't have to go physically farther afield. Wider audiences are nearby when you:

- Look for newly hybrid workers
- Consider age as an interest group rather than a demographic
- Schedule talks and performances during other organizations' off-seasons
- Plan a fifteen-minute Q&A session at the end of a talk or performance to instill engagement and repeat attendance

Different audiences enrich the museum in more ways than tickets and prospective membership. They shuffle the mix, propel new interactions. When new friendships are made, the museum gets the credit. If a new idea is brought home, it gets discussed.

"Doors open at 7 o'clock. The Trouble to begin at 8 o'clock."

So said the handbill advertising Mark Twain's 1866 lecture at Maguire's Academy of Music in San Francisco. At Mark Twain House & Museum, The Trouble Begins lecture series covers important Twain-iac topics such as Mark Twain and—

- Civil War generals
- Spa towns
- Camping in the Catskills
- Olfactory jokes
- Stand-up comedy

Twain was a man of many parts, and his brand lives anew in this Twain-ish series.

There's another dimension here, and it comes from the other side of the footlights. Audiences are encouraged to talk to the scholars—from all disciplines—in actual discussions. Interaction like this also molds your brand.

This next program is entertaining; but it's not entertainment, it's branding.

The Trouble Begins lecture series is held each spring and fall with free presentations featuring distinguished scholars who discuss elements of the life, work, and era of Mark Twain and use them to explore wider themes in the humanities and both historical and current issues.

Mark Twain the writer and Mark Twain the house and museum are never far apart. And they shouldn't be. The brand endures because the museum honors his writing and his writing processes. A fall 2023 talk on "work" and "play"—the conditions that Twain found beneficial for his creative processes—brought a bounty of insight and encouragement that writers need.

This tight connection between talk topic and museum is another factor that separates a program from entertainment.

REVEL IN AND REVEAL LOCAL HISTORY

New England Civil War Museum in Rockville, Connecticut, takes pride in its meetings, which have been held in an original Grand Army of the Republic meeting hall and local building for over a century. It also can boast of an ongoing lecture series, regular encampments, reenactments, and living history days. It partners with other local organizations on some events. It continues, with great consistency, to interpret Civil War life in Connecticut. The actual stages vary from season to season, but the backdrop is New England.

Museums on the Green sets the stage for its talks on Cape Cod:

"Join author Dana Cameron as she talks about Cape Cod Noir, a collection of fictional short stories from authors about the area's more wicked side. Hear about the writing process and delve into her research about what Cape Cod stories inspired the writers"

The spires of Falmouth are also the setting for talks about bells, including a retired engineer who spoke "about some of Falmouth's bells and the gems of history that they bring. They include church bells, school bells, fire bells and even a bell salvaged from a WHOI [Woods Hole Oceanographic Institution] research ship before it went to the scrap yard."

It's a heavy weight that Newport Mansions carries when it brings its history to the public. Gilded Age mansions were furnished and burnished to a grand degree. But that's just part of the mission of Newport Mansions. In protecting, preserving, and presenting an excellent collection of house museums and landscapes, its responsibilities include "one of the most historically intact cities in America." The brand embraces not just phenomenally wealthy homeowners but an entire city. So it handed over the microphone to two Preservation Society Fellows who researched the making of that wealth. One person who made wealth was a businessman with interests all over the world. The other makers of wealth were Chinese craftsmen. Newport Mansions reinterpreted its history by presenting the people in the city of Newport who lived beyond the grandeur of the moneyed mansions.

Other museums can relate stories that take place behind the scenes. For example, research the men and women who:

- Worked in historic houses
- Dug for artifacts
- Sold artists their canvases
- Pruned the botanic garden roses
- Drove the school buses
- Tagged migratory fish

A look at the wider community reveals more than topics for talks; it gives wider meaning to a museum's goals, expands visitorship, and boosts donor support.

The setting for one Cable Science Museum talk couldn't be dearer to local hearts: "Deer Widows Walk" takes place amid the forest trails on the opening day of gun deer season in Wisconsin, a major holiday. The beautiful property is off-limits to deer hunting (although "blaze-orange clothing" is recommended), and the walk is conducted by a museum naturalist, who explains the natural wonders along the paths.

The ticketed program connects locale to the soul of the museum, whose science is never far from its nature setting. Many people talk about the intersection of art and science; this event walks the talk and enriches the brand.

Museums don't shy away from new interpretations of objects; they can be intrepid in defining talks and lectures, too. Why not a moveable speech? Speakers, talks, and lectures work best when they jog minds in new directions.

It's anticipated that a city history museum will schedule talks about local history. Augusta Museum of History in Georgia sharpens that perspective with its 2023 Brown Bag History Lecture Series. This series has a thesis, turning points: "Sometimes a turning point in history has immediate repercussions . . . sometimes, the impact of an event or decision or person is clear only in retrospect."

Booking speakers from a range of institutions, the Augusta museum in 2023 covered topics ranging from "Cyber Arrives in Augusta" to "Augusta and Public Art" to "The River Region as a Sporting Venue." The calendar continuity is reinforced by thematic consistency. Turning points, significant and visionary change, are a through line that defines not just a lecture program but a forward-thinking museum.

UNIVERSAL TOPICS

Universality is a big topic, best visited one museum at a time.

Newport Mansions presented a Fall 2023 Series on Chinese American experience and "the many ways life in Newport and America was influenced and enriched by people of Chinese heritage." In conjunction with "The Celestial City" exhibition at Rosecliff, one of the Newport Mansions, talks survey life in the region beyond the mansions, in this case Chinese family life, women's suffrage in China, individual contributions of Chinese Americans, and social practices in the Newport area across the whole United States in the sometimes-misnamed Gilded Age.

Social leaders like Mrs. Vanderbilt opened their parlors to speakers on social issues like suffrage, and that's a connection between the museum brand and the speakers' topics. Newport Mansions' identity is with the big stories of its era and community, not just its big houses.

Museums of any size or genre can explore universal trends and topics and add input to subjects beyond their zip code. Universality means the cooperation of the many. The advantages to a museum's brand include:

- Understanding of all its audiences
- Ongoing awareness of new ideas and challenges
- Professionalism in addressing large themes
- Vision of its value to the community

Planet Word Museum in Washington, D.C., also introduces the immigrant experience, and true to this museum's persona, the person on stage speaks in the language of food. Introducing the chef at Immigrant Food+ and a different kind of performance, in script form, it continues its spot-on use of language, right down to the forks and empanadas. The "+" in Immigrant Food+ clues one to the learning ahead: the sustenance from other cultures, traditions upheld, joy of getting together; it's all on the table. And yes, there was a speaker on the subject. The speaker, a Stanford professor who authored a book on food and language, talked about the history and linguistics of global cuisines and their influence on how we all talk about food.

COLLABORATION WITH OTHER ORGANIZATIONS

What kind of talks do museum visitors want? Know your community. In rural areas, like the Hill Country of Texas, it's wildlife in all its feather and footed, rooted and flowering, studied and protected species. Agritourism flourishes here. So does research. So does environmentalism in its most effective and generations-old form. Most communities can claim an area of unifying interest among its constituents. Find speakers in these categories.

Briscoe Western Art Museum, in San Antonio, invites representatives from Bracken Cave, a protected bat preserve in the neighboring Texas Hill Country, to teach the community about the importance of these furry flying mammals to agriculture and other aspects of modern life.

Governmental agencies—state, county, and municipal—offer trained speakers to organizations that want them. It's part of their job to engage and inform their communities (and voters).

Local colleges and universities have experts available to speak. They may not be on the speaker circuit and may not be as entertaining as the author circuit, but they will resonate with museum audiences that want information. Talking knowledgeably to these audiences, with speakers you endorse—and who endorse you by their presence—renews respect for your brand.

The tabletop is the stage at Burke Museum's International Archaeology Day. The Seattle museum's archaeologist and event partners will demonstrate techniques, identify objects, and answer questions at booths throughout the museum. This partial list of participants illuminates the level of expertise on display:

- Archaeological Institute of America
- Association for Washington Archaeology
- King County Historic Preservation Program
- Nisqually Indian Tribe Historic Preservation Program
- University of Washington Anthropology

The speakers are professionals, the audience is curious, the set design is makeshift laboratory. Entertaining is not the goal, but the enjoyment is real. This is high-order branding, a serious museum, with its eye on science now and tomorrow, connecting with audiences appreciative of the chance to learn.

Giving a museum's experts a role to play heightens branding; curators, educators, researchers, and interns are the human face of mission and reputation. Let your experts have their day in the spotlight with:

- Tools of their trade
- Objects they work with
- Documents that inform their studies
- Guidance for audience participation in creating, analyzing, and interpreting

LESSONS FROM THE PODIUM

A stage, a microphone, and audience. Expectations attend every word that emanates from that stage. The speaker has passed the selection process and earned a slot on the event schedule. The audience has bought into the topic by acquiring a ticket and allotting valuable time to attend. Savor this trust and leverage it whenever you can. Every small production, carefully tied to your mission and values, produces large benefits for you and your community.

BRANDING CHECKLIST

To stay on brand and keep talks, lectures, and performances from slipping into generic entertainment, review each one for how well it:

- Represents what your brand represents
- Differs from similar offerings of other museums
- Survives being strange, different, and unexpected
- Avoids seeming generic
- Appeals to other than our usual audiences
- Showcases your collection, exhibits, and staff
- Offers new or specialized knowledge
- Complements learning
- Promises to withstand the judgments of time

REFERENCES

"2023 Brown Bag History Lecture – Augusta Museum of History" (email to mailing list), November 1, 2023, Augusta Museum of History, amh@augusta museum.org

"Armstrong Now: Louis at Newport Presented in Collaboration with the Louis Armstrong House Museum," November 21, 2023, Jazz at Lincoln Center, https://www.louisarmstrong.org/armstrong-now/ [accessed May 8, 2024]

"Art Lovers Book Club: April: Peacock & Vine: On William Morris and Mariano Fortuny by A.S. Byatt," Cedar Rapids Museum of Art, April 20, 2023, www .crma.org/events/art-lovers-book-club-april-peacock-vine-william-morris -and-mariano-fortuny-s-byatt-free?occurrenceID=749 [accessed April 8, 2023]

"The Bells of Falmouth," Museums on the Green, Falmouth Historical Society, November 9, 2023, https://museumsonthegreen.org/event/the-bells-of -falmouth/ [accessed September 19, 2023]

"Birmingham Civil Rights National Monument, Alabama," National Park Service, www.nps.gov/bicr/index.htm [accessed December 3, 2023]

"Bracken Cave Preserve," www.batcon.org/our-work/protect-restore-land scapes/bracken-cave-preserve/ [accessed December 3, 2023]

"Bully Pulpit," Definition, C-SPAN Congressional Glossary, https://web.archive .org/web/20000311134819/http://c-span.org/guide/congress/glossary/ bullypul.htm [accessed November 26, 2023]

"Cape Cod Noir," Museums on the Green, Falmouth Historical Society, October 5, 2023, https://museumsonthegreen.org/event/cape-cod-noir/ [accessed September 19, 2023]

"Click Here for Information About Our Speakers Bureau," Jewish Heritage Museum of Monmouth County, https://www.jhmomc.org/ [accessed November 18, 2023]

"Creating Communities: A History of the North Shore," November 2, 2023–February 28, 2024, Winnetka Historical Society, www.winnetkahistory.org/ [accessed November 18, 2023]

"Deer Widows Walk" (events), Cable Natural History Museum, November 18, 2023, www.cablemuseum.org/event/deer-widows-walk-3/ [accessed October 14, 2023]

"A Delicate Balance: Work and Play in Mark Twain's Creative Process. Knowledge and Satisfaction, with Kerry Driscoll," The Trouble Begins, October 4, 2023, The Mark Twain House and Museum, https://ci.ovationtix.com/35359/production/1171932 [accessed September 25, 2023]

"The Eaddo and Peter Kiernan Lecture," August 1, 2023, Newport Mansions: The Preservation Society of Newport County, www.newportmansions.org/events/the-eaddo-and-peter-kiernan-lecture/ [accessed July 25, 2023]

"Explore," Tellus Science Museum, https://tellusmuseum.org/about-us/ [accessed October 4, 2023]

"Fall Lecture Series," October–November 2023, Newport Mansions, The Preservation Society of Newport County, www.newportmansions.org/events/category/lecture/ [accessed October 11, 2023]

"Goat Yoga," Hancock Shaker Village, June 3, 2023, https://hancockshakervillage.org/calendar/goat-yoga-9-2/ [accessed May 20, 2023]

"Guided Meditation at the Grant Wood Studio," April 13, 2023, Cedar Rapids Museum of Art, www.crma.org/events/guided-meditation-grant-wood-studio-call-new-childlike-wonder?occurrenceID=747 [accessed April 8, 2023]

"Immigrant Food+," Planet Word, https://planetwordmuseum.org/ [accessed June 25, 2023]

"International Archaeology Day," October 22, 2023, Burke Museum, https://www.burkemuseum.org/calendar/international-archaeology-day-0?utm_source=newletter&utm_medium=email&utm_content=Learn%20more&utm_campaign=PUB%20archy%20day%202023 [accessed October 13, 2023]

Jackson, Liz. "Storytime Stampede," Briscoe Museum of Western Art, www.briscoemuseum.org/storytime/ [accessed November 10, 2023]

"The JHMOMC's Speaker Bureau." Jewish History Museum of Monmouth County, https://docs.wixstatic.com/ugd/37a075_62a7f83605ac4c5b8f3b3c6c0e494aa2.pdf [accessed May 31, 2023]

"The John G. Winslow Lecture," August 10, 2023, Newport Mansions, The Preservation Society of Newport County, www.newportmansions.org/events/the-john-g-winslow-lecture/ [accessed December 4, 2023]

"The Language of Food," lecture by Dan Jurafsky, August 22, 2022, Planet Word Museum, https://planetwordmuseum.org/events/language-food/ [accessed December 4, 2023]

"Lunch Menu," Immigrant Food, Planet Word Museum, https://planetword museum.org/wp-content/uploads/2023/06/IF_PW_Lunch-Menu_612.pdf [accessed June 25, 2023]

"The Mark Twain American Voice in Literature Award, November 3, 2023," https://marktwainhouse.ejoinme.org/avl2023 [accessed October 15, 2023]

"Meet Author Tony Barnhart, College Football Insider," December 5, 2023, November newsletter, Georgia Writers Museum, message from a mailing list, November 14, 2023

"Nature Workshop," Briscoe Western Art Museum, www.briscoemuseum.org/earth-day/ [accessed April 17, 2023]

New England Civil War Museum & Research Center, www.newenglandcivilwar museum.com [accessed August 9, 2023]

"One Night Stand with the CRMA," April 11, 2023, www.crma.org/events/one-night-stand-zoom-free-1?occurrenceID=754 [accessed April 8, 2023]

"Organizational History," McKinley Presidential Library & Museum, https://mckinleymuseum.org/about-us/ [accessed July 24, 2023]

"'Our Sisters in China Are Free': Chinese Women's Contributions to US Suffrage," Fall Lecture Series, October 2023, Newport Mansions, The Preservation Society of Newport County, www.newportmansions.org/events/our-sisters-in-china-are-free-chinese-women-contributions-to-us-suffrage/ [accessed October 11, 2023]

"Project Details, Bracken Cave Preserve, https://www.batcon.org/our-work/protect-restore-landscapes/bracken-cave-preserve/ [accessed April 17, 2023]

Schoenherr, Molly. Adult Services Librarian, Winnetka Library, email conversation, April 19, 2023.

"Search Out New Digital Archives," Winnetka-Northfield Public Library District, https://vitacollections.ca/winnetkanews/search [accessed November 18, 2023]

Texas Parks & Wildlife, https://tpwd.texas.gov/huntwild/wild/wildlife_diversity/

"The Trouble Begins," Mark Twain House & Museum, https://marktwainhouse.org/the-trouble-begins/ [accessed August 21, 2023]

"Wow of the Day – Spurring the Suffrage Movement – from Trudy Coxe," email to mailing list, The Preservation Society of Newport County, October 11, 2023 [accessed October 12, 2023]

5

E-Newsletters

"You are receiving this email because you are on a mailing list. You opted in by signing in when you visited our museum, being a museum member, linking to a program, buying a ticket, attending a talk, or buying something in the store."

Never underestimate the critical importance of people on the receiving end of an emailed message. Even more important are those who actually signed up for the newsletter. They are interested in your museum. When someone has visited your website and chosen to get regular reminders and reasons to return, you've found a valuable friend. Now, continue to pique that person's curiosity, offer an ever-changing schedule of new ways to fulfill their curiosity, retain their loyalty, and keep at it.

This chapter gets down to details: (1) the subject line, the most important branding benefit of e-newsletters. Here, in just a few words, fast-scrolling email viewers will learn why they should engage more fully in your exhibits, workshops, talks, and merchandise. Other communiques reach audiences in different ways, and all further your brand. However, only tried-and-true email is read by everyone, every day, at least somewhat.

Other important branding features of e-newsletters also need first-rate attention: (2) targeting. For a variety of individual reasons, people are interested enough in your museum to share their email address. Now you have a solid target to talk to. Talk the talk they want to hear. When they open the email, order and phrase the announcements with them in mind. Write well. Avoid cliches. Develop your museum's tone of voice. This detail is called good writing and there are books on it. If you have the wonderful gift of a ready audience, pay detailed attention to your language.

(3) newsiness. This means items that are newsworthy to your audience. And to keep this from being a one-way announcement, make it an audience-focused FYI. Individual emailers have used this tactic for years. Instead of oversharing their personal thoughts on a topic, they send a link and an FYI. A simple noun in your e-newsletter announcement panel can help:

"Tracking Connecticut's Bats"
"Marine Debris"

Thanks to Bruce Museum, Greenwich, Connecticut, these headlines, can't be ignored. They could have been boring, but The Bruce understands the benefit of an arresting noun.

Caution: After writing a specific, intriguing subject line, remember to repeat the same headline in the email text and browser version. Small detail, smart consistency. When viewers are interested in opening your emails, give them what they expected to see.

(4) retention. Once a visit has been made to a program, an event, your store, or your website, stay in touch with the visitor. Thank-you notes are always appreciated.

(5) continual presence. Newsletters are the best way to maintain brand awareness. Stay involved in people's lives, without intruding, by simply sending a short, newsy, relevant, consistent email. Everybody scrolls down.

SUBJECT LINE

Note that subject lines of email messages are short. Their length is somewhat determined by the width of the column you've set on your device, but good discipline will assume five to ten words, the first five of which should be brand appropriate.

Here are some branding don'ts in subject lines:

- "This month's calendar"
- "On sale this weekend only"
- "News from the director"
- "Plan your visit"
- "Lecture series continues"

In contrast, here are some engaging subject lines, all offering an irresistible, brand-specific experience, in the first ten words:

- "Edith Wharton's Lost Play: A Reading." Driehaus Museum, Chicago
- "Registration for our Quest for the West Art Show and Sale closes Sept. 1." Eiteljorg Museum, Indianapolis
- "The Glass House Announces the Restoration of the Historic Brick House for the 75th Anniversary in 2024." (For architecture professionals and buffs, this is significant 2023 news. Sometimes it's smart to be long.)
- "160-Year-Old Foundation Finds!" Tenement Museum, New York City. The museum resides in a nineteenth-century restored tenement building. Archeological finds on the site are critical to the stories it tells. Any follower of the museum will understand newsiness in this subject line.

Thoughts for all museums:

- Email remains a nonpareil marketing tool; don't slight the first words readers see.
- The subject line isn't an afterthought. That's the visitor you're talking to!
- The subject isn't about the museum; it's about an event at the museum of specific interest to your audiences.
- Have your valued writer write the subject line.

TARGETING

The Martin House, in Buffalo, New York, preserves and interprets a major artwork—itself—a house designed by Frank Lloyd Wright with its collection of interior design and furnishings, plus an innovative garden. The house is a shining star in architecture; Frank Lloyd Wright is a brighter star. Two different audiences will feel different allures, and they are served by:

- Subject line: "Music in Bloom and Seasonal Tours at the Martin House"—news for followers and loyalists
- Announcement page: Martin House logo in which the "M" is designed in a Wrightian font—information on the museum for those not so familiar with it.
- Sender line: Frank Lloyd Wright's Martin House—name recognition of museum and the famed architect

The mailing list has gathered the names of all kinds of audiences who signed up because of their interest in era-making architecture, one-of-a-kind houses, or purposeful gardens. E-newsletters keep them engaged.

For example, a plump, furry bat emphasizes the point of Bruce Museum's upcoming event:

"Tracking Connecticut's Bats"

That three-word subject line targets more specifically the science in store for the museum's followers.

As part of the museum's First Science Sunday events, its audiences will be messaged via email dated one week before the event, consistently every month, underlining the event's popularity and place in the community's weekends.

Battleship New Jersey Museum is a multiple threat: tours, commemorations, overnight bunk-sleeps, research, veteran gatherings, video oral histories, community partnering, parties. For Battleship, this means a mélange of audiences marching up its gangplank or thinking about it. The brand message

reflects those target audiences: "When everyone can experience history in their own way, history is preserved."

Here's another example of good targeting, from the Museum of Contemporary Art Chicago. Not everyone knows the artist Basquiat; everyone knows Warhol. For an art museum that is stocking the shelves of its store, new names are essential to new merchandise. An MCA e-newsletter headlined:

"From Basquiat to Warhol, shop artist-inspired products"

With Basquiat and Warhol, a wide segment of contemporary art lovers is targeted. Specificity in merchandise description is as important as a well-written label. Those who don't know the references, especially younger audiences, might take the time to look them up. Importantly, by keeping an open mind about your target audiences, you'll capture newcomers as well as the anticipated.

Families are a market segment defined by more than age, zip code, education, or household income. Families are a subculture with their own rituals, traditions, language—even food—and they're fiercely loyal to their diverse status. San Francisco Museum of Modern Art targets this segment with its own Families Hub. The following description of the Families Hub demonstrates that SFMOMA understands family dynamics; that understanding builds brand loyalty: "everything you need to plan your trip to the museum, plus a suite of free online art projects, videos, and artwork guides created by our Education department."

Some reminders about targeting for all museums:

- Families comprise a different target audience than children and adults. This category has its own behaviors and motivations.
- Be creative in identifying different target audiences.
- Seek newcomers to the communities; they'll return the attention many times over.
- Be aware of new work and leisure schedules.
- Embrace one-time or single-event visitors; they'll come back for more.

NEWSINESS

Opening to the text page, here's how a variety of museums fulfill their promise of newsiness. Their brands' originality asserts itself:

"It's going to be wild this June" (from Milwaukee County Zoo)

This is followed up with subheadings like:

"Wild Connections Animal Encounter Tours"

This up-close and personal visit is specific to this zoo. Wild connections with animals sound adventurous and different from other summer museum offerings. It has its own branded name.

The Franklin Institute, in Philadelphia, announces the last episode in a year-long podcast with: "Now on So Curious!: Our Season's Coda." And then explains the connection between a musical term and a science museum: the science of music's effect on the brain. Episodes have titles like "Wild Voices . . . the science behind how and why birds sing" and "Science in Concert . . . what happens in the brain while musicians are improvising."

At Locust Grove Estate, in Poughkeepsie, New York, the museum offers the chance of a lifetime for artists, an important audience for the museum with an art gallery on its campus:

Calling all artists

And when that tempting announcement is opened:

Are you an artist?

Or know someone who is?

Apply now for a chance to have a solo art show at Locust Grove!

We are seeking four artists to show their work in their own 3-month-long solo show from April 2024–April 2025 in The Transverse Gallery of Contemporary Art here at Locust Grove!

The news section is brief and to the point; a photo of the gallery proves the point. Perfect branding of the museum's goal of education. It is a generous museum, and this newsworthy activity supports the brand's values.

When Bruce Museum announced in an email subject line that marine debris had an impact on the local waters of Long Island Sound, it was a warning with a newsworthy plan of action: a lecture on the subject. And, by the way, it emphasized that the one-off lecture was part of an ongoing lecture series.

As evidenced in its emails, this is a serious museum, serious about science and local effects, serious about its audiences' involvement, and serious about following through, month after month. Great branding, that starts with its ideological supporters in an email.

"Edith Wharton's Lost Play: A Reading and Talkback with Ghostlike Ensemble." When the Driehaus Museum e-newsletter announced a reading of a play by Edith Wharton, the Belle Epoque Museum used an anachronism. A "talkback" was not gilded age language, but definitely appropriate for today's audiences who like a forthright discussion. The Driehaus brand emphasizes the

OPENING OF
NEW YORK AND CHICAGO TELEPHONE LINE
OCTOBER 18TH 1892

When Alexander Grahm Bell first said "ahoy," he started a daily habit that endures in email. Like all iterations of the telephone, email is right at hand, direct from sender to receivers, and "hi" sounds close. Email newsletters expand the concept, and museums continue the process. *E. J. Holmes, "Alexander Graham Bell," 1892. National Portrait Gallery, Smithsonian Institution. CC0*

relevance today of nineteenth-century culture. It knows its nineteenth-century history as well as how to talk for the twenty-first century.

Speaking of discovering and using a relatable tone of voice, here are some thoughts:

- Show the newsletter to a younger staffer in another department and ask them to put it in their own words.
- Ask yourself: What does this mean, and describe it out loud.
- Before writing an e-newsletter announcement about a science project, a new class, or a featured speaker, read some of the writings about the subject in question.
- Your writer's style is already just fine; it's familiar to your audiences. Keep that writer on board so all newsletter items maintain that familiarity.
- Don't ever give an announcement to a committee to edit, comment on, or rewrite. It's certain disaster!
- If your announcement is available with a link to the website, or ticketing page, make sure the wording on all pages is the same.

In 2020, Aspen Historical Society wanted to keep the interest of a community of scholars and history buffs. So AHS instituted an e-newsletter for "History at Home," with short capsule histories. "History at Home" continues today in e-newsletters, an important resource for geographically dispersed researchers. AHS develops its stories from a variety of sources:

- Family documents
- Videos of past programs and site tours
- Other previously created content
- Content from partners

For museums of all sizes and genres, there are good branding reasons for "capsules":

- Brand explication
- Lessons for learners of all ages
- Background for media
- Background for developing donors
- Archival material for scholars looking for thesis topics

In 2023, Plimoth Patuxet Museum in Massachusetts celebrated the 50th anniversary of the museum's Native Studies Program, later known as the Wampanoag Indigenous Program. This yearlong series of programs is described in one long scroll in an email text. It's a survey course in brief of native tribes' history and culture, up through today. What makes this history lesson

up-to-the-minute relevant is that it lives, it's alive, not defunct. Native history continues every day. The title of the program is:

"May Their Voices Resound"

The concept of putting a museum studies program in one email is different enough to be considered news, different enough to give other museums ideas. Even a small program is large when reported in a long email with facts, supplementary programs, and visuals all in one place.

RETENTION

Don't hide your entire museum experience behind one email, one piece of news, or one event. Keep your audience engaged. The newsletter audience has already expressed interest in—and made an online connection with—your museum; remind them to visit again.

At the end of every e-news announcement page, place an easily visible link to your continuing role in their range of interests.

As Abilene Zoo says: "Don't Miss the Adventure."

The Bruce invites readers to sign up by saying: "Your monthly dose of art and science."

Once a visitor has taken the time to scroll down to the Subscribe Here button, you're one lucky museum. You've enticed a casual visitor to learn more and return for more. Hang on to that visitor. Bakken Museum in Minneapolis seizes the opportunity and reminds the visitor of specific updates to come: "Subscribe to Updates from The Bakken. Join our mailing list and receive monthly newsletters, event invitations, and museum updates."

Basque Museum of Culture and History builds retention from a solid base, the Basque community covering five states in the American west and northwest: "Euskara Classes are getting ready to start—have you signed up? The teachers are great, there is a specific level for everyone, and we can work with you to make sure you get in the right one."

This is a museum that has well-defined audiences but doesn't assume their loyalty. It wants to retain them and builds on shared interests with a variety of efforts:

- Language classes
- A volunteer program that engages its current members in recruitment
- Pairing local Basque families with a Bilbao, Spain (Basque Country) exchange student

Retention incorporates a long-term goal with everyday implementation. Newsletters keep followers in the loop. "New" appeals to loyal followers because they've visited often, attended many programs, donated regularly.

Museums with strong brands need new initiatives to hold their audiences' interest. Retention includes:

- Relevance for today, because even continual audiences need replenishing with new ones.
- Specific appeals for your constantly changing audiences, because strong brands pay attention attracting new visitors.
- Follow-up, because loyalty thrives on attention.

When Historic Locust Grove, in Louisville, Kentucky, sent an e-newsletter announcing a concert in the garden, it was appealing to music lovers in its audience. Music is a wonderful way for a brand to extend its tent to all ages, backgrounds, interests. However, Locust Grove strutted its brand a little more. This concert was all Mozart. Not just anybody's music, but Locust Grove's playlist. Then they listed the performers by name, emphasizing that they were part of the Locust Grove Pavilion Players. Not just any performers, but Locust Grove's. The newsletter continued by connecting the Pavilion to its natural surroundings and the "sounds of nature" accompanying Mozart's chamber pieces. Not just any venue, but Locust Grove's new and fully accessible venue. More branding. Finally, a colorful illustration of Mozart himself. Strong brands always share the limelight with other strong brand names.

CONTINUITY

For people who faithfully work a puzzle every day, Planet Word Museum has the puzzles. It keeps loyalists in the loop, regularly. So a newsletter topic announcing the fact is spot-on branding:

"Introducing Larry's Puzzle Corner"

It's a regular puzzle offered, not on the website like so many other regular puzzles, but in the newsletter. Two places to reinforce the Planet Word brand, both newsletters and puzzles have proven effective for involvement.

In scrolling down through this email announcement, what glitters is: "Lecture Series Continues.'" Even if one wasn't looking for a lecture, the fact of a series that will continue is intriguing. What's coming next? Good brands satisfy their regular audiences with ongoing programs that relate to the museum's mission. This announcement makes that point: "Dr. Mancia will be discussing monastic practice in the European Middle Ages, and striving to answer the question: What common ground did the Shakers have with earlier monastic communities?"

Now the reader learns that Hancock Shaker Village isn't just any living history museum, but rather a representation of a monastic tradition. A distinctive brand.

It has a lecture series with speakers, like Dr. Mancia, with wide ranging credentials and other talks on her CV.

It's a series one can count on, maybe even in colder months when living history museums aren't busy.

Small museums wonder how often they should schedule e-news. It's up to you and your resources, because the main point is consistency. Send your emails regularly, whether it's weekly or monthly, less often or more often; whatever your staff and budget allows, do it with a known day and time. You'd be surprised how many times it's helpful to say: "Look for our emails every Thursday at 4 PM"

Bruce Museum highlights the regularity of its newsletter. When it asks for an email address, it doesn't take a name without giving something in return. Here's what the Bruce Museum offers, every month, in return for your contact information: "Your monthly dose of art and science."

Strong brands, like all successes, need to be nurtured. Ongoing attention, continuity, keeps a museum's name upfront. It rewards the loyalty of visitors and members. It reassures supporters of a smooth-running operation. It provides scholars, PhDs, high school students, and educators with current information and expertise.

Milwaukee Zoo is the animal's friend. It's your friend, too, sending conversational, informative newsletters. And look how the brand is reinforced when, at the end of a page, it says to readers: "Lions roar. Cows moo. We send emails. Stay in touch with our newsletter!"

Never underestimate the critical importance of subscribers to an email newsletter. When a visitor to your website asks to be added to your mailing list, brand awareness begins. Your identity takes shape. Manifestations of loyalty are offered. Support enters their mind. Acknowledge that. When Submit is clicked, say thanks and promise a future. That's what Bakken Museum does: "Thank you for subscribing! We can't wait to share what's next."

CREATIVITY

Museums excel at creativity. Every exhibit, label, tour, and talk is informed by original perspectives and a wealth of information, tempered with insight. The new ingredient in the mix is the digital factor, the preponderance of data and the challenge to analyze it. To dip quickly into artificial intelligence (AI), there are infinite ways to gather information, find patterns in it, and generate the right message for the newly targeted audiences. Let's dip quickly out of AI and stress that it functions on finding patterns. Creativity is original. One reads about making emotional connections or, with a nod to emojis, making people smile with delight. This section on creativity lauds the personal and individual ways museum newsletters delight their readers.

Never forget the power of a pun (groaning at them is part of the connection). Then there's the joy of wordplay; many people love the twists and turns

of language. Visuals give a lot of pleasure; they say so much. Conflict always rouses a reaction: Wow! Pow! And a little gossip. Curiosity is an underestimated emotion. Pique curiosity in emails; people need more exposure to other ideas they never thought of before.

Planet Word Museum has a branded name for its newsletter. *Word on the Street*. In its hometown of Washington, D.C., those are boldface words. A name conveys singularity; it suggests a fresh perspective. As does news, which is always fresh, recent, not previously experienced, forward-looking.

Here are some ideas for naming your forward-looking newsletter:

- Gather your staff and ask what's new. Listen for just one new word in their report.
- Look for one distinctive feature in your physical space: a rotunda, weathervane, tree, whatever.
- Read the annual report for ideas.
- Ask tour docents what they point out.

Names play an especially important role for small museums. Easily recognizable, they connect museums to audiences among messages that arrive more often and more glaringly. A museum newsletter of a single page merits a name. Newsletters with quarterly publication need names.

I will "Make Andy's house look like a miner's shack."

The boast about Carnegie was made by Henry Clay Frick, and with that scoop, The Preservation Society of Newport County proved its knowledge of gilded age history with an architecture lecture on Newport, RI titled: "Spite Mansions."

> "When Henry Clay Frick first saw the stately New York mansion of his former business partner Andrew Carnegie—with whom he had had a bitter split—he vowed to build himself a mansion that would 'make Andy's house look like a miner's shack!' The result was the imposing edifice that now houses the Frick Collection."

Insider gossip is newsworthy in many settings, as when Andrew Carnegie and Henry Clay Frick jousted on who had the bigger mansion. It's fun reading and also insightful, with a peek into mores of the era the museum represents.

Here's one from The Whale Museum in Friday Harbor, Washington:

> "Help the Cause: The Whale Museum—a small museum with a big mission!"

Teaser headlines have to be opened to learn more, and it merits the time. Even if readers live near smaller bodies of water, with nary a whale in sight, don't

second-guess their interest. Always suppose that interested supporters, and possible donors, exist in places you never expected. It's a tenet of fundraising.

Saving stranded whales is a worthy branch of environmental responsibility, and any museum lover has to respect this museum's support of a cause that reflects its brand.

Here are some other creative headlines that embellish the brands of their museums. Wit and whimsy are friendly, approachable. These big museums have a sense of humor!

- They only come out at night [with an illustration of a jack-o-lantern]— Chicago Botanic Garden
- "Join the Flock"—Abilene Zoo puns a request for email recipients to sign up for its social platforms

If you have an unusual logo, one that demands a second look, that's creative. When viewers of the Abilene Zoo email they see the "A" in Abilene as two giraffes with necks intertwined. "Z," "O," and "O" are fashioned from zebra stripes, giraffe "jigsaw pieces," and leopard spots.

Newsletters are forms of journalism, and, along with news and facts, personal style is a staple of good journalists.

Everyone gets email, and they read it, if selectively, every day. They are a staple of life. But there is nothing quotidian about them. Newsletters cover a lot of territory, reach many audiences, and involve every department, nook, and corner of your museum. They unlock limitless combinations of behaviors and motivations, just like your brand.

BRANDING CHECKLIST

When planning, timing, and creating an e-newsletter, review these branding opportunities and think about:

- Audiences—Who is targeted? could there be others?
- Message—Is it newsworthy? and does it sound new and different?
- Images—Do photos, illustrations, or charts clarify your brand, or are they diverting?
- Singularity—In describing a museum's activities, have you stretched your brain to find a better word or phrase?
- Commonness—Does your subject line and content sound like it could emanate from any other museum?
- Follow-up —Do you foster loyalty by following up on newsletter invitations?
- Writer—Are you working with a writer who has a unique style and tone of voice that helps identify your brand. It's important.

REFERENCES

"160-Year-old Foundation Finds!," e-newsletter to mailing list, August 24, 2023, Tenement Museum, https://go.tenement.org/webmail/987572/10 90823058/356c590a488d19a1197d7f4f7fead27341b83f22a75d8579e40 f037e8e5b10f2 [accessed August 25, 2023]

"Abilene Zoo: Where the Wild Meets West Texas," https://abilenezoo.org [accessed August 25, 2023]

"About the Museum," Bruce Museum, https://brucemuseum.org/about-the -museum/about/ [accessed April 19, 2023]

"An Evening in Bloom," The Martin House, https://martinhouse.org/visit/eve ning-in-bloom/ [accessed August 28, 2023]

"Art Exhibits in the Transverse Gallery of Contemporary Art," Transverse Galley of Contemporary Art, Locust Grove Estate, https://sites.google.com/lgny .org/locustgroveestate/art-exhibits [accessed August 27, 2023]

"August 2023 E-News," The Whale Museum [accessed August 16, 2023]

"Bruce Museum's 38th Annual Outdoor Crafts Festival May 20 & 21!," May 19, 2023, e-mail to mailing list, https://mye-mail.constantcontact .com/Bruce-Museum-s-38th-Annual-Outdoor-Crafts-Festival-May-20 ---21-.html?soid=1110378314611&aid=DCO7F58gvS0

"Chamber Music Concert in the Pavilion: Completely Mozart!," newsletter to mailing list, June 4, 2023

"Creative Marketing," Quantcast, www.quantcast.com/wiki/term/creative-mar keting/#:~:text=Aspects%20of%20creative%20marketing%20include ,memorable%20and%20relevant%20to%20users [accessed November 22, 2023]

"Digital Resource Library," Aspen Historical Society, https://aspenhistory.org/ about-us/digital-resources-library/ [accessed August 28, 2023]

"Dr. Lauren Mancia, Lecture Series Continues," August 21, 2023, e-newsletter to list, Hancock Shaker Village, https://1427.blackbaudhosting.com/1427/ Dr-Lauren-Mancia [accessed August 21, 2023]

"Edith Wharton's Lost Play: A Reading and Talkback with Ghostlike Ensemble, Wednesday, March 8, 6:30-8:30 pm," February 21, 2023, email newsletter, Driehaus Museum, https://driehausmuseum.org/programs/detail/edith-whartons-lost-play-a-reading-and-talkback-with-ghostlight-ensemble [accessed August 25, 2023]

"Explore Our Curated Collection of Artist-Inspired Products," MCA Store, Museum of Contemporary Art Chicago, https://mailchi.mp/fea796a98503/dont-wait-to-shop-only-1-day-left-for-member-double-discount-185892?e=71c48a0813 [accessed October 30, 2023]

"Fall 2023 Euskara Classes," The Basque Museum and Cultural Center, https://basquemuseum.eus/learn/language-classes/fall-2023/ [accessed August 30, 2023]

"Follow us," Milwaukee County Zoo, https://milwaukeezoo.org/# [accessed November 25, 2023]

"Fred Elser First Sunday: The Impact of Marine Debris and Plastics On Long Island Sound," September 10, 2023, Bruce Museum, https://brucemuseum.org/whats-on/fred-elser-first-sunday-the-impact-of-marine-debris-and-plastics-on-long-island-sound/ [accessed August 29, 2023]

"From Basquiat to Warhol, Shop Artist Inspired Products," October 26, 2023, message from mailing list, Museum of Contemporary Art Chicago, https://mailchi.mp/fea796a98503/dont-wait-to-shop-only-1-day-left-for-member-double-discount-185892?2e=71c48a0813, [accessed August 25, 2023]

"Introducing Larry's Puzzle Corner," November 3, 2023, e-mail message to mailing list, Planet Word Museum, https://mailchi.mp/planetwordmuseum/word-on-the-street-november23?e=2b4773de3b [accessed November 3, 2023]

"July 2023 Battleship New Jersey E-Newsletter," https://mye-mail.constantcontact.com/Battleship-New-Jersey-August-E-Newsletter.html?soid=1101251851675&aid=5UhzxIKwofl [accessed August 29, 2023]

"May Their Voices Resound," October 27, 2023, message from a mailing list, Plimoth Patuxet, https://mailchi.mp/plimoth.org/plimoth-patuxet-news-october-2023?e=fbd9846bd4 [accessed October 27, 2023]

"Night of 1,000 Jack-o'-Lanterns," Chicago Botanic Garden, https://view.enews.chicagobotanic.org/?qs=875bc4164b213bbe77d209fc59ab97dffb54be6b

48f378aad0048ef21b7db381e45172eb74fbfb8974eb25d5b9b5504ed33d
067691aecf9649c7c491e68516542847aab9be299610553df87d0fae2a77
[accessed November 22, 2023]

"Press Release: The Glass House Announces the Restoration of the Historic Brick House for the 75th Anniversary in 2024," email to list, November 15, 2023, contact@theglasshouse.org [accessed May 8, 2024]

"SFMoMA For Families," San Francisco Museum of Modern Art, https://www.sfmoma.org/for-families/ [accessed August 29, 2023]

"The Stories Behind the Mansions: Headlines of the Week - Wine & Food Festival Nearly Sold Out - from Trudy Coxe," newsletter to mailing list, The Preservation Society of Newport County, August 11, 2023, tcoxe@newportmansions.org [accessed August 12, 2023]

"Subscribe to Bakken," Bakken Museum, https://thebakken.org/calendar [accessed April 5, 2023]

"They Only Come Out at Night," August 24, 2023, message from an email list, Chicago Botanic Garden

"Tracking Connecticut's Bats," Fred Elser, First Sunday Science, May 7, 2023, Bruce Museum, https://mye-mail.constantcontact.com/Reminder--Make-your-reservations-for-Tracking-Connecticut-s-Bats.html?soid=1110378314611&aid=U771qXccF1o [accessed April 24, 2023]

"Word on the Street," Planet Word Museum, https://mailchi.mp/planetwordmuseum/word-on-the-street-august23?e=2b4773de3b [accessed November 25, 2023]

"Your Monthly Dose of Art and Science," Bruce Museum, https://brucemuseum.org/about-the-museum/about/ [accessed April 20, 2023]

6

Partnerships

Effective partnerships have nothing in common except a goal. The partners—institutions or people—might barely know each other. Their circles of friends intersect just a bit, Venn-like. Their work habits conflict and personalities clash. And that's the point. Partnerships increase effectiveness because they spawn different ideas and multiply assets. Partners know this, and being in the business of growth and success, get to work together.

As described in this chapter, there are six good reasons to venture beyond the zone of comfort with collaborators and partners:

1. Reinvigorating a good reputation
2. Attracting new audiences and seeing different perspectives
3. Reframing connection to community
4. Refreshing visions and mission
5. Creating new visibility
6. Updating research

REINVIGORATING A GOOD REPUTATION

Reputations are built on solid, respected past performance, and present excellence. The future is built on innovation. Strong brands build on all three. It's a big job and could use help.

Montana Historical Society recognizes that its personality and identity are wrapped up in the robust, sprawling, big sky personality of the state. It's hard to exhibit that on a tour, so it is collaborating with a statewide group to enlist the homes and businesses of ordinary people who live everywhere under the big sky.

"Hidden History Montana," a collaboration of Montana Historical Society, the Museums Association of Montana, and Preserve Montana, offered a rolling series of one-day events in the summer 2023 in which a town's or county's hidden historic places opened to the public for self-guided tours. Think of the

new audiences experiencing the museum from the inside: inside their homes, businesses, social clubs, civic buildings, or lands. Visitors get personal tours, with the insightful commentary of insiders.

Here are some unknown places any museum could compile into a list for volunteer hosts:

- Local hotel meeting room
- Historic home attic
- Business storage room
- Old storefront
- Historic fire station
- Bank vault
- School closets

Cooperative projects like this demonstrate your area's enduring history, cultural environment, and community spirit. It's a reassuring demonstration for visitors, tourism, business, education, and donors.

ATTRACTING NEW AUDIENCES TO APPRECIATE YOUR VALUES

Locust Grove, a museum, and Belle of Louisville, a riverboard tour event, started their partnerships in big trouble. Their emailed announcements of a Fourth of July event confused the dates. Their audiences might have been confused. So, Belle of Louisville sent another announcement clarifying matters and publicizing the Locust Grove's. Across the Louisville area, to a broad mix of audiences, they appeared as partners in camaraderie, not just an event. Each got new readership for the event and renewed awareness.

In the rush to be a good partner, did it get a little crowded? The more the merrier. That's what partnerships can accomplish. If there are glitches along the way, that's the learning curve in action and collaborations need practice.

Not all partnerships are new; some partners are old friends. The Bakken Museum invites volunteers to bring their friends, as many as fifty of them, if they want to schedule a specific day to learn the territory. As guests for a day, these prospects are preconditioned for group loyalty. Think in terms of a local book club, or flower arranging committee. They're diverse in age, interests, talents, circle of friends, and connections to your area. They're also loyal to causes; these are already confirmed loyalists.

The Bakken also invites volunteers "to bring a friend or bring your kiddo—the more, the merrier!" Merriment is an underrated quality; happy workplaces get a lot accomplished. And including a younger generation in a participatory way is brand-building at its merriest!

SEEING DIFFERENT PERSPECTIVES

Museums are irrevocably part of their towns and cities, counties, states, and regions. Their audiences embrace many viewpoints, as well as demographics. Look at your founders as partners, and build on their interests, too. As does Mai Wah Society Museum, in Butte, Montana: "We are funded in part by coal severance taxes paid based upon coal mined in Montana and deposited in Montana's cultural and aesthetic projects trust fund."

The Montana Trust, good partner that it is, offers a different perspective on audiences, and lists them in its application process. Applicants come from a wide range of disciplines and concerns including:

- Visual arts
- History
- Architecture
- Folklore
- Archives
- Collections
- Research
- Historic and cultural preservation

Applications are "encouraged" from institutions serving:

- Rural audiences
- Racial and ethnic groups
- People with disabilities
- Institutionalized populations
- The young and the aging

That's a long list—and there will be others—because new audiences, new behaviors, and new ideas demand profligate thinking. Think large, far-out, and down deep. After you've stretched, you can pull back and select the most promising new directions.

Looking at the wider picture, the changed landscape, and all the other newness in our sphere takes very good eyesight. One must look hard and really see. Partners and collaborators help.

ATTRACTING NEW AUDIENCES WITH INTERNATIONAL DIVERSITY

Diverse, welcoming, and nourishing. "America at its core," is how the executive chef views the menu he created for Immigration Food + Café at Planet Word Museum. It also describes the museum's action-ready goal of bringing immigrant views and visitors to Planet Word. "Planet" is in its name with good reason.

The menu items come from India, Jamaica, Venezuela, the Middle East, Far East, and Southeast Asia. And there's more than physical nourishment available. A Think Table invites visitors, online and off, to think about immigration and immigrants. A call-to-join paragraph suggests donating a meal to immigrants. Planet Word Museum is a physical presence in Washington, D.C., which is a city of many immigrant groups and NGOs. At Immigrant Food+ Café, it gathers well-connected partners in immigrant-based philanthropy. A young and agile museum, Planet Word vitalizes its global city and the country beyond.

Looking for ways to start a conversation with prospective partners? Inviting local businesses and organizations to join a community cause is comfortable for all sides. It's just a conversation. At the least, your museum has met another community member, and when you cross paths in the future, you'll have already broken the ice. At best, you've found a partner that shares your brand's outlook.

REFRAMING CONNECTION TO COMMUNITY

Proud of your hometown? Say so. Eiteljorg Museum in Indianapolis posted on its website its goal to join forces with all communities of the city. In a letter to the museum family, the new president and CEO praised partnerships and pledged "to introduce new ways of engaging Indianapolis communities with programs developed through community collaboration."

When museums decide to redefine their goals, to reach audiences that were formerly distant, they do so in collaboration. Beyond the community where a museum is rooted are ripple-out communities best reached with help from teams of neighbors such as:

- Libraries
- Women's clubs
- Sports clubs
- Lifelong learning organizations
- Religious organizations
- Theaters
- Community colleges
- Public housing
- Organization buildings with rooftop gardens
- Park districts
- Extension courses

Chicago Botanic Garden collaborates with a local nonprofit for the benefit of the Chicago urban area: Windy City Harvest as part of its Urban Agriculture program. The result is the "Farm on Ogden," located in a Chicago neighborhood to promote healthy eating and jobs together in one place. Note that the urban farm is twenty-five miles from the suburban Botanic Garden, a museum whose commitment covers a broad territory.

Don't overlook this resource: an A-team of neighbor institutions, such as other museums of all sizes and genres, libraries, community colleges and high school extension courses, non-credit learning programs, cultural organizations, clubs, theaters, and community centers. Like museums, their fields of inquiry know no boundaries—except, of course, budgets, staff, and time. They need collaborators, too.

National days invite local partnerships. Community organizations benefit from being associated with big, well-publicized "days." They are already well-known, and their publicity mill saves work and expense for all partners, existing or prospective. Briscoe Western Art Museum in San Antonio finds brand synergy with Earth Day, and in 2023. partnered with a Certified Texas Master Naturalist in this way: "Learn from Certified Texas Master Naturalist Drake White about the propagation of native plants and herbs, their value in nature and their habitat uses. . . ."

Combining museums' strengths in learning, with the corresponding strength of other institutions, candidates for your Earth Day partnerships might include:

- High school or college zoologists or agronomists
- Municipal arborists
- Veterinarians
- Botanic gardens
- Zoos

The Briscoe also writes a community message into its Event description: "Take this knowledge and leadership skill back to your community and YOU will be 'propagating' good nature know-how."

All museums should strive for that brand-builder: knowledge you can take home, forever.

It's acknowledging what you always do and re-asserting it.

With Juneteenth declared a federal holiday in 2022, several U.S. cities began building Juneteenth museums. The DuSable Black Museum and Culture Center in Chicago beat them to it. The museum and the historic day have been a community partnership for years.

In structure, it's a museum plus Juneteenth festival that combines music, food, and games with health stands and history booths, where teachers revisit with the community a history that got hidden. The museum is in a leafy park in a sprawling Black neighborhood; the celebration feels organic, which is how Juneteenth celebrations have always been, growing out of the spirit and personality of individual Black communities across America. It's a good brand event for the DuSable: "the only [museum] that grew out of the indigenous Black community." The name DuSable is part of American history. Jean-Baptiste Pointe DuSable, was a Haiti-born trader who founded at the mouth of the Chicago

River (ca.1799) the trading settlement that was to become Chicago. The museum owns an identity, a distinct personality, and a brand with deep roots.

Summer of 2023 saw Driehaus Museum celebrate Belle Epoque Paris in Chicago. The Driehaus is, after all, housed in a Belle Epoque mansion that's filled with Belle Epoque furnishings, Cheret posters, and stained glass. It even has a cancan performance scheduled, thanks to its partner, the French Consulate in Chicago.

The Driehaus acknowledges the good company it keeps with an email announcement: "Salute to a partner." It's a gesture to France, French culture, and the Consulate. Let it be noted that the performance doesn't even take place at the museum. This is also a gesture to Chicago, a city that had its own style and culture in the late 1880s-1920.

Sometimes, the best branding is giving a shoutout to others in your community:

- A winning high school basketball team
- A local scholarship winner
- A prize-winning journalist
- A helicopter weather person
- A school crossing guard
- Centenarians
- The first New Year's baby
- Snowplow operators or, alternatively, air conditioner repairmen
- Your partners at the local library, orchestra, theater, historic site, and other museums

In Philadelphia, one museum's connection with another is geographic. As the vice president of curatorial services at African American Museum in Philadelphia noted:

> "It's just a few blocks on Arch Street between the Pennsylvania Academy of the Fine Arts, the oldest art school and museum in the United States, and the African American Museum in Philadelphia, founded in 1976 to celebrate the achievements of African Americans from pre-colonial times to the current day . . . How do we create this corridor between us?"

The answer is an exhibition at both museums, "Rising Sun: Artists in an Uncertain America," in which twenty depict their reaction to the question: Is the sun rising or setting on the experiment of American democracy? The concept, intertwining two colonial stories, each with myriad versions, echoes the rising sun quote of Benjamin Franklin (as reported by James Madison):

"Whilst the last members were signing it [i.e., the Constitution] Doct FRANK-LIN looking towards the Presidents Chair, at the back of which a rising sun happened to be painted, observed to a few members near him, that Painters had found it difficult to distinguish in their art a rising from a setting sun. I have said he, often and often in the course of the Session, and the vicissitudes of my hopes and fears as to its issue, looked at that behind the President without being able to tell whether it was rising or setting: But now at length I have the happiness to know that it is a rising and not a setting Sun."

This long, deliberate observation is often misquoted. It's given in its entirety here for any rigorous historian to read. For museum partnerships, who could be a better advocate of collaborative effort and hope than Ben Franklin?

As for brand synergy, how serendipitous it is for two museums located in Philadelphia to share municipal roots reaching back almost as far as the Constitutional Convention, which was convened in Philadelphia in 1787?

REFRESHING VISION AND MISSION

New paths don't open without looking for them. If they did, more people would find them. They come from around the corner, frequently when you're looking down another road. Imagine all of these different signposts available to Georgia Writers Museum at one event alone, the 2023 Writers Retreat. Here, panels of speakers numbered in the double digits. They're all writers, of course, so they have contacts with:

- Publishers
- Bookstores
- Other conferences
- Colleges and universities
- Schools
- Various social networks

Any museum can learn from authors. Invite an author to talk (and do a book signing) , and you'll see the world in new lights. Plan 15 minutes for Q&A so that you can listen to your audience's thoughts on new pathways.

NEW VISIBILITY

When a museum is a tourist destination, partners need you. Newport Mansions, in Rhode Island, attracts multitudes, and that's a selling point it makes in its Join & Support page:

"The Newport Mansions hosts hundreds of thousands of visitors each year coming from all fifty states and more than a hundred countries around the world. Because of this visibility, the Newport Mansions present a valuable sponsorship opportunity for discriminating companies."

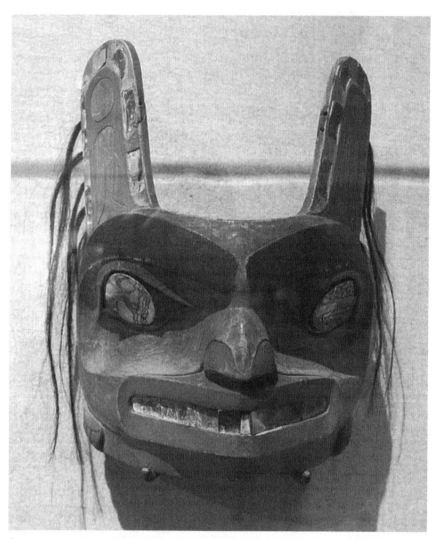

Strong museum brands know that to be a good part of a partnership, you must open your ears before opening the presentation. From the collection of Eiteljorg Museum. *Creative Commons Attribution 3.0 Unported license © Image by Sailko, Aconcagua/Alaska*

It's a tempting partnership for any museum that needs support for off-season months and for local businesses that benefit from the crowds at their height.

Museums that aren't famous destinations still have cachet and visibility that attract visits from which local business benefits. Here are some to consider and then publicize:

- Beautiful grounds
- A terrace for concerts
- Food trucks
- Weekly farmers markets
- Book fairs
- Pet parades
- Pop-up stores

If you host something busy, noisy, and colorful, people will stop—and visit other places as well.

Water is the wider world in which Calvert Marine Museum lives, situated in Maryland at the convergence of the tidal Patuxent River and surrounding Chesapeake Bay. Its brand joins several distinct marine concerns: "We are dedicated to the presentation of our three themes: regional paleontology, estuarine life of the tidal Patuxent River and adjacent Chesapeake Bay, and maritime history of these waters."

This museum, like so many, thrives on its visibility to many interests, and Calvert calls them clubs:

- Canoe and Kayak Club
- Small Craft Guild
- Fossil Club
- Purple Martin Club
- Model Boat Club
- Garden Guild

Any of these clubs, whose members all have museum memberships, might suggest partnerships for your museum, whatever its genre. Clubs engage new audiences with different kinds of knowledge, skills, hobbyist enthusiasms, professional input, and future-looking ideas. When you look at attributes like these, you can see how your visibility extends.

Multi-partnerships to enhance your visibility might include:

- School clubs
- Extension course clubs

- Business clubs
- Local sports clubs (e.g., a suburban Chicago women's group is exploring a croquet club!)

GLOBAL PARTNERSHIPS ARE THE FIT OF THE FUTURE

One World is with us now, and smart organizations—thriving ones—respond to life's new geography.

For example, Columbia River Maritime Museum stretches its neighborhood from the Pacific Coast to Japan. Fifth- to eighth-grade classes in the Pacific Northwest and Japan learn to "cooperatively design, build, launch, and track seaworthy GPS-equipped boats on a journey across the Pacific Ocean." It's creative, intensive, satisfying, empowering, and world-shaking.

The Miniboat Program was developed and sponsored by Columbia River Maritime Museum, the Consular Office of Japan in Portland, Oregon, Pacific Power Foundation, U.S. Coast Guard, NYK (Nippon Yusen Kaisha), and other organizations in both countries. It's ongoing and ambitious.

The scope is unusual, the partners are a compelling mix of entities, and the focus—on young mariners from two nations thousands of miles apart along the Pacific Rim—is shockingly brilliant. The kids are just fine.

RESEARCH

Citizen scientists are a successful form of collaborative research. Many museums already have prospective volunteers, waiting for more work. It's demanding work, and volunteers like that. It also functions on a clearly defined schedule, and today's volunteers—which include many part-time or hybrid workers—need to know how to manage their flexibility.

Here's an example: The Midwest Crane Count at Cable (WI) Natural History Museum announces: "Get involved with citizen science! We need help counting sandhill and whooping cranes at sites in Ashland, Bayfield, and Sawyer counties from 5:30-7:30 a.m." The project has statewide partners. It's a survey organized by the International Crane Foundation. It allies professional scientists and researchers with dedicated volunteers, and it adds rigor and breadth to Cable Museum's already renowned brand.

The Whale Museum in Friday Harbor, Washington, the main town on San Juan Island, is looking for partners as avidly as it looks for whale sightings and orca sightings. The Whale Museum proclaims, "We've been collecting sightings data for over 45 years!" That's a mammoth amount of data, leading to excellent research, that any museum would find challenging. The Whale Museum continues to live up to its reputation as a maritime researcher, enlisting and engaging the public in a sighting network.

Partnerships can fulfill missions and expand them. The orca survey in the state of Washington expanded its field of vision to include all cetaceans and

marine mammal strandings. In so doing, it also broadened its audience: "the Whale Hotline has successfully allowed a large spectrum of the public to directly participate in the stewardship of local marine mammals."

Note the term *stewardship*. This audience is composed of doers and acknowledges that behavioral and temperamental differences define audience segments.

What do museums' collaborators and partners want? How do they think? They wonder the same about you. All collaborations and partnerships have brand synergies and shared values; they respect their roots, understand change, and head straight for the destination called forward.

BRAND CHECKLIST

Use this checklist at the beginning and end of collaboration and partnership discussions:

- Missions and goals are clear to all partners.
- Stakeholders are agreed.
- A point person is appointed for each organization.
- Brand assets are inventoried. You know what defines your museum's collection, mission, personality, identity, DNA, image, reputation—what enhances your brand.
- Document what worked, and what didn't. Ask, "When did we fall off brand?"
- Knowledge of partners' growth or success goals is shared.
- Location of both partners—neighborhood, city, or region—is reviewed.
- The category of each partner (e.g., arts, science, history; finance, retail, hospitality, government) is assessed for compatibility.
- Standing in community is understood to be complementary.
- Partners share the stage of fundraising.
- Talents and experience that all partners bring to the project are highlighted

REFERENCES

"2023 Writers Retreat, February 24–26, 2023," Georgia Writers Museum, www.georgiawritersmuseum.org/2023-writers-retreat/ [accessed June 27, 2023]

"About," Mai Wah Society Museum, www.maiwah.org [accessed June 23, 2023]

"Celebrating Juneteenth in Chicago," NBC-TV, June 19, 2023, https://www .nbcchicago.com/top-videos-home/one-of-chicagos-biggest-juneteenth

-celebrations-takes-place-at-dusable-black-history-museum/3164309/ [accessed May 10, 2024]

"Clubs and Affiliates," Calvert Marine Museum, www.calvertmarinemuseum .com/9/Clubs [accessed June 20, 2023]

"Cultural and Aesthetic Projects," Montana Arts Council, https://art.mt.gov/ca [accessed July 15, 2023]

"Early Chicago: Jean Baptiste DuSable," DuSable to Obama, Chicago's Black Metropolis, WTTW, https://interactive.wttw.com/dusable-to-obama/jean -baptiste-dusable [accessed June 19, 2023]

"Farm on Ogden," Windy City Harvest, Chicago Botanic Garden, https://www .chicagobotanic.org/urbanagriculture/farm_on_ogden [accessed July 17, 2023]

"Hector Guimard's Designs for Living," October 21, 2023, Alliance Francaise of Chicago, https://www.af-chicago.org/events/hector-guimard-a-forum-of -ideas/ [accessed May 12, 2024]

"Hidden History Montana," Montana Historical Society, https://mhs.mt.gov/ education/hiddenhistorymt [accessed June 17, 2023]

"Introducing Kathryn Haigh, the new President and CEO of the Eiteljorg Museum," letter to mailing list, Eiteljorg Museum, March 9, 2023, http://editor.ne16.com/ vo/?FileID=c4e0e839-5a12-428b-a5d5-6119b2c61c4c&m=0d4a032b -8029-4a62-a142-25fad02ff2da&MailID=4965722&listid=1002054&Re cipientID=8748896773 [accessed March 9, 2023]

"Join & Support the Preservation Society of Newport County: Partners in Preser- vation," Newport Mansions, www.newportmansions.org/join-and-support/ [accessed June 24, 2023]

"Juneteenth on the River," May 30, 2023, email to list, https://fareharbor.com/ embeds/book/belleoflouisville/items/464255/calendar/2023/06/?full -items=yes&back=https://belleoflouisville.org/&flow=862572&a=yes&g4 =yes [accessed July 15, 2023]

"Locust Grove on the River," May 30, 2023, newsletter to mailing list, Locust Grove, www.belleoflouisville.org/cruises/special-events/locust-grove-on -the-river/ [accessed July 15, 2023]

"Making Good History," The DuSable Black Museum and Education Center, www.dusablemuseum.org/about-us/ [accessed June 19, 2023]

"Midwest Crane Count," Cable Museum of Natural History, www.cablemuseum .org/event/midwest-crane-count-2023/ [accessed March 27, 2023]

"Miniboat Program," Columbia River Maritime Museum, www.crmm.org/mini boat-program.html [accessed May 30, 2023]

"Nature Workshop – Propagation Station," Earth Day at the Briscoe, https:// www.briscoemuseum.org/earth-day/ [accessed April 17, 2023]

"New York Times: What Would Ben Franklin Say?" March 23, 2023, Philadel- phia Academy of Fine Arts, https://www.pafa.org/news/new-york-times -what-would-ben-franklin-say-artists-weigh-dream-democracy-032323 [accessed July 17, 2023]

"Our Mission," Calvert Marine Museum, www.calvertmarinemuseum.com/ 150/Our-Mission [accessed June 19, 2023]

"Plate it Forward: Donate a Meal to Someone in Need," https://immigrantfood .com [accessed June 25, 2023]

"Project Details, Bracken Cave Preserve," www.batcon.org/our-work/protect -restore-landscapes/bracken-cave-preserve/ [accessed April 17, 2023]

"The Rising Sun Armchair (George Washington's Chair)," www.ushistory.org/ more/sun.htm [accessed July 16, 2023]

"Texas Wildlife," Texas Parks and Wildlife, https://tpwd.texas.gov/huntwild/ wild/wildlife_diversity/ [accessed April 17, 2023]

"Volunteer at the Bakken," The Bakken Museum, https://thebakken.org/volun teer [accessed June 24, 2023]

"The Whale Hotline & Sightings Network," The Whale Museum, https:// whalemuseum.org/pages/the-whale-hotline-sightings-network [accessed July 16, 2023]

7

Visuals

Visuals are seen all over the museum, of course, inside and out. Beyond the galleries, departments from Development to Volunteers communicate more effectively with visualization. Photos with captions, videos, and charts have leapt from page to platform to tomorrow's message system to further your museum's message.

This chapter focuses on visuals that appear on websites and email, communication workhorses that, day after day, introduce your museum to interested audiences. On home pages and email announcements, time is short; you have only moments to convey a message to an unknown assortment of visitors and viewers. A strong, clear visual cuts to the chase.

You brand says so much about your museum's place in everyone's life. Words alone can't tell the large story. They need the added power of the seen.

The following are some aspects of a museum brand that need visualization, regularly.

COLLECTION

It all starts with your collection. Let your visitors see your philosophy, the objects that are your pride and which propel your forward trajectory.

Abilene Zoo collects a hundred different kinds of animals. And it shows them all, in rotation, on its home page. In close-up, visitors can get to know them. This is more than a zoo; it's a gathering of animal friends at Abilene Zoo, and photos say that. Familiarity makes a good brand stronger.

At Tenement Museum, the collection is its portfolio of stories of families who lived in the building, on the Lower East Side of New York City, newly arrived in America, in the mid-1800s. The museum's archive holds thousands of documents from which data and information and analyses the stories were assembled. These documents are not only tangible, they're also visual, and the website shows them.

In Newport, Rhode Island, emails from the Newport Preservation Society often lead with a column-wide photo over the headline: "From Our Collections." From rugs to mugs, emails throughout the year lead with an object from the

collection. These are framed in the announcement column; they have pride of place, as a collection item should. The photo is accompanied by a caption that serves as a gallery label:

> "This Bakshaish pictorial rug (Persian, Northwestern Iran, mid-19th century) at Kingscote is a wonderful example of the works of art that adorn the floor when you visit our houses . . . the rug depicts a magical landscape of rose-colored mountains packed with deer, and trees sprouting from hilltops."

With the photo of a silver mug is some text indicating the maker and recipient (retaining the original spelling): "BALL TOMPKINS & BLACK / SUCESSORS TO / MAROUAND & Co."

With each email, in addition to the announcements that follow, the recipient is reminded of the heritage and mission of the museum.

It's a template any museum can adapt, whenever you email announcements. Depict an object from your collection, in the galleries, archives, or storage. Picture and caption that object in an e-newsletter. It put your news in the context of the museum's mission, an important connection to acknowledge.

Reminders by photo, that's one way a good brand is reinforced with collection artifacts that:

- Typify an important period in your history
- Depict some of the topics covered by next month's lecture
- Picture a significant event in your community
- Remind viewers of the people important to us on holidays, major and minor
- Receive mention in a book in the store
- Were used by the people who lived in your historic house
- Bloom in the garden all summer
- Demonstrate skills like those children will learn in workshops

Emails work hard for your brand. They go to audiences who have already expressed interest in your museum; they appear often; they get noticed. Highlighting a collection item is an extra assignment emails can easily handle.

YOUR BUILDING

A museum's building is a huge hunk of branding. With a solid place in the community—not to mention maps—buildings get noticed, and often written about. Use them on your home page with branding intent; show one of its distinctive architectural features.

Blanton Museum of Art features its upward sweeping staircase. At the bottom of the photo see a lone figure in a jaunty hat and flip-flops heading up them. It's wonderful branding to show a visitor taking the steps—up and up—to see what you offer.

Take inventory of your museum's architectural details; it could be a very small one that tells a story. Ask an architect for their slant.

Words can't tell the whole story. The Glass House, in New Canaan, Connecticut, takes an architect's perspective: "As a historic site owned and operated by the National Trust for Historic Preservation, the Glass House serves as a catalyst for the preservation and interpretation of modern architecture, landscape, and art, and as a canvas for inspiration and experimentation."

And then, to embellish the words, a lovely image of a bridge, a glass facade, and a landscape completes the thought. Architects, as artists, envision. The amateurs in your audiences might need the help of a professional photo.

Far below the chandeliered rooms of Drayton Hall, in Charleston, South Carolina, we see a conservator in the bare space scraping paint off a cellar door. A cellar! Seeing it tells a whole history that can't be condensed into a few words. The text reveals that animal fats in the paint suggest this was where enslaved people prepared meals for themselves and slept. Text continues the story along with the "You" part, a request for donations. Understanding enslaved history would be hindered without the photo. Giving requests would be less effective, too.

Museums' buildings are too often described as architecture and design, amazing structures, either new and advanced or heroically restored. Look further and you'll find history in even the humblest of them. Whatever the plan of your museum, apply the tandem power of pictures with the words, the two sides of any story:

- Identify rooms that once were used for storage before they became the store
- Find outdoor spaces, repurposed as patios or pocket nature observatories
- Show the grand plaza populated with people relaxing with brown paper bag lunch
- Picture the view from the museum, next to the online Directions map

YOUR COMMUNITY

Websites are organized to look like a catalogue-with-encyclopedia. They want to tell everything about the museum, its history, its offerings, its idiosyncrasies. As it should; the web holds it all. Which makes it easy to expand your place in the world, specifically your community. It's a significant part of your brand.

Door County Maritime Museum has a live feed on its website. The videocam is positioned, immovably, on a tower overlooking a causeway bridge. If you're not a maritime museum, feel justified in asking who would want to look at a body of water and one of its bridges? Maritime people, who probably like checking out ice, water levels, and traffic flow. A little technical cleverness,

some smart collaboration with the community, and a lot of audience awareness is working here. The visuals work hard and work smart.

> **Exercise:** Where would your museum place a live video-cam feed? How would it energize your brand?

Locale is fundamental to the brand of the recently opened International African American Museum in Charleston, S.C. It is situated on Gadsden's Wharf, which is where, the museum estimates, almost half of the tens of thousands enslaved Africans entered the country. Photos on the home page and succeeding pages show the modern museum, on the historic water and—this is central to the brand—very much in the sunny, positive, future-facing present.

When looking for the right home page visual, start by discarding the cliches—the images all institutions have on file:

- Your facade
- Galleries
- Overhead shot of a beautiful building
- Scenic vista
- Logo (we'll make an exception for the Mark Twain House & Museum)

Look for photos that include objects, street signs, recognizable buildings, residents engaged in daily life, and special projects. There are probably ideal photos in the archives of your local newspapers.

A museum with roots in the community needs to avoid preconceptions in selecting branded visuals. Visitors to websites like the Peshtigo Fire Museums can come from anywhere, and they won't know your history; certainly not the way Wisconsinites do. Peshtigo was razed by the worst fire in U.S. history . . . on the same day as the Great Chicago Fire. That's some story. The home page of Peshtigo Fire Museum exists to tell it well, starting with a home page photo of a blazing conflagration.

For any museum, visuals can become the lead paragraph of its story, a visual beginning for the tale of a special hometown.

BOARD OF TRUSTEES

Why does a website visitor read the Board of Trustees page? Some are there on purpose, vetting the museum, and a list of board members is essential reading. Other people will skim it while scanning through the Support tab. But with a photo? Suddenly the Board is interesting, especially if the group is in an interesting setting. That alone conveys a brand message. And if a board includes people of all ages, of all cultures, in all styles of dress, and everybody smiling like they love their job? That announces a well-run museum with a view forward.

What would a museum loyalist find on your Calendar for This Week? Highlights tour? Sketch class? Conservator's talk? Museums' breadth and depth look fuller when visuals help tell your plans. Visuals matter; the walls can't talk. On every communication you send, words and pictures work together. *The Creative Commons Attribution 4.0 International license*

The photo of the Cooper Hewitt, Smithsonian Design Museum in Manhattan pictures twelve individuals, and that is what a viewer sees first, not a list of names and titles.

It's amazing how a photograph can capture the personality of its subject. What do people see when they see your board? Hopefully some of these:

- A setting that reflects the look or outlook of your museum
- Art types
- Scientists
- Scholars
- Techies
- Hard workers
- Professionals
- A variety of ages
- Someone wearing sneakers

EXHIBITIONS

Exhibitions exhibit. Bring out the exhibitionist in your curators with offbeat photos for your website.

Vesterheim Norwegian-American Museum in Decorah, Iowa, found a photo that looks like a water wheel crossed with a Ferris wheel. Actually, explains the caption, it's a Norwegian-American inventor's ice cream cone-making machine. Vesterheim mounted an exhibition of Norwegian-Americans who were responsible for improvements we see all the time. Website visitors need to see these innovations to understand the theme of the exhibition, not to mention the focus of the museum. and how it relates to its brand. It's not just fluff.

In the same exhibition was a photo of a young Queen Elizabeth II and Prince Philip visiting Vesterheim—very appealing, an endorsement almost. However, unlike the invention, this wasn't related to the museum's brand.

> **Exercise:** Walk through a current exhibition at your museum and select two items that will tell the best story on your website. Take photos and write captions.

Good exhibitions also exhibit expressive headlines, like the one that says: "On the Edge of the Wind: Native Storytellers & The Land."

It's on the home page of the State Historical Society of North Dakota.

What makes the marketing perfect is the web page visual showing a sweeping, toward-the-horizon landscape of valley and butte, leading to mountains and sky. With four galleries depicting the history, culture, connections, and

into-the-future plans of North Dakota, the expanse of land in the banner visual previews the story. The image pulls the viewer in, encourages a longer look. It pictures the museum as representative of its audiences, true to its heritage and visionary about what follows.

From a design standpoint, the home page visual encourages a click and a further look.

Good thinking for the museum, its brand, and its web communicators.

Exercise: Open your photo file and look for teasers, the surprising shot, the one that prompts a "what is this?" and invites a look inside to the rest of the exhibits.

LEARNING PROGRAMS

Learning programs that involve children have a branding challenge. Children are, arguably, all cute and they all wear T-shirts. What differentiates a summer camp in Ohio from a family workshop in Utah? A strategic directive for the photographer is needed: Take photos of the program, not the participants.

Burke Museum, in Seattle, in depicting its summer children's programs, shows small hands working with "A DIY camp in a box" fossil kit. It shows more small hands holding a large, purple geode. It shows the Burke Backpack and its brightly colored magnifying glass, instruction cards, a shell, and a rock. Now parents and caregivers get the picture: Burke's learning program is about science.

No museum is immune from the people-in-photos problem. Here's how to distinguish your learners of all ages:

- Put the people in a setting, indoors or out, unique to the museum
- Place an object, specific to your collection, in the hands of the people
- Never show an audience; show the stage, preferably with identification such as a logo onscreen or a podium
- Show a distinctive feature of the lecture hall or auditorium or theater
- Tell people to dress like they really do for the photo (possibly eliminating suits and ties)
- Ask a featured speaker for a snapshot, rather than a portrait
- Hire a people-photographer when honoring a staff member with a story

Learning is complex enough without the obstacle of special tools. In the case of Cable Natural History Museum, what's needed is hiking equipment. Mammal Trails and Mushroom Forays are part of the "get outside!" ethos of Cable Natural History Museum. And the museum supplies free equipment rental to maximize learning along the trails of Cable, Wisconsin. Photos of

snowshoes, birding backpacks, and cameras help beginners picture the nature experience and make it approachable, a goal integral to Cable's brand.

What can your museum picture on its website to preview the tools of learning, to familiarize your audiences before they sign up for a program?

- Artists' supplies like paints, brushes, pencils, papers
- Microscopes
- Close-ups of leaves, insects, nests
- Writing tools
- Cooking utensils
- STEM kit

Photos take the mystery out of new experiences. They'll make your museum comfortable and friendly early in the process. Loyalty starts early.

MEMBERS, DONORS, AND SUPPORTERS

Requests for support compete amid a sea of emails and web pages. The appeal from The Whale Museum, in Friday Harbor, Washington, stands out. A Letter from the Director is eloquent in words: "The orcas, like the oceans . . . are inspirational and energizing . . . let's rewild our planet."

Also eloquent is a photo of calm waters with "Members of J Pod" in residence.

Many website visitors are prone to donate to your museum. Their reasons are idiosyncratic and based as much on emotion as logic. Give them photos that inspire and energize.

Whales turned out to be helpfully photogenic at a 2023 Online Auction Fundraiser for the Whale Museum; the items up for auction were marked on a paddle topped with a fluke. Without the photo of the whale paddles, the gala auction might merely have looked gala-ish.

Auctions, like all fundraisers, do more than raise money. They raise the visibility of your brand. Photos will document the event in newsletters, your website, annual reports, and media releases. Find a creative way, like a whale fluke, to add your brand image to the record.

STORE

When it comes to connecting the museum's store to the museum's exhibitions, not to mention its mission, the Skirball Cultural Institute in Los Angeles sets a high standard. A horizontal banner scrolls across the top of Audrey's Museum Store page with an image from each of several exhibitions and a link on each one:

For the exhibition "This Light of Ours" — Link Here

For "Yinka Shonibare CBE RE The American Library" — Find a New Story

For "A Family Painting Reclaimed" — Products Here

Visuals of a specific exhibition linking to the store are timely, helpful, good branding. Those responsible for effective web design did great work on this one.

Tamastslikt Cultural Institute in Pendleton, Oregon, connects its store to its heritage by picturing a native-design wool blanket for sale in the store. In a world of generic toys, books, jewelry, and mugs in a cluster of small images, a mission-related item stands apart. The text shows the price, and it's expensive. The visual shows it's worth it.

Museum stores work hard at finding, stocking, and displaying good merchandise. Make those items work a little harder by finding the most visually powerful ones for emails. Emails go straight to interested people's homes; store items are quick symbols of the museum's identity. Don't squander this opportunity to communicate your brand. Get a good visual and picture it large.

As you lay out store merchandise, look for photo ops:

- Enlarge a book cover so it dominates the space
- Juxtapose two very different items—have fun with the contrast
- Show close-ups of pieces from a game
- Drape a necklace on a plush toy
- Fill an array of mugs with flowers

BLOG

A story without visuals is just an article. Blogs are documents that tell stories. They record the stages of research, the routines of zoo workers, growth in gardens, work of conservators, experiences of tour guides. Why not chronicle a project pictorially? There's no shortage of blog topics, and they all enhance a museum brand. Photos can help compose the outline. Give an intern a camera and set them loose.

Show them the home page of the Historical and Cultural Society of Clay County, in Moorhead, Minnesota. Their mission is: "to collect, preserve, interpret, and share the history and culture of Clay County, Minnesota. In short, we tell local stories."

Taking photos of museum workspaces makes stories easier to imagine. Interview with a camera, instead of a pad and pencil, and shoot the undertakings that underpin your goals. Ask staffers to show an item that makes their job different. Look through the archives for a historic image or visual that underlines your heritage.

Blogs may be written by writers, but their words are immeasurably enhanced by pictures and, thus, a much better story is told.

VOLUNTEERS

Visuals are a manifesto of a museum's brand values and mission; they belong on every Volunteer page. Volunteers, like all stakeholders, uphold the brand message and values. Arguably, they are the most important messengers of the brand, because they face your audiences across all departments, nooks, and crannies of the museum property. The volunteer page is for them, and those who want to join them, and it's self-defeating not to place pictures of colleagues there. Many museums recognize the branding aspect of volunteerism by titling their page "Get Involved" rather than "Support Us." Volunteers want to be involved, and visuals prove that.

Harbor History Museum, in Gig Harbor, Washington, shows its volunteers in action, a team of guys working together on the deck of a boat in the harbor. For museums in any port of call, take a good look at what your volunteers actually do. They may be in a gallery, next to a store table, at a potting table, or dockside; it's the connection to your brand that counts.

TOURS

Abilene Zoo uses photography on its web page that offers animal tours. These are specialized animal tours, named after specific animals, and they can cost $45. This is a bold branding move; price tags, even expensive ones, show the value of a package, and value is part of branding. A high-value concept benefits from a good visual, and Abilene provides an eyeball-to-eyeball tour star, a sloth. All zoos let you see animals; Abilene lets you walk the walk with sloths.

> **Exercise:** Is there a day-in-the-life story living in your museum? Bring it to life in a tour, self-guided or docent led. Find a suitable photograph to put on your docents' phones or tablets. Add it via a QR code to a self-guided tour sheet.

THE POWER OF THE SEEN

Museums befuddle their audiences daily. So many new experiences, so much to wrap their heads around. And you have to tell them about this mass of marvels before they arrive. They already know your name, trust your reputation, and expect ideas. Visuals help new messages get delivered. With visuals, new scenarios take shape. Visuals escort your brand into people's lives. And they're such a pleasure to look at.

BRANDING CHECKLIST

Check every communication your museum sends for good visuals. Are they:

- Specific to your museum?
- Interesting as a stand-alone image?
- Cropped, for focus?
- Large enough to be significant?
- Clear messages (visuals should be articulate, too)?
- Not cliché?
- Reflective of the tone and attitude of your message?
- Useful for other communications?
- More than a group of smiling adults, cute children, or busy galleries?
- If an object in your collection, is it beautifully photographed?
- If a map, chart, or graphic, is it perfectly comprehensible?
- Captioned?

REFERENCES

"About," The Glass House, https://theglasshouse.org/about/ [accessed June 28, 2023]

"Articles and Blogs," Historical and Cultural Society of Clay County, www.hcscc online.org/blog [accessed June 18, 2023]

"Board of Trustees," Cooper Hewitt, Smithsonian Design Museum, www .cooperhewitt.org/board-of-trustees/ [accessed July 8, 2023]

"Building & Garden," International African-American Museum, https://iaa museum.org/building-and-garden/ [accessed January 10, 2023]

Cotter, Holland. "In Charleston, a Museum Honors a Journey of Grief and Grace," Critics Notebook, *The New York Times*, June 23, 2023, www.nytimes .com/2023/06/23/arts/design/charleston-african-american-museum .html [accessed December 25, 2023]

"Equipment Rental," Cable Natural History Museum, www.cablemuseum.org/ equipment-rentals/ [accessed November 3, 2023]

"Featured Auction Items," December 4, 2023, e-newsletter, The Whale Museum [accessed December 5, 2023]

"Get Involved," Harbor History Museum, https://harborhistorymuseum.org/ get-involved [accessed July 30, 2023]

"Headlines of the Week – Audio Tour for Chateau-sur-Mer – from Trudy Coxe," July 7, 2023, message from a mailing list, Preservation Society of Newport County [accessed December 29, 2023]

"Headlines of the Week – 2023: What a Year! – from Trudy Coxe," December 29, 2023, message from a mailing list, Preservation Society of Newport County [accessed December 29, 2023]

"Innovators & Inventors," January–May 2022, Vesterheim, https://vesterheim.org/exhibit/innovators-and-inventors/ [accessed December 23, 2023]

"Kusi Family Special," https://www.tamastslikt.org/product/kusi-family-special/ [accessed January 10, 2024]

Letter from the Director, November 2023, The Whale Museum, https://mcusercontent.com/161d483e002ee13b2dbbbcb57/files/2692262f-9c26-dc08-1573-9de8cc9c006e/2023_Year_End_Letter.pdf?goal=0_4afc0d8ef6-90c427bcb2-92929474&mc_cid=90c427bcb2&mc_eid=b2f776b929 [accessed November 21, 2023]

"Live Video Feeds," Door County Maritime Museum, https://dcmm.org/live-video-feeds/ [accessed January 4, 2024]

Mark Twain House & Museum, https://marktwainhouse.org/ [accessed January 9, 2024]

"Meet the Animals," https://abilenezoo.org/meet-the-animals/ [accessed October 29, 2023]

North Dakota Heritage Center and State Museum, https://statemuseum.nd.gov [accessed October 25, 2023]

Peshtigo Fire Museum, http://www.peshtigofiremuseum.com/ [accessed December 24, 2023]

"Plan Your Visit," Blanton Museum of Art, https://blantonmuseum.org/ [accessed August 31, 2023]

"Sloth Tour," Abilene Zoo, https://abilenezoo.org/?utm_source=gmb&utm_medium=organic [accessed December 27, 2023]

"Summer Activities," Burke Museum, www.burkemuseum.org/education/summer-activities [accessed January 4, 2024]

"Union of Hope," https://www.tenement.org/new-exhibit-coming-soon/ [accessed November 4, 2023]

"Vesterheim Blog," 2022, Vesterheim, https://vesterheim.org/innovator -inventor-profile-keith-elwick/ [accessed December 28, 2023]

"The Whale Museum's Online Auction 2023," The Whale Museum, https:// new.biddingowl.com/AuctionLanding?QueryAuctionId=906a01f1-81f6 -40bf-b0c3-00dc9e4cef37 [accessed December 5, 2023]

"What a Scalpel, Microscope, and YOU Can Tell Us About American History," Drayton Hall, https://mailchi.mp/draytonhall/giftboxes-79006?e=7ea4ba 1771 [accessed December 3, 2023]

"Yinka Shonibare CBE RE The American Library," Audrey's Museum Store, https://shop.skirball.org/ [accessed December 19, 2023]

8

Blogs

Blogs are a branding boon.

Blogs, when they're well researched, selected for interest to the museum's audiences, and clearly written, embody the museum, its forward vision, and familiar personality. Blogs are a special godsend for small museums, which have collected objects and documents for generations. Their staffs, many of them volunteer, include legions of knowledgeable archivists.

Maybe it's your good fortune to luck into great writers—interns, volunteers, local historians, amateurs with curiosity—those talented people who speak the voice of their audiences and put the words on paper.

EXPERTISE

For almost a decade, Cincinnati Art Museum has written a blog a week on conservation. Of all the departments and projects possible to place under the scholarly microscope, conservation won out. Week after week, another close look at blanched retouching, wrinkled canvases, varnish removal, textile damage, porcelain cleaning, and other arcana beloved by conservationists and, it turned out, the public. As the first blog post read:

> "Since our 'Behind the Scenes in Conservation' posts have been so popular on social media, we've decided to give them more room to shine (and analyze and treat and conserve)! Each week, our conservation team highlights a project from one of their four specialty areas (paper, objects, textile or paintings conservation), giving you an exclusive look into the lab."

And that's another branding advantage of a blog. Proving the scholarly credentials of a respected institution in the wider art community.

More smart branding: responsiveness to the interests of specific audiences. A museum might not expect conservation to be so popular, but it's the people's expectations that matter; they decide your brand value.

Blogs offer museum professionals the opportunity to go deep into their area of expertise, in this case, a decade deep.

Cable Museum Community Science initiatives connect amateur and volunteer scientists and observers with academics throughout the north woods of Wisconsin. The museum's iNet Blog documents the training for and applications of observation, notation, record-keeping, and internet open platform information sharing. This is solid research that teaches scholarly research principles. It represents the museum's love of science and dedication to sharing it;

"Join the Cable Natural History Museum and other partner organizations across the state in our second season of a statewide community science initiative! During the 2023 season, we will work together to monitor plants, bumblebees, and butterflies at our local properties. We provide a variety of opportunities to build identification and survey skills during scheduled programs. Staff and volunteers are also available to help get you started with a survey at any time."

Locust Grove Estate offers original research, ripe for interpretation and analysis, in its easily accessible archive. A current catalogue lists the many documents and items of Henry Lathrop Young, 1818-1900, including letters, bills, and ledgers relating to the family business, Sing Sing Gas Company of Ossining, New York:

- Correspondence
- An auction poster
- Calling cards
- A horticulture journal
- Last Will and Testament
- Newspaper clippings
- Obituary

The research possibilities are tempting!

The Whale Museum, Friday Harbor, Washington, offers podcasts with titles like:

- All in a Day's Work: SJCMMSN Adventures in Marine Mammal Rescue, Research, and Education
- Our Northerly Neighbors: Northern Resident Killer Whales
- Salish Sea Sharks: The Jawsome Truth!
- Are You Smarter Than a Killer Whale? Exploring Orca Intelligence
- Extinction Is Not an Option! Washington State's Efforts to Recover Salmon
- Ancient Evidence: First Peoples and the Management and Use of Salish Sea Marine Resources

This is a partial list. One key thought for podcasts is: series. Podcasts accrue credibility when there's an overarching strategy or theme the museum continually explores and disseminates. A series builds awareness. There's an expectation of more to come. A trust and familiarity with brand ensue.

CONTINUITY AND DURABILITY

Blogs document museums' inquiries and analyses over a period of time. Posts, articles, and research findings verify commitment. It's a museum version of "1001 Nights," a story of achievements that continues and continues.

Gig Harbor Literary Society, at Harbor History Museum, in Washington, tells a similar story; its stories are book club books whose titles are listed on its website six months in advance. The viewer can see this is a museum with staying power. Under the Events tab, each book gets a brief review, demonstrating its relevance to the Washington coast, and even a list of links to further information. One swath of time, from July through December 2023, was promised; whatever else busied the days of its members, a dependable, stimulating, social evening awaited every first Wednesday evening at Gig Harbor History Museum.

In Solomons, Maryland, *The Bugeye Times*, a publication of Calvert Marine Museum that was in its 48th volume in Spring/Summer 2023, typifies the flexibility of the blog concept. It doesn't publish often, but its regularity makes up for that. It looks like a newsletter but acts like a blog (and branding), focusing with academic rigor on one topic and including citations for all its factual content. Its credentials include:

- Focus on marine topics
- Photos of maritime subjects and objects
- Reference to local people and institutions
- Significant information on natural science, water history, and regional issues that support the brand mission
- Byline to identify individual input (named contributors add credibility)
- A one-of-a-kind name that complements the unique charter of the museum
- Definition of "Bugeye" in the masthead, an integral part of all editions (The bugeye was the traditional sailing craft of the Chesapeake Bay, and was built in all its glory at Solomons, "the Bugeye Capital of the World.")

Franklin Institute, as in Benjamin Franklin, has a legendary brand name. Ben's statue is in the lobby. Not only its name, but the museum itself, has a firm reputation for science exploration and science attainability. And like all good brands, not only science brands, it doesn't rest on its heritage. It dares. The podcast format is a perfect place for museums daring to try something new. By definition, it attracts visitors who like to learn by listening.

In 2022–23, the Franklin Institute's "So Curious" podcast explored science and music. This was enticing for new audiences and intellectually stimulating for listeners who want to stretch the usual boundaries. Here's a sampling of the podcast titles:

- "Let's Dance! Why Music Makes Us Move"
- "Wild Voices: In Tune with the Animal Kingdom"
- "Remember That Song? Music and Memory"
- "In Tune With the Body: Music in Athletic Performance and Healthcare"

Note: A major branding benefit is found in this statement: "New Episodes Every Tuesday!"

Podcasts are available to everyone, listeners and museums alike. They can be short and monthly. New ideas matter. Continuity is more important than frequency.

PERSONALITY

Tippecanoe County Historical Society does its citizens proud; it records an astounding range of adventures and accomplishments by its citizens, covering almost two hundred years. Meet amateur explorers who traveled the length of Africa by canoe, steamer boat, and on foot; an Underground Railroad porter; and Orphan Train children. Whigs rallied there, of course, and, in the same decade, its small African American community established an enduring education system.

The histories contained in Tippecanoe County are well researched, well-written, and archived for viewing at any time. They portray the personality of one county and one museum, through the people that lived there and the lives they lived. Some tips for all museums can be gleaned from this:

- Length, about 1,700 words
- Citations
- Photographs, current and archival
- Variety of subjects
- Guest bloggers
- Links to other museum articles

Blogs corroborate their branding credentials with entries like those of Time and the Valleys Museum & Lost Catskills Farm in Grahamsville, New York, in the heart of Hudson River country. Some are straight articles, with excellent illustrations, diagrams, and maps (such as Catskill Mountain Pre-History). Many are recorded slide presentations for its YouTube channel (Great Covered Bridges of the Mid-Hudson Region; Medicine During the Revolution; Tri-Valley One-Room Schools; The Price of Water; The Story of New Netherland: Dutch

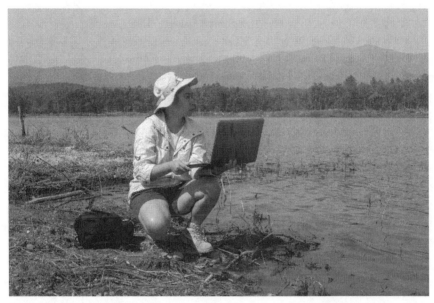
Beginning of a blog: a researcher documenting environmental conditions. Daily entries reinforce a museum's commitment to exploration. *Getty Images royalty free*

Colony 1624–1644). The titles clearly connect to the museum's background, current programming, and identity with its historic Hudson River region.

Creators of slide presentations deliver valuable, carefully researched proof of museums' expertise and forward vision. These presenters also represent stakeholder loyalty to the museum and its mission. Preserving these documents, in several platforms, is good branding.

Vesterheim Museum, in Decorah, Iowa, focuses intently on Norwegian history and culture. It has a long record of folk art instruction, in person and virtual, and a catalog of videos on crafts and craftspeople. Vesterheim's Folk Art Workshop showcases historic skills and a current respect for a culture; this is a museum that has offered tours of Norway for over forty years.

The Vesterheim blog introduces the individuals who create and teach Scandinavian crafts. Instructional and historically fascinating, the blog strengthens the museum's brand by demonstration and promulgation, heritage with a future.

Emphasizing your brand with a workshop has the benefit of engagement and sociability. Everyone learns from doing. And working with others is like traveling together on a tour: Two is better than one when it comes to remembrance.

Drayton Hall, in Charleston, South Carolina, devotes one of its several blog categories to African American history. To tell the history of enslaved people, an ongoing archaeology project is excavating 100 years of artifacts necessary to its mission: to foster "a deeper understanding of colonial America and the evolution of life in the South."

A series of posts documents the brand's exploration: The foundations and building materials used in enslaved peoples' houses comprise a story that couldn't be written by people not allowed to write. In another post, shards of pottery are brought to the microscope, and the writer tells the story of researching the artistry and crafts that enrich large portions of colonial American history.

While archaeological research and techniques are key to Drayton Hall's brand, there are blog lessons for any museum looking to enhance its research credentials:

- Describe the background of the project
- Give the research a name
- State its goals and processes
- Use scholarly terms, but not too many
- Write with precision and, when necessary, write a lot
- Use photos and illustrations with captions (this is part of documentation)
- Credit the author—name, title, and appropriate suffix

PERSONALITY: REAL PERSONS

Blogs differentiate between museums' mission and their personality. The first is a rather official, carefully reasoned statement of philosophy and intent. The second is warm and friendly. Museums want to be open-arms friendly. Especially corporate museums.

Wells Fargo Museum balances two goals of corporate museums. First, they showcase a company's success and growth, communicating America's business and entrepreneurial history. Like all museums, they refresh their exhibits and revitalize interpretations. Blogging tells their ongoing history and demonstrates their record of vitality.

Second, corporations must demonstrate that they are part of a community; they are corporate citizens. Wells Fargo Bank joins its community authentically, featuring stories of local people throughout its history. Formerly known as a stagecoach company, Wells Fargo reaches into the archives for a series of articles on Trailblazers in the Western States. They're rightly called historical archives; they teach history from the perspective of transportation. Teaching from a new perspective burnishes any museum's identity; it sheds a new light on their communities, both professional and geographic.

Museums don't need a corporate archivist to write a history of their community. Invite local people to contribute:

- History teachers
- Bookstore newsletter editors
- History buffs
- Your staff
- Local businesses

Pick a month, any month, from the archive of Harbor Museum at Gig Harbor, Washington, and see what remarkable character emerges from history.

> "While in the old country Spiro Janovich had been a sailor in the Austrian Navy. Upon coming to America he went to work for Hunt Transportation Company of Gig Harbor, Washington as a skipper on several of the small vessels of the Hunt mosquito fleet. Janovich also became somewhat involved in the commercial fishing business."

There follows a long reminiscence of an immigrant entrepreneur, the commerce and industries around Puget Sound, and a lot of beloved boats. Names, dates, and photos are provided, and the writer installs them in memory. Blogs are a gift that museums give to their audiences and their community.

Harbor Museum credits a wonderful volunteer. If your museum attracts people with the knowledge and writing skills to bring people to life, lucky you. Now you have two authentic voices narrating history. Some tips:

- Discuss with volunteer writers a strategy for the blog posts
- Develop a theme, broad or focused, and stick with it
- Change to another theme when a theme, or the writer, loses steam
- Set a deadline and maintain a regular schedule—monthly, quarterly, it doesn't matter if it's consistent
- Stand back and let writers write. Their tone of voice, its locality, is important and unassailable.

Local culture, of course, depends on whose locality you're in. American Writers Museum acknowledges all localities with a Reading List blog that encourages patronizing independent bookstores. Writers understand the importance of author readings and signings scheduled by the bookseller in readers' communities. Writers, museums, bookstores—these name brands support each other.

Language is people writ large. It covers talk, play, work, school, the arts, science, entertainment, and cookbooks. That's diversity! In the interest of diverse blog posts for many different interests, Planet Word Museum, in Washington, D.C., opts for huge diversity in formats. Each post is approximately 500 to 800 words and some contain visuals—photos, illustrations—in the text. Here are some of the topics:

- Neologisms
- Maker projects that use diagrams, as well as words
- Love songs
- Words from children's books

The format of each blog varies. Variety in format, as well as topic, gives leeway to guest bloggers. Each post looks different, which shows that your brand explores new ideas and welcomes different kinds of writers. At the same time, the regularity of the blogs demonstrates your museum's dependability. The readability of blogs keeps readers coming back, and that's really good news for brand familiarity and loyalty.

MEMORIES OF VOICE AND SOUNDS

Voices, so often lacking in the brand identity of a museum, are recalled in this blog: the sound, the accent, the references of a past decade in northern Minnesota. Here's an example of articles in the blog of Historical and Cultural Society of Clay County (Minnesota), population 64,690 in 2020. Note the date of the blog and imagine the need it must have met as a member of the community:

"Walter and Karin Krueger in the 1952-53 Polio Epidemic"

Markus Krueger, March 26, 2020:

"'I remember when I was not yet ten, my grandpa and grandma, Walter and Karin Krueger, wrote up their life stories. They kept working on it until grandpa's was 80 pages and grandma's was 122. Everyone take note: this is the best possible gift anyone can give to their loved ones. As I read the pages, in their words, I remember their stories and I hear their voices. My feisty grandma Karin had the Scandinavian accent so often imitated when poking fun at Minnesotans. Walter's voice cannot be imitated. In 1952, polio deadened his speaking muscles. In time, he trained different muscles in his throat to move and contract and vibrate with the breath he could muster from the quarter of a lung that still functioned. His voice was raspy, deep, kind of (but not exactly) like what you hear coming out of an old fast food drive-thru intercom. You and I cannot make the same noises.'"

LOCALE

Being part of a community means understanding your natural world, having a feel for its sounds, weather, and terrain.

The concept of a professor leading hikes for adult and school-age learners showcases several attributes of successful blogging. It certainly puts nature and the outdoors front and center; it glamorizes actually walking around in nature. These are visions and goals central to Cable Natural History Museum. Blogs deliver because they're focused, brief, and written with heart.

Cable houses its blogs under the title "Natural Connections: exploring northwoods nature through science and your senses." Again, restating its goals. "Natural Connections" is written by a writer who loves the topic and the art of writing about it. Emily M. Stone is a published author, and that's a plus (but not a minus for smaller museums who don't have professional writers on staff). Museum interns, volunteers, and even busy staffers often love to write about the museum they're entwined with. So a blog is a heartfelt aspect of a museum; it wears its heart on its rolled-up sleeve.

Cemeteries are museums in the making, history in headstones, combining physical viewpoints and contemporary documentation of people and culture. Forest Lawn Museum in Glendale, California, has the added advantage of a well-known name, synonymous with Los Angeles. Its blog captures Southern California cultures, from automobiles to famous TV cops. Blogs are the perfect place to embody memes like "just the facts, ma'am."

At Connor Prairie in Fishers, Indiana, the overarching perspective is nature. Nature is in Connor Prairie's name. The museum's setting, as a re-created village, is in nature. The people who work at the museum like being in nature. The Conner Prairie Blog connects the museum to nature in different ways for different audiences. Here are some of their blog titles: Spending Time in Nature for Mental Health, Birding at Conner Prairie, Playtime on the Prairie.

Blogs are expansive. They're open to a wide variety of posts, on many topics. Some are long, some brief. Some are illustrated with photographs or charts. They don't exclude any topics; however, inclusivity requires a perspective that's clear. The point of view in a blog derives from your brand personality. As you discuss possible blog posts, your brand may come into clearer focus.

RECORD OF RESEARCH

Research conveys curiosity. It embodies expertise. It demonstrates scholarship and credentials, no boasting needed. All museums, any size, any genre, benefit from some kind of research.

Mai Wah Museum in Butte, Montana, has been preserving and interpreting Butte's Asian heritage for 30 years. It's a singular museum with a wide audience over the Rocky Mountain West. Part of its mission is research and publication of material of scholarly and general interest in the Chinese diaspora in America.

The museum blog "Inside The Box" and a standing column, "Artifact of the Month," center on articles about objects saved in boxes from the Mercantile Exchange store, Wah Chong Tai Mercantile, an amazingly complete Chinese store from the early 20th century. The museum understates when it says, "Research opportunities abound." One artifact is a medallion from a society to train armies in America to support the last emperor of China before the Republic of China was established in 1912. (The group mostly drilled and disbanded after a few years, but it's still fascinating.)

At Milwaukee Public Museum, an annual research project spends the day on a "BioBlitz" for biodiversity. It's a yearly contest to see how many species could be identified in one day in familiar locations around Milwaukee. Biodiversity was the object and message: Discover the wide range of life in your own backyard. In a recent competition, 57 surveyors and educators from 18 institutions and organizations found 1,048 species, including 450 fungi and lichen, 450 insects, 11 mammals, and 60 birds. Results, with photos of the event, are saved in an archive that goes back to 2015. The yearly event includes a day of discovery for all with topics like:

"Little Things Are a Big Deal: Microscopes and Why We Use Them"

"Come explore the BIG world inside a tiny droplet! We'll use microscopes to delve deep into the details of aquatic life"

"Pressing Matters: Plant Presses and Why We Make Them"
"Unleash your inner botanist with our hands-on activity!
Craft your own plant press and learn how to preserve
specimens for future study in your own herbarium"

"What Is a Scientist? What They Do and How They Do It"

This pursuit of curiosity and joy in discovery is wonderful for a museum's image. It enhances the institution by empowering the individual. And it's real, needed citizen research. Museums have the citizens; give them the challenge of inquiry.

BRANDING CHECKLIST

Some questions you and other museum staffers should respond to:

- Do you have a blog? Why not?
- Does it publish regularly (e.g., weekly, monthly, or quarterly)?
- Explain in one sentence how your blog relates to your mission, vision, reputation, and heritage.
- Describe the personality of the blog. Use as many sentences as you want.
- Have you recruited guest writers?
- Can you identify five experts in the museum or broader community who could contribute a brand-related article?
- Do you know what treasures are in your archive?
- Where do you list your blog on your website; under what tabs? Or is it buried at the bottom in small type?

REFERENCES

"AWM Staff Picks: August 2023," American Writers Museum, https://american writersmuseum.org/awm-staff-picks-august-2023/ [accessed September 29, 2023]

Babal, Marianne. "Meet the Chinese Business Partners Who Left a Legacy in Oregon," Trailblazers, May 10, 2021, www.wellsfargohistory.com/meet-the -chinese-business-partners-who-left-a-legacy-in-oregon/ [accessed October 2, 2023]

Babal, Marianne. "Serving Veterans," Trailblazers, November 9, 2021, www .wellsfargohistory.com/serving-veterans/ [accessed October 2, 2023]

Billing, Susan. "The Powerful Magic of Play at Playtime on the Prairie," Conner Prairie, December 12, 2022, www.connerprairie.org/the-powerful-magic-of -play/ [accessed October 2, 2023]

"Blog," Time and the Valleys Museum & Lost Catskills Farm, www.timeandthe valleysmuseum.org/blog/ [accessed August 4, 2023]

"Blog," Tippecanoe County Historical Association, https://tippecanoehistory .org/blog/page/4/ [accessed October 12, 2023]

Bradley, Adam. "What Makes a Great Love Song," Planet Word Museum, https://planetwordmuseum.org/what-makes-a-great-love-song/ [accessed October 2, 2023]

Bugeye Times, Spring/Summer 2023, Calvert Marine Museum, http://www.calvertmarinemuseum.com/275/Bugeye-Times [accessed October 12, 2023]

"Car Shows—2023," Forest Lawn Museum, https://forestlawn.com/2023/07/11/car-shows-2023/ [accessed July 27, 2023]

"Category: African-American History," Drayton Hall, www.draytonhall.org/category/african-american-history/ [accessed September 28, 2023]

"Celebrating Alice in Wonderland with Neologisms and Whimsy," July 4, 2022, Planet Word Museum, https://planetwordmuseum.org/celebrating-alice-in-wonderland-with-neologisms-and-whimsy/ [accessed October 2, 2023]

Conservation, "Behind the Scenes in Conservation: The Total Look Sneak Peek!" January 15, 2015, Cincinnati Art Museum, www.cincinnatiartmuseum.org/about/blog/behind-the-scenes-in-conservation-the-total-look-sneak-peek/ [accessed June 17, 2023]

"Distinguished Resident: Jack Webb," Forest Lawn Museum, https://forestlawn.com/2023/05/04/distinguished-resident-jack-webb-peace-officers-memorial-day/ [accessed July 27, 2023]

"Drayton Hall Participates in Identifying Ways to Recognize Potting Traditions of West African Enslaved," Drayton Hall, www.draytonhall.org/drayton-hall-participates-in-identifying-ways-to-recognize-potting-traditions-of-west-african-enslaved/ [accessed September 28, 2023]

"Experience History in the Making," Wells Fargo, www.wellsfargohistory.com/museum/ [accessed February 18, 2023]

Friedman, Ann. "A Couple of Neologisms for Today," March 15, 2023, Planet Word Museum, https://planetwordmuseum.org/from-the-founder-deepfakes-and-a-couple-of-neologisms-for-today/ [accessed October 2, 2023]

Galuska, Tara. "Extinction Is Not An Option! Washington State's Efforts to Recover Salmon," September 29, 2022 [accessed October 13, 2023]

Gibson, Richard I. "Artifact of the Month: CERA Medallion, www.maiwah
.org/?s=Artifact+of+the+month [accessed August 6, 2023]

"Gig Harbor Literary Society," Harbor History Museum, https://harborhistory
museum.org/events [accessed October 12, 2023]

"Great Covered Bridges of the Mid-Hudson Region" (blog), Time and the Valleys
Museum & Lost Catskills Farm, www.timeandthevalleysmuseum.org/great
-covered-bridges-of-the-mid-hudson-region/ [accessed October 12, 2023]

Historical & Cultural Society of Clay County, www.hcscconline.org/blog/
archives/03-2020 [accessed February 16, 2023]

"How to Make an Origami Poetry Envelope," April 17, 2023, Planet Word
Museum, https://planetwordmuseum.org/how-to-make-an-origami-poetry
-envelope/ [accessed October 2, 2023]

King, Jackie. "Salish Sea Sharks: The Jawsome Truth!" October 7, 2021
[accessed October 13, 2023]

"Linguistic Diversity in D.C. and the 'D.C. Dialect': Q&A with Natalie Schilling,"
What in the Word?, May 24, 2023, Planet Word Museum, https://planet
wordmuseum.org/the-d-c-dialect-and-linguistic-diversity-in-d-c-q-a-with
-natalie-schilling/ [accessed October 2, 2023]

The Locust Grove Estate archives, www.lgny.org/archives [accessed Septem-
ber 26, 2023]

Mai Wah Museum, www.maiwah.org/?s=Inside+the+box [accessed August
6, 2023]

"The Mai Wah Society," www.maiwah.org [accessed June 22, 2023]

Makovich, Lee. "Out of the Past: The *Monitor*: A Fond Remembrance," October
1994, Harbor History Museum Blog, November 30, 2017, http://harborhis
torymuseum.blogspot.com/2017/11/ [accessed October 13, 2023]

Marino, Lori. "Are You Smarter Than A Killer Whale? Exploring Orca Intelli-
gence" (podcast), Whale Museum, https://www.youtube.com/watch?v=ea
CaPwbKWSo [accessed October 13, 2023]

Morton, Michelle. "Birding at Conner Prairie" (blog), March 27, 2023, https://www
.connerprairie.org/birding-at-conner-prairie/ [accessed October 2, 2023]

Noel, Carol. "Spending Time in Nature for Mental Health Awareness Month" (blog), Conner Prairie, May 9, 2023, www.connerprairie.org/mental-health -awareness-month/ [accessed May 24, 2023]

"Professor Hike" (blog), June 22, 2023, Cable Natural History Museum, http:// cablemuseumnaturalconnections.blogspot.com [accessed June 23, 2023]

"Roger Abrahamson," Woodworking, Vesterheim Folk Art School, Vesterheim, https://vesterheim.org/exhibit/roger-abrahamson/ [accessed September 3, 2023]

"Salish Sea Association of Marine Naturalists," Whale Museum, https://whale museum.org/pages/salish-sea-association-of-marine-naturalists [accessed September 25, 2023]

Salomon, Anne. "Ancient Evidence: First Peoples and the Management and Use of Salish Sea Marine Resources (podcast)" The Whale Museum, https://drive.google.com/file/d/1jEn3rTbxUvz8lkg1Vp2C4OcuSRX1NbCv/ view [accessed February 9, 2024]

Scott, Alyssa. "All in a Day's Work: SJCMMSN Adventures in Marine Mammal Rescue, Research, and Education" (podcast), December 6, 2021, Whale Museum, https://drive.google.com/file/d/1M1ar2FUWRNHTZnW 48bqbRTFUJ1VC5mK7/view [accessed May 9, 2024]

"So Curious," Franklin Institute, https://podcasts.captivate.fm/media/95b21b87 -3fda-4ff0-ae0b-8ba78714c4e0/E12-master-v1.mp3 [accessed October 1, 2023]

"Statewide Community Science Project," Cable Natural History Museum, www .cablemuseum.org/community-science/ [accessed October 2, 2023]

Towers, Jared. "Our Northerly Neighbors: Northern Resident Killer Whales," January 12, 2022, https://drive.google.com/file/d/11ELbsli4MZ8eF2FziHT _UzDBZFcdUlvT/view [accessed May 9, 2024]

"Walter, Karin, and the Polio Epidemic of '52-'53," Historical and Cultural Society of Clay County, www.hcscconline.org/blog/archives/03-2020 [accessed June 18, 2023]

"What is a BioBlitz?" Milwaukee Public Museum, www.mpm.edu/BioBlitz [accessed August 18, 2023]

Young Collection, Locust Grove Archive, https://drive.google.com/file/d/1wY 5fTj5aGT-zAddL-CYydnen2-63_eVQ/view [accessed September 26, 2023]

9

Tours

Today's tours are a game plan: a guide for visitors in experiencing the museum.

Today's tour guides are coaches, helping not telling. The goal is showing visitors how to learn about your exhibit in their own way, with the learning styles they use best. Contemporary strategy puts the emphasis on the visitors, to observe, analyze, and discuss with each other what the exhibits mean to them.

It's all about the audience, the many audiences that come to your door. The museum's meaning is for them to decide; you guide but they know how to interpret your exhibits.

Different tour formats, like different gallery layouts, will interpret and be interpreted differently.

The six tour goals in this chapter contribute to better visitor understanding of museums' singular exhibits. As audiences and exhibits change, you can adapt tours to facilitate the former understanding the latter.

1. Creating pathways—helping visitors understand the narrative of your museum, and how to interpret what is shown.
2. Showing context—explaining the people, community, and era of your museum and its vision.
3. Gathering different people together—visitors learn more deeply when talking and listening to others.
4. Satisfying questing people—when the visitor says, "now I get it," you've given them a wonderful gift.
5. Relating to personal experiences—when people in a group share what they've seen, they appreciate the museum's relevance in their lives.
6. Facilitating different learning styles—reading, hearing, doing, describing

Add this goal for the tour leaders themselves: Ask yourself, will these visitors who take our tours remember us a little longer, and feel satisfied with what they've learned? That's how supporters are developed. Tours are excellent development tools.

You have only a short time with visitors, so before the tour even starts:

- Be welcoming; this includes everyone, beginning with the front desk.
- Get to the "tours start here" sign early.
- Chat a little, if appropriate, to warm up the audience.
- Ask tour-takers what they like or want in a tour.

Some visitors want a knowledgeable guide; some want to stroll among the rooms and galleries on their own.

Ask the tour group, especially those with children, what they like about museums in general.

Homeschooling families have different goals for museum visits. Guides are usually advised in advance of such groups, but individual families also visit. Be aware of their goals.

On virtual tours, or on-site, discover your guests' hometowns, the museums they know. It's an icebreaker, and provides clues to their museum literacy

Some of your potential virtual tour-takers are in Oslo or Lagos or São Paulo, anywhere on the compass points. You might want to acknowledge this.

Some virtual viewers must stay at home; some work untraditional hours; some love the technology that allows for, say, close-ups, or in-depth video labels; and some need audio to compensate for vision problems.

Prepare a question to ask at the end of the tour. What did you like? Did anything puzzle you? What will you remember three days from now? This helps visitors engage, and it helps the guides, too.

CREATING PATHWAYS

Visitors like to stroll and explore through a museum, and Cable Natural History Museum in Wisconsin starts early with this concept. In the Curiosity Center, children can follow their curiosity—enter a tree, peer into a giant bird's nest, or walk a bog. This self-guided tour for children is a carefully planned one.

With curiosity as a guideline, here are some other tour types, applicable for any museum.

- "Can you find examples of how people use food"
- "Do you see any examples of teamwork in this room?"
- "How are mornings different, all over the world?"
- "Who is the most important person in these woods?"
- "Who else lived in this historic house beside the famous person? How can you tell?"
- "Does anyone here get to play?"

The visitors create the tour, following their own curiosity.

Some pathways are geographic, actually covering a lot of territory.

Mill towns are a historic monument, seen throughout the northeastern United States, with legacies dating back to rural England. The people and the town are a unit. In Maine, the Biddeford Mills Museum has the complex mission of documenting and preserving "the historical and cultural mill heritage in Biddeford and the surrounding area." Its collection, its exhibits, comprise objects, buildings, and a walk that display a complex way of life pervading every street. Biddeford Mills Museum offers rather long tours—up to two hours—because it is an extensive "museum." The population of this mill town in 1860 was 9,349, and their lives are the subject of the museum.

> "Walking tours are often guided by former mill workers, who know first-hand the history of these old brick buildings. See the unique architecture of a cotton house, walk among the towering walls of a weave shed, and visit the underground canals where the Saco River once powered these historic textile mills."

Of course, water mills are American history, the textile industry has moved all over the world, and small towns that now number 23,000 denizens have a wildly different profile from the days when small towns were 99 percent White. You don't have to be a data scientist to imagine who your audiences might be today. Museums with brands as expansive as their tours will adapt tour talks to include:

- Businesses in our town today
- Population trends then and now
- One-town events that commemorate our heritage

SHOWING CONTEXT

Museums are part of their community, and small museums may be geographically close to other town institutions that you can make use of. For example, your museum may be in the same neighborhood as a cemetery. Take a walk through the history of the cemetery and imagine how it might reflect the history of the museum. Does anyone in the history of your museum now "reside" there?

A tradition of the Wisconsin Veterans Museum since 1998, Talking Spirits Cemetery Tours bring to life the interesting and often unknown stories of souls interred at Forest Hill Cemetery in Madison. Cemetery Tours are held each autumn. In 2023 they focused on the 50th anniversary of the last U.S. combat troops withdrawn from Vietnam. Wisconsin was there in more ways than one in remembering Vietnam veterans who came home 50 years earlier.

Cemetery tours are a walking-talking way to bring your museum into the lives of your audiences by telling stories of the people who could have been

their neighbors. The people are well documented, names spelled correctly, birth and death dates accurate, family size often indicated. Census research, if possible, takes the stories from bare bones to full context. Cemetery tours are engrossing, significant to your community's history, and a commemorative gift from your museum.

House walks and garden tours are another way to showcase your community and your value to each other. Museums that sponsor or collaborate with a tour can help strengthen the tour script with related objects, artists, and researched stories. Tablets, carried by tour guides, make this adjunct information portable. Informed background for a house or garden tour might include:

- People who built the house
- House and garden architects
- Others who lived and worked there
- Science-based botanical information
- Multicultural influences

And here are some questions to research before the tour:

- Were any of the homes/gardens designed by immigrants?
- What kind of schooling did the owners/builders/inhabitants have?
- Relationship of the buildings to historic events?
- Pets or farm animals who lived on the premises?

And perhaps ask these questions of the tour-takers themselves:

- Have any of you lived in a house like this?
- How did your family use the various rooms?
- Can you adapt any of this for your garden?

Tour leaders themselves are also learning; good ones learn something with every tour. Keep an ear open for side comments. A tour of the grounds at Chautauqua Institution demonstrated this. The guide was having trouble encouraging the walkers to become talkers. He overheard one tour-taker comment to another, "That's the kind of plant we use in our garden, but in Ohio we call them. . . ." The guide asked permission to share this comment with the group and restated the question:

"What do you call this plant in your area? Or any of these other plantings?"

The discussion suddenly revived. Although tours are tabbed as Events or Learning, in reality they are engagers and connectors between your audiences and your brand.

The African American Museum in Philadelphia, a city with a deep and broad history, constructed tours linked to the city's 300-year-old culture: "Philadelphia's 1830 Black Metropolis Walking Tour," partnered with the museum and its exhibition, "Rising Sun: Artists in an Uncertain America," to connect the museum and the community.

At Museum of Work & Culture, in Woonsocket, Rhode Island, the culture is French Canadian, the story of people who left their farms in Quebec for work in the factories of the New England area. This museum "showcases the remarkable story of a people's preservation of their faith, language and customs and their acculturation into the working class of America."

Here, the context is the melting pot, a term that risks getting lost. America in the 1800s was multi-cultured, full of variety. There were differences, of course, but the goal, as with this museum, was not just including but welcoming. As a student said, "We don't handle difference, we love it."

Museums of today, in reassessing their audiences, also review their context. If immigration is touchy, talk about the people rather than the policies. To attune tour groups to the context of immigrants, ask:

- Where did your family come from?
- Where did they work?
- How was school for them?
- Did they speak more than one language?

GATHERING DIFFERENT PEOPLE TOGETHER

At the Museum of American Arts and Crafts Movement in St. Petersburg, Florida, tour guides use prompts instead of talks. Tour guides select five to seven exhibits to point out on the one-hour tour. At each stop, the guides ask a prompt question, such as:

- "What do you see here?"
- "What makes this object unusual?"
- "How was this object used?"
- "What was the artist conveying or exploring?"

The guides prepare many prompt questions in advance to keep the discussion flowing. This format:

- Involves every person in the tour
- Furthers the art of listening to each other
- Honors diverse observations, backgrounds, and experiences
- Teaches the guides new ideas to present on their next tours

For example, a 2023 visitor to the museum was part of a small group of visitors that included a granddaughter of an Arts and Crafts Movement artist, a snowbird who had been a volunteer at a northern city museum, a note-taking man, a question-asking woman, a woman who pointed out an aspect of the work the guide didn't know about, and a couple who wanted the names of nearby restaurants. Diverse attitudes, to be sure, and all possible loyalists.

Note: The well-trained guide several times thanked the woman who taught him something new, and said to the group: "Tell me if you see something I haven't mentioned . . . I don't know everything . . . you can fill in some gaps."

Some people avoid groups; they visit the museum solo. There are advantages to cultivating solo museumgoers: They like to create their own connections; they spend a lot of time with their thoughts. They don't just visit your museum; they deeply enjoy it. You can still provide a branded template for their contemplations, as the Museum of Fine Arts in St. Petersburg, Florida, did on a shelf on the wall of the first gallery after the entrance. There, a series of brochures awaited the self-tourer. Here are a few examples:

- Wild Creations & Women Artists
- The Divine & Belief
- Death & Remembrance
- Animals & Insects

These small, single-topic brochures were designed with photos and a paragraph on five works to be found in various galleries. There was also a QR code: "Scan this code for a map identifying the locations of the artwork."

Several branding benefits accrue. The museum helps a valued visitor enjoy the visit. There's a tangible take-home item, serving as a countertop reminder of the visit. There's short, to-the-point reading to enhance individual thoughts. And the technology-enhanced QR code, which replaces the space-gobbling gallery map, is also a nod to another kind of learner.

A warm-climate museum will have a lot of short-stay visitors and members, even in the largest sunbelt cities. They may not stay in your city for a long time, but you can encourage them to stay a little longer with each visit.

Again, from the St. Petersburg Museum of Fine Arts: In the 2022–2023 exhibition of its collection, at certain points in its galleries visitors could hear music that related to works on display. The Symphony of Florida is a partner. People tend to linger a little longer when there's music to listen to. Seeing and hearing quietly widens the meaning of a brand.

Maybe they'll hum along.

SATISFYING QUESTING PEOPLE

One uncomfortable truth about asking "Are there any questions?" is, you never know what's coming next. Conventional wisdom says children's first question

Describe this room. What do you notice first? Who uses this room? Who else lives in the house? Compare it with other rooms you've seen. These are the questions tour guides might ask visitors. Guides don't tell; visitors discover and discuss among themselves. George Eastman Museum. *Mattlapointe, CC BY-SA 3.0, via Wikimedia Commons*

always is, Where's the bathroom? Don't let a question—scholarly, detailed, or urgent—render the visitor unsatisfied until it's answered. Prepare in advance. It's a large remit for docents and staff, but necessary for a successful museum journey. Here's what Newark Art Museum did:

"Meet Our New Visitor Experience Staff

"Part host . . . with equal amounts tour guide . . . ambassador . . . and Museum promoter . . . they need to know their way around the building's multiple wings . . . basic knowledge of our . . . collection, services, programs, special events . . . take . . . ownership in answering a wide range of visitor queries, including [about] the surrounding area of Newark."

Some version of this initiative is worth considering:

- Ambassador on duty at (affix a "back on duty" clock here)
- Front desk attendant wearing an "Ask Me" badge
- Intern hired to be a roaming question-answerer
- Collaboration with the local Rotary to provide a guide sheet for the community
- People who look for answers often want a look behind the scenes. It's unknown territory!

In Georgia, Augusta Museum of History maintains an archive it is proud to show off in a one-hour tour that goes behind the scenes. It shows the care and effort that go into preparing, storing, and displaying artifacts:

"In this program, . . . [the] Registrar will demonstrate how the Museum col- lects, catalogs, preserves, studies, cares for, and displays archival collections . . . how historically important objects reach the Museum . . . are evaluated, prepared for display or stored. . . . At the end, you'll understand how these processes are central to the Museum's mission of the preservation and inter- pretation of history."

Understanding—it's good for your brand's success, and tours help. What- ever form a museum tour takes, here's how to underscore understanding:

- Start the tour by introducing the concept of understanding what the museum is all about.
- At the end of the tour, ask: Did you see anything that you just didn't get?
- Do you get it now?
- Give visitors a few extra minutes at the end to reflect and to share their thoughts.

In Colorado, Aspen Historical Society works so determinedly toward understanding that they offer a money-back guarantee: "Learn something NEW, or we'll give your money back to you! This first-ever money back guarantee for all guided tours underscores what might seem obvious about the past: The stories are endless. . . ."

RELATING TO PERSONAL EXPERIENCES

Frank Lloyd Wright's Martin House in Buffalo, New York, is a dream destination for architects, architecture scholars, amateur architecture scholars, designers, and photographers. The museum offers special tours to accommodate people with professional equipment and a need for extra space, plus the more-than-willingness to pay $35+ for the privilege of shooting a Frank Lloyd Wright masterwork. One evening a month, the museum is open for an hour to photographers.

The branding value of targeting photographers with a photo privilege ripple outward:

- Photographers comprise a large club with its own network.
- Photos are shared, again and again.
- Photos are studied intensively by photographers and their audiences.
- Pictures tell stories.
- Exclusivity—including a one-time privilege—is at the heart of branding.

Any museum can use this branding tool!

FACILITATING DIFFERENT LEARNING STYLES

In honor of even more diversity, let's give extensive thought to learning styles.

- Some people like hearing information.
- Many prefer to read information.
- Some people use tours like classes.
- Others want a classroom to themselves.
- Some take notes to learn.
- Others prefer projects.

Museums, in a mix of learning, caring, and innovating, have developed tours that put learning above teaching, and individual style above their own.

And now we come to the sense of touch. Children who touch things are said to be curious. Adults who touch things are thought to be childish. Learners who touch are experiential learners.

With Augusta Museum of History's TouchCart Tours, visitors can "interact with selected objects by touching and using historical reproductions. By comparing the past to the present, children learn more about their world." Different

tours offer touchable options such as Native American, Antebellum Period, Creating Mill Town, and Civil Rights. Experiential learning for any museum emphasizes:

- Using an object
- Feeling how they are handled
- Understanding a process, not just the result
- Learning the satisfaction of mastery

Satisfaction at the end of a museum visit is a singular experience. Happy learners remember the museum where they discovered for themselves a new concept. A child will remember that for a long time!

Imagine an on-site exhibition tour with seven people. Chances are one:

- Reads labels and wall panels
- Prefers ear buds
- Learns in many different ways
- Has difficulty hearing
- Relates the visit to family members who can't visit the museum
- Donates to museums, and does background research first
- Is a potential volunteer guide

Cincinnati Art Museum developed a tour for all the above, an audio tour available on-site and to many more, free on its website. "Creating Connections: Self-Taught Artists in the Rosenthal Collection Audio Exhibition" features paintings by self-taught artists with short one- to five-minute narrations. This is an adjunct to a current exhibition and a preview of a recent collection gift. It has many advantages to a museum whose brand mission includes a new look at ways of "turning out to the community" to "engage visitors inside and out."

Inside and out; that's another good definition of how a museum manifests its brand.

Norton Simon Museum, in Pasadena, California, knows that the vast museum public lives outside its geographic zone. Responding to that reality, it provides audio tours online, audio tours, and written narration complementing views of art.

For an example, a two-paragraph description and photo of Toulouse-Lautrec's "At the Cirque Fernando, Rider on a White Horse, 1887-1888" is accompanied by a link to a 90-second audio track offered in English and Spanish. Many of these audio tours are condensed to a short form for children.

Here are some brand advantages of tours with online audio plus written text and photos:

- Broader audiences

- Different format, for the format-collecting/format-savvy generation
- Educational uses
- Membership extra
- Fundraising and development, emphasis on development

Not quite a tour, the Mark Twain House & Museum offers "just three hours of uninterrupted writing time in Mark Twain's own library . . . to write, reflect, and plot whatever piece of literature you're working on . . . [in a space] infused with Mark Twain's spirit." How better for one audience—writers—to understand what Mark Twain was all about?

Learning by doing sounds like a roadblock on the tour journey. Sure enough, fifth graders on the ARTworks Tours at Sioux Falls Art Center, stop, sit down, and create art. After a docent-guided tour of art exhibits, "the class moves to the ARTworks studio where the docent leads the group through a creative and artistic hands-on activity related to the viewed exhibitions." Children learn to love a museum by learning how its art is made. Teachers better understand the goals by completing a questionnaire on the process. There's no shorter path to respect than asking for advice along the way.

The Met Copyist Program aims for very specific learners, artists, with a custom-made tour. Instead of a series of stops throughout the museum, or a group discussion in front of one work of art, The Met allows one person an in-depth, all-around look at one work of art for multiple weeks of study and copying.

This style of learning is common practice in European museums, less formalized in American ones. It's a heads-up that our small world creates broader audiences for every museum. And it's a template for any museum that caters to a large niche that crosses many traditional audience segments. Consider offering special treatment—with a price tag that proves its distinctiveness—and providing a comfortable, purpose-proper environment.

Ask tour guides to categorize the types of people in any of their tours, and they could probably describe them pretty well: intense, curious, questioning, talky, single and involved, in a couple and comparing observations, label readers, careful listeners. In other words, diverse learners.

If a museum wonders how to embrace such a multitude, why not invent a new category?

Martin House in Buffalo, New York, offered a new tour type that appealed to the day-long tourer. The tour, a full day, two-site, box lunch journey, was unusual in other respects. Participants were expected to buy a higher price ticket, pick a lunch menu, walk a lot, get in their cars and drive, and walk some more.

What kind of visitor would sign up for that? Well, new ideas are always a risk, and novel tours are one way to assess potential new visitors.

Museums of any size or budget might consider a one-time trial tour to test the market. Be assured of one thing: Your audience is changing, and assessment tools must change, too.

BRANDING CHECKLIST

Tour guides are your best frontline researchers. They see the visitor, know the museum, and are attuned to questions and confusions. Learn from your guides:

- Confer with tour guides about what worked, what didn't.
- Discuss how well visitors connected the tour with the museum's goals.
- Collect tour participants' questions.
- Take the tour yourself, at different times.
- Watch the other people on the tour.
- Give guides name badges with the museum's name on it so visitors feel comfortable talking to them.

REFERENCES

"Application Form," www.metmuseum.org/events/programs/met-creates/copyist-program [accessed June 1, 2023]

"ARTworks Tours," Sioux City Art Center, https://siouxcityartcenter.org/tours/ [accessed September 19, 2023]

"Before You Arrive," The Nelson-Atkins Museum of Art, https://nelson-atkins.org/plan-your-visit/ [accessed June 10, 2023]

"Behind the Scenes," Augusta History Museum, www.augustamuseum.org/BehindtheScenes [accessed August 25, 2023]

"Black Metropolis Walking Tour at AAMP: Part 4 – Emancipation in Education," African American Museum of Philadelphia, https://tockify.com/aampmuseum/detail/634/1694538000000 [accessed September 21, 2023]

"Candlelit Cemetery Tours: Vietnam: 50 Years Later," October 7, 2023, Wisconsin Veterans Museum, https://wisvetsmuseum.com/event/candlelit-cemetery-tours-vietnam-50-years-later/ [accessed [September 23, 2023]

"Creating Connections: Self-Taught Artists in the Rosenthal Collection Audio Exhibition," www.cincinnatiartmuseum.org/art/exhibitions/creating-connections-self-taught-artists-in-the-rosenthal-collection/creating-connections-audio-exhibition/ [accessed September 15, 2023]

"Curiosity Center," Cable Natural History Museum, www.cablemuseum.org/curiosity-center/ [accessed September 23, 2023]

Hanson, Amy, quoted in "Transforming Growth Underway with Cincinnati Art Museum's Groundbreaking 'A New View' Campaign," Cincinnati Art Museum, September 29, 2021, www.cincinnatiartmuseum.org/about/press-room/a-new-view-presser/ [accessed September 15, 2023]

"Martin House/Graycliff Experience," July 24, 2023, Frank Lloyd Wright's Martin House, https://ci.ovationtix.com/35631/production/1155539 [accessed July 13, 2023]

"Meet Our New Visitors Experience Staff," June 6, 2021, Letters from the Director Archive, Newark Art Museum, https://newarkmuseumart.org/2021/06/04/meet-our-new-visitor-experience-staff/ [accessed September 20, 2023]

Murphy, Kelly. "An Historic Guarantee," Annual Update, Winter 2020, Aspen Historical Society, https://aspenhistory.org/wp-content/uploads/2020/06/AHS-annual-update_final-proof.pdf [accessed August 28, 2023]

"Museum of Work & Culture," www.woonsocketri.org/about-us/pages/museum-work-culture [accessed September 21, 2023]

"Photography Tour," Martin House, https://martinhouse.org/tours/ [accessed August 31, 2023]

"Take a Tour," Biddeford Mills Museum, https://biddefordmillsmuseum.org/tours [accessed June 29, 2023]

"Talking Spirits Cemetery Tours," Wisconsin Veterans Museum, https://wisvetsmuseum.com/madison-cemetery-tours/ [accessed March 31, 2023]

"Talking Spirits Tour: Anne Roach," Learning & Research, Cemetery Tours, Wisconsin Veterans Museum, https://youtu.be/V7AM8X4YJWM [accessed August 19, 2023]

"Talking Spirits XXV: Forest Hills Cemetery Tours," Wisconsin Veterans Museum, https://wisvetsmuseum.com/madison-cemetery-tours/ [accessed September 23, 2023]

"The Met Application Form," https://metmuseum.wufoo.com/forms/z6lzkal0uuv7sm/ [accessed June 1, 2023]

"Touch Carts, Crafts and Mini Tours," Augusta Museum of History, https://www.augustamuseum.org/GroupTour [accessed August 31, 2023]

"Walking Tours," The 1838 Black Metropolis, African American Museum of Philadelphia, www.1838blackmetropolis.com/walking-tours [accessed September 21, 2023]

Wallace, Margot, visitor on guided tour of grounds, Chautauqua Institution, July 2015

"Watch and Listen Audio Tour, Norton Simon Museum, https://www.nortonsimon.org/learn/watch-and-listen/audio-tour/ [accessed September 23, 2023]

"Writing in Mark Twain's Library," Mark Twain House & Museum, https://marktwainhouse.org/programs-events/writing-programs/writing-in-mark-twains-library/ [accessed September 17, 2023]

10

Fundraising and Development

Fundraising and development is a backward term. Development should come first. Look at the development that goes into all the activities that convert visitors to members, or members to higher levels of donation and support. Those long-term relationships rely on a brand that is respected, trusted, and familiar. As you seek to develop stronger ties with potential supporters, connect your brand's values with theirs. This chapter looks at the practices that develop loyalty and lead to fund-giving:

1. Member engagement: don't just sign them up
2. Tourist hospitality: treating tourists as friends rather than one-off visitors
3. Newcomer welcome: a place to meet the community
4. Wider vistas: geographic and professional
5. Hands across the border: how reputation and community stretch connections
6. Social needs: your brand has credentials to address challenges
7. Following up
8. Location: where you are is what you are
9. Future

MEMBER ENGAGEMENT

Traditions attract and retain like-minded people to a cause. When starting a relationship, sharing traditions with each other helps form bonds. Small museums, formed with a historic or regional mission, have a lot of tradition to wield when asking for donations. When the Civil War Museum of New England wanted to add to its collection, it used this battle cry to the troops: "Help the NECWM Bring Seth Plumb's Uniform Home!"

The relationships involved in this effort expanded the usual definition and included members of the museum, members of the historic community surrounding it, and a global recruitment pool of Civil War enthusiasts.

Which person is the fundraiser? Which is the prospect? At the initial stages of fundraising and development, both museum and prospective supporter work together to develop a relationship, where they develop a rapport, for themselves and their brands. Getty Images

Thanks to a new-old relationship builder, GoFundMe, the tradition of all-for-one and one-for-all kicked in. The museum's values and goals were broadcast so potential donors could assess if they matched their own.

When you engage people in an effort, rather than just solicit money from them, a relationship grows that:

- Lasts longer
- Extends further
- Engages more completely
- Feels more satisfying
- Reinforces loyalty
- Lengthens memories

TOURIST HOSPITALITY

Tourists are people like you and me. They're somebody's neighbor, somebody's colleague. Don't treat them like visitors; treat them like friends. Think of them as prospective donors who travel a lot.

Zoo visitors exemplify tourists. They might come back, might purchase a membership, might donate. Might not. However, they had wonderful time, so try to retain them as members. Lean on your animals, those wonderful ambassadors, to help.

Indianapolis Zoo, with its "Animal Adventures," addresses its audiences forthrightly with a program that costs $20 to high-five a dolphin, $68–$75 to touch a white rhino. In addition to raising funds, these programs show the hard work of caring for animals, and build an understanding of what the zoo accomplishes. The connection the zoo made with visitors was literal—through touch. One imagines it started a long-term relationship that would continue in memory, long after the visit. The zoo immediately demonstrated its reputation as a caring, innovative animal environment by letting visitors "get up close and personal" with a sloth and "experience firsthand" bathing an elephant.

Membership starts with respect for your brand. Next step, a return visit. Then, a segue to developing a more lucrative relationship.

- Put a premium price on your tickets, occasionally. If you value your brand's programs, others will.
- Use touch and taste with your events, where appropriate. The connection becomes tactile and more brand-specific.
- Hire an animal for the day. Of course it will upstage you, so put your logo on its collar and enclosure and identify with the good time.
- Show, tell, or demonstrate your local history and ask visitors to relate it to their hometowns.

This works on tours and in after-lecture Q&A sessions. This also captures visitor data.

One of the must-see spaces for tourists is the museum store. They'll just about always visit the store after an in-person visit; and they probably revisit or pre-visit it online, too.

One of the items that Adams Museum, in Deadwood, South Dakota, stocks on its shop shelves is membership. Although gift memberships are usually found hiding under the Support tab, Adams realized a universal human need—shopping—and put this fundraising device in its store. Brilliant! For prospective donors, it should be part of their due diligence. Everyone goes to this page sooner or later. Visitors and prospective donors at all levels. It's part of due diligence and it's a human irresistibility. Also, if a museum is boldly looking for large gifts, as Adams is, the store is where big spenders go. Membership documents, as gifts, don't look exciting. But they sound fantastic here:

- Bullwhacker—$100
 Premium membership benefits with: two guest passes
- Homestake—$1,000
 Premium membership benefits with: eight guest passes

Are these membership gifts true to the Adams Museum's brand? For a tourist, visiting Deadwood, South Dakota, yes indeed.

NEWCOMER WELCOME

A subset of tourist is newcomer. These are strangers who stay; and let's not call them "stranger" ever again! Museums are eminently qualified to call them opportunities.

- Create newcomer programs for children. They'll need lots of welcoming.
- Collaborate with your local library on toolkits and exhibits that bring stories to life.
- Promote your volunteer program as a way to learn about the new community.
- Create a tour—Story of Newcomers Tour—for your historic home.
- Create a workshop—New Garden in a New Town—for your science museum or botanic garden.
- Designate a community table in the cafe.
- On ticket or mailing list forms, add a check box for:
 ___ New to town

Membership is appealing to new people seeking to participate in their new surroundings. As the relationship builds, becoming a donor or supporter eases

the way to serious involvement in the life of the community. Museums can work with businesses on special programs and tours.

Not all newcomers bring families. Empty-nesters, retirees, and seasonal residents all want to belong to a community. The local museum attracts all of them at some time, and front desk personnel make a good welcoming committee. Train them on welcoming tactics that position your brand as a friend to rely on, one to join and contribute to:

Hello, are you a new visitor?

New in town?

Our store has books about our town.

Here's a newcomer discount ticket for the cafe.

WIDER VISTAS

Membership is an easy, well-known way to raise money and develop a relationship with a museum. So when Anoka Country Historical Society heard these words—"Visitors want the programming, not the membership"—they saw an opportunity and created a relationship through programming.

For this small museum in a county-wide region north of Minneapolis, a podcast proved very popular as a new program. It comprised stories about the people and towns in its county-wide area. Who created and told the stories? The people themselves. They felt involved and, more importantly, saw that the museum was genuinely engaged with them. The series of interviews in this continuing program took time and multiple visits. In other words, it slowly developed relationships.

Here's how the project worked, and how it could work for other museums:

- Visited the cities and towns in the county to develop relationships
- Interviewed local people
- Looked for stories about landmarks in town
- Explored histories of local businesses
- Visited sites and people of interest
- Enlisted people in senior facilities, schoolchildren, businesses
- Archived the stories
- Archived the oral histories, edited down from two hours
- Provided one small museum with a grant to assess how programs affect visitor experience
- Established a relationship that could be retained going forward

Seeking success beyond your zip code requires a map, good eyesight, and—let's be realistic—creativity. Developing loyalty in new territory takes breakthrough writing and talking. Then, it requires a shift of mindset on the part of a wider audience of prospective donors and members: They have to be creative in re-imagining Your Museum as Our Museum.

Starting at page one—the home page—Seymour Marine Discovery Center in Santa Cruz, California, asks for a new look-see. The banner says:

> "Join over a million others who have touched a shark,
> gone behind-the-scenes at a real marine mammal lab, and
> discovered the next step in their conservation journey."

Then the photo captions sound different:

> "Forum highlights role of insurance in climate disasters"

> "Humans and housing density are the leading cause of death for local pumas"

Insurance! Housing density! This is new language for a science museum. It suggests to people from a radius of more than fifteen miles that they plan a different visit and learn to love a new museum. It banters with prospective supporters who think differently. The action line gets down to business:

> "Support the Seymour Center. Spread marine science
> education throughout our community and beyond."

HANDS ACROSS THE BORDER—REACHING OUT FURTHER

Hagley Museum and Library, in Wilmington, Delaware, focuses on the history of business, technology, and society, from early waterwheel-powered textile mills and E. I. DuPont's gunpowder works to today's technology. Hagley's range of fundraising projects, from cash donations to tree-naming, targets the world: "This support enables Hagley to share its programs and collections with visitors from around the world."

With the world just a link and click away, many museums can establish their brand as global-ready:

- Identify staff or volunteers available for immediate language assistance
- Provide the front desk with brochures in a second language
- Show country of birth origin flags near exhibits (think of the leader board in sports)
- For volunteers or staff who speak a second language, indicate it on their badge

Professional associations and their conferences stretch borders intellectually. Don't let attendees return home without getting their names:

- Keep a stack of brochures, with your contact information and a locator map, at the sign-in counter
- Display a QR code on a large sign to access your business card quickly
- Capture contact information—and comments—on a laptop
- Add attendees to your database
- Send a thank-you note to attendees

SOCIAL NEEDS

In big cities, many families find museum programming inaccessible, and Hammer Museum in Los Angeles doubled down on a fundraising project plus long-term relationship building.

K.A.M.P. (Kids Art Museum Project) Family Fundraiser introduced multiple generations to "local painters, sculptors, architects, and creative types" in workshops at the museum. Parents showing and telling their children about philanthropy—that's long-term relationship building at its best!

Hammer Museum is an art museum. Other genres of museums can create their own brand-connecting events that engage young people in the pleasure of giving, such as:

- A fun fundraising event around a social cause children will understand
- A named program connecting a cause to your museum's brand
- A family discussion group on a local issue

Membership confers valuable emotional rewards, including connecting with like-minded people. Isolation continues to be a major health problem in the United States, according to the Surgeon General, and connecting people is a goal museums can realistically achieve. It's part of the development process.

Consider the repeated iterations of "connecting"—interacting, joining, participating, discussing—found in this testimonial to Skirball's discussion groups:

> "Community, connection, and exploration are strong values for me. I find all this and more at the Skirball . . . interacting with young feminists at a Gloria Steinem talk, joining a multicultural Seder . . . [participating] in Skirball classes . . . the book, movie, and current events discussion groups. I come back time and again for the . . . friendly community."

This testimonial also comes with a photo, volunteered by the sender. Photos communicate members and communities much better than paragraphs of words. (Be sure to get releases!)

Other ways to implement events that connect people:

- A book club—choose a different category of book and schedule the club every month—or week
- A film discussion group—categorize films by genre or subject and offer them every month
- Current events—review the news every week

Social causes are so compelling, it's important to be careful to not let them overpower the museum addressing them. The Skirball states its mission of connection on its home page: "You belong at the Skirball! Participate in a warm and welcoming community at a place that's rooted in Jewish tradition and designed to be an oasis for all."

FOLLOWING UP

Theater companies do an excellent job of following up with attendees: "Thank you for attending. . . ."

- How would you rate the performance?
- Did the scenery help your enjoyment of the play?
- Which characters impressed you?

These are thought questions. Rather than expecting a response, they prompt attendees to remember and engage a little longer with the theater company. The Chicago Botanic Garden sent a similar thank-you note, acknowledging "the largest single gift in its history," and it went to the entire mailing list: "With this generous support, our scientists will be able to curate and continue building world-class seed and pollen banks, help prevent the loss of genetic diversity in botanic garden collections, and train new conservation scientists."

This note engaged readers not just in giving, but getting, value. Small museums also can demonstrate expertise, good management, and fiscal responsibility with the same transparency. These are good relationship starters:

- Thank you for registering for this class. Your fee contributes to the maintenance of our dedicated classroom for all our courses.
- Thank you for attending the first of our five-play series, which continues next month.
- Thank you for participating in our annual Walk the Talk. Your time and generosity help support our learning program.

Colleagues and competition in arts organizations are sources for borrowing and adapting fundraising ideas. The competition is friendly and beneficial to all. Libraries and museums follow many parallel paths. Their programs start early in

developing relationships. Children's programs endure and spread their message to years of siblings. Library book and film discussion groups are well-conceived and executed, and some run for many years.

LOCATION

A relationship based on location already exists between Tenement Museum and many New Yorkers—in all its boroughs—who know families of immigrants to Manhattan's Lower East Side. In a tenement building there, immigrants lived, worked, and flourished from the 1870s through 1930s. That building still exists. The museum's brand has always clearly focused on the stories—the New York and American stories—of these families. Tours of their actual apartments on Orchard Street have been offered for years. During the pandemic, virtual tours were quickly assembled and announced in e-newsletters. The virtual tours continued throughout a massive, long-term renovation. All virtual tours carried an invitation to become a member—which is both development and fundraising.

The museum's "Rebuilding Our Foundations" gala already had a deep reservoir of goodwill. Their ongoing proof of sustainability appealed to savvy supporters who like to back proven-successful enterprises.

Does your museum have a meaning-full location?

- Address or street name?
- A specific or memorable view?
- A district such as Old Town, New Town, Station District, or Park Corner?
- A locally known location may already have started relationships for you.

THE FUTURE

Prospective donors look for specific future plans, which demonstrates a businesslike approach to growth, the toughness to focus on the details of change. Future plans show how the museum's brand vision endures.

Georgia Writers Museum, on its Donation page, lists specific, compelling reasons and uses for donations:

- Funds ongoing costs associated with operating a museum in a historic building
- Supports the museum exhibits of 69 Hall of Fame authors and research on the nine featured authors from the Lake Country
- Ensures our website is reviewed and updated monthly for vital software updates and easy access
- Maintains our customer relationship database each month, helping us send emails and schedule programs
- Manages our social media each month, keeping you up to date

Other narrowly focused museums can learn from the details that power the brand of Georgia Writers Museum.

How do museums honor the future when they're so clearly historic—and old? Pennsylvania Academy of Fine Arts, in Philadelphia, describes their singular brand by associating age with firstness. PAFA proclaims itself: "The First Art Museum and School in the United States." And: "For more than two centuries, the Pennsylvania Academy of the Fine Arts has played a pivotal role in defining the future of American art." And "PAFA First." The lines are repeated on every web page. First isn't just the beginning of a long history; it's a positioning for the future. And here's the punchline that every museum of any size and genre should emulate:

> "Your gift ensures that PAFA, the nation's first museum
> and art school, will thrive for generations to come."

Museums of any size, genre and age can adapt the PAFA credentials:

- American (or ethnic, country of origin) institution
- Deep roots
- Enduring
- Long history of success and growth
- Strong foundations for tomorrow's growth

Donors in the top tier of giving look for security, growth, and a future for the institution. They love their cause. That's why they're called philanthropists. And not just in the City of Brotherly Love.

Here's another example from a museum that had its telescope on the future: "Brilliant: A Fundraising Fete." Development of donors started with a showy kick-off that quickly got down to business. As Minneapolis's Bakken Museum says: "Skip the chicken dinner and join us to experience ... and support inquiry-based STEM education." Future was on the agenda. After the obligatory passed appetizers, cash bar, silent auction, and open grounds: "experience our nationally recognized education programs and support inquiry-based STEM education."

Supplementing the high-level meet-and-greet with The Bakken Museum's board and president:

- Experiments and demonstrations presented by museum educators and curators to spotlight what we do best—inspire innovators
- Fundraising games
- American Sign Language interpretation available throughout the event

For museums of other sizes, locations, and genres, here are some other ways to demonstrate solid plans for change:

- A sculpture or drawing demonstration showing trials, errors, and re-dos
- Historic house objects that show how life changed through history
- Games to suggest how things will change in the next 10 years
- Video of young people telling what they want changed
- Recipes made with insect protein (really, many will want to try it!) or recipes made with hydroponic vegetables
- A guest appearance with influencers

ASSESS YOUR MUSEUM'S RELATIONSHIP DEVELOPMENT

This is an assessment for museums to conduct on their own. Even if you opt for a professional consultation, conduct a self-assessment first. Talk to colleagues, the board, other stakeholders. This is a long questionnaire because it requires relationship development and branding:

- What do we offer of value (e.g., learning, entertainment, satisfaction, socialization, family experience) to encourage membership?
- What do we lack that other institutions offer?
- What do we take special pride in that would motivate a membership purchase?
- What do we convey to our volunteers about relationship development?
- What first impression do we make to visitors both in person and online?
- What do we communicate in the lobby that might discourage a budding relationship?
- What do we promote to school educators about membership?
- Do we exhibit at facility-rental events to motivate return visits to exhibitions or performances?
- Do we present guest speakers and topics that will start a relationship with ticket holders?
- Do we know about philanthropy being passed along to succeeding generations?
- What do we learn in our contacts or chats with prospects?

And to be frank:

- Have you talked recently to anyone you don't know; who isn't your age or education level; who is learning- or mobility-challenged; who doesn't speak your language as a first language; who isn't of your culture, skin color, or race?
- Do you know "diverse" people?

Continue assessment with:

- Have we built relationships with prospects based on our shared values?
- Are solicitations made only after we've established these relationships?
- Do fundraising events such as seasonal celebrations or galas include clear connection to our brand mission, values, personality, and reputation?
- Do fundraising programs (e.g., ticketed talks, author visits, personal tours) emphasize the connection to our brand reputation?
- Are "Plus-One" names (people who attend an event with the person on the mailing list) added to subsequent mailings? Have we developed a relationship with them, too?
- Have you engaged members after signing them up?
- Are volunteers kept in the loop when they aren't available?
- Do we have contacts in other cultural organizations in our town or region?
- Do we have collaborative relationships with other organizations?

REFERENCES

"A Transformative Gift for Plant Science," Chicago Botanic Garden, view.enews .chicagobotanic.org [accessed May 22, 2023]

"Animal Adventures," Indianapolis Zoo, www.indianapoliszoo.com/learn -explore/animal-adventures/ [accessed May 8, 2023]

"Brilliant: A Fundraising Fete," August 17, 2023, Bakken Museum https://cbo.io/ bidapp/index.php?slug=tbm [accessed June 8, 2023]

Carter, Carryl H. "Member Moment," Join the Skirball, Skirball Cultural Center www.skirball.org/join [accessed July 25, 2023]

"Donate," Join & Give, Georgia Writers Museum, www.georgiawritersmuseum .org/donate/ [accessed August 16, 2023]

"Giving Opportunities," Support Hagley, Hagley Museum and Library, www .hagley.org/support-hagley/giving-opportunities [accessed July 21, 2023]

"Help the NECWM Bring Seth Plumb's Uniform Home!" GoFundMe [accessed July 17, 2023]

"History 21" (podcast), Anoka County Historical Society, https://anokacounty history.org/history-21-the-podcast-show-notes [accessed August 8, 2023]

"K.A.M.P. Family Fundraiser," May 23, 2023, Hammer Museum, https://hammer.ucla.edu/kamp [accessed May 8, 2023]

"Membership," Online Store, Adams Museum, https://fareharbor.com/embeds/book/deadwoodhistory/items/397470/calendar/?full-items=yes&back=https://www.deadwoodhistory.com/&a=yes&g4=yes [accessed July 24, 2023]

"PAFA First," Pennsylvania Academy of Fine Arts, www.pafa.org/support/pafa-first [accessed June 29, 2023]

"Rebuilding Our Foundations," May 2023, www.tenement.org/gala/ [accessed August 9, 2023]

Robinson, Bryan. "U.S. Surgeon General Cites Loneliness as Serious Mental Health Hazard in New Report," *Forbes* magazine, May 6, 2023 [accessed August 10, 2023]

"School Program Donors," The Barnes Foundation, www.barnesfoundation.org/teachers [accessed July 26, 2023]

Seymour Marine Discovery Center, https://seymourcenter.ucsc.edu/2023/03/ [accessed May 10, 2024]

"Your Support Makes a Difference," Pennsylvania Academy of Fine Arts, email sent to mailing list, June 29, 2023

11

Data

Face the facts! Data is simply information, and museums need more of it to maintain the brand identity they have, stay relevant as audiences and stakeholders change, and look forward to new possibilities.

What information do you need? What will it do for you? How do you translate it into action? This chapter will inculcate you and your staff with a sensitivity to data. It will remind you to discuss and interpret data because information functions best when shared. You should soon be seeing data lurking everywhere and announcing regularly: "We need more information."

Among the places we look are:

- Museum visitors, inside and online
- Email and newsletters
- Membership
- Educators
- Libraries and archives
- Social media
- The museum store
- Business partnerships (tsunamis of information!)
- QR codes

Your brand flourishes with data. Your stakeholders—visitors, members, staff, educators, donors, partners and sponsors—demand it.

MUSEUM VISITORS

At your website, visitors hold a privileged place in the hierarchy of data sources: They're already interested in your museum. A range of creative data gathering projects shows how museums acquire insightful information. At Blanton Museum of Art, in Austin, Texas, an online program allows web visitors to "collect" their favorite works online:

"Click the Favorites tab at the top. Choose Sign In to create a login and register your account. You'll receive an email to authenticate your account before logging in. You can save your favorites by Selecting the Heart Icon below an artwork. To Share your favorites with others, choose Edit below the favorites folder you want to share, and it will appear in our Community Favorites."

Each link supplies a different kind of information about online visitors. Museums always interpret information in their own way, and for their specific needs. Let this inspire you to think in nuances about the information helpful to you.

Annual reports are exemplary repositories of information because of the new trend to graphically display the numbers that represent progress and initiative. This format challenges museums to think creatively in interpreting the meaning behind the facts.

In the annual report of Frist Art Museum, in Nashville, Tennessee, data is presented in a graphic that announces the fact and lets the reader interpret it:

- "Sixteen is the number of 2022 interns: 1 in design; 2 in communications; 5 in curatorial; 2 in high school program; 1 in editorial; 5 in education and engagement." Analyze further: What were comparable numbers in prior years? What are popular internships? Why does your museum need interns in these departments?
- "4,327 Memberships and Renewals; 1,307 new; 8,125 households." Analyze further: numbers in various age brackets; numbers in membership levels.
- "143,148 total guests. 20,796 are under eighteen." Analyze further: What does a museum infer from these numbers?
- "9,967,473 Social Media impressions." Analyze further: Which platforms get the most comments? Does length or accompanying visual boost reposts?

A museum that wanted to analyze this kind of information more granularly might ask:

- How many are out of town?
- What section of our museum did they visit?
- Did they make store or cafe purchases?
- How many were on school trips?
- Do any social media followers stand out? Are they influencers?
- What is the number of followers of posts in comparable museums?

Exercise for your museum professionals: Analyze these numbers published on the Frist Art Museum website with an eye to comparable programs at your museum:

- 13,351 total tour attendance
- 700 tours
- 5,157 public programs attendance
- 92 public programs
- 8,650 Education & Community Engagement attendance
- 61 programs
- 990 attendance for family programs
- 12 family programs

Fort Wayne Fire Museum collects artifacts of the Fort Wayne Fire service and teaches and promotes fire safety and prevention. Although its legacy engines and gear are old, its mission is up-to-the-minute. Scroll down the About Us and you'll find a mission and 501(c)(3) information; a brief description of collection and displays; dates, hours, and tour information. And hard facts:

Annual guests: 3,000
Board: 15
Staff: 6
Years: 48

Site visitors will interpret this as they will.

Data tells stories. Here's another exercise: What kind of story would a selection of numerical data tell about your institution? This is not a call for cold facts but rather an invitation to depict your museum based on solid information. It's a creative assignment, a reminder that data—sometimes an underappreciated word—sparks the imagination.

The Basque Museum & Cultural Center in Boise, Idaho, wants to locate parents and grandparents of actual visitors to its Basque school in Boise. These are visitors with a strong connection to the institution and all it stands for. The link is so strong, it extends across generations, a brand with an abundant birthright: "If you or your children/grandchildren attended Boiseko Ikastola, we want to get your contact information so we can commemorate 25 years with all the alumni and friends."

EMAIL RECIPIENTS

People who are on your mailing list are golden; they aren't just names, they're followers. Appearance on a mailing list means they have inquired about a program, acquired a ticket, reserved a space, purchased merchandise, dined at the

cafe, queued up for a popular exhibition, or joined as a member. And that's just the beginning of the information you can glean about your visitors. As you send them more news and updates, you will learn even more. Here's how Abilene Zoo keeps these valued readers close: "Thank you for subscribing. Stay tuned for news and updates delivered straight to your inbox."

Saying thank you is a powerful way to begin a loyal friendship. Signing up is so easy that Abilene Zoo will remind you of it immediately with a welcome email. The logo is reproduced so that in the future you recognize it in all e-newsletters, social media posts, signage, third party communications, and—for members and supporters—targeted solicitations.

Look the data points in the above paragraph:

- Name
- Email address
- Date of first response to request to sign up
- Content of email that led to signing up for more

Consider the ongoing information gathered in subsequent emails:

- Date(s) of continuing interest
- Types of programs that motivate clicks
- Dates of various events that prompt opening of an email
- Addresses that email is forwarded to
- Graphics of the sender's logo, recognizable in all other future communications

MEMBERS AND MEMBER SOLICITATIONS

At Conner Prairie in Fishers, Indiana, a solicitation newsletter item included this data:

> "Gifts of any size make a difference. (Did you know it costs only $35.31 to provide a bale of straw for our animals' bedding? Or $12.47 to grow new heirloom plants for our gardens?)"

Interesting and informative solicitation messages collect data, as well as money:

- Amount of donations—can be tracked yearly, compared year on year
- Tier levels indicate level of involvement
- Geographic area of donors
- Relative appeal of selling points like "bales of straw" or "heirloom plants"
- Contact information on friends and colleagues of supporters

This is data that museum donors, corporate sponsors, board members, scholars, in-kind donors, and funders request. Museums can use the information to operate now and in the future.

About corporate sponsors: They're important not only for their donations but for their seal of approval within the community. Every nonprofit prides itself on corporate validation. Tellus Science Museum in Cartersville, Georgia, thanks corporate supporters, and showcases them, by showing their logos under a "Corporate Sponsors" banner on every email.

EDUCATORS

Museums and educators are natural partners in the challenge of long-range learning. Every field trip and exhibit-based lesson plan adds to the community of learners. Of course, you have a database of them. When it comes time to analyze this information—and, of course, you will make time for analysis—look at the information your museum has acquired:

- Names of schools that scheduled a tour
- Subjects they trust the museum to enhance
- Specific exhibits that educators in both institutions agree on
- Grade of students—elementary through high school, undergraduate and beyond
- Geographical range of schools
- Questions generated at end of sessions
- Fields of inquiry being explored by scholars

In thinking of scholarship and learning—at all ages—Crystal Bridges Museum of American Art defines its role like this: "The Library provides the highest quality of access to resources and services, as well as commitment to the highest ethical standards for privacy, copyright, intellectual freedom, and preservation of information."

A museum library is a democratic sanctuary for people who want to learn and need a welcoming place to do so. Use the information you get wisely.

Thinking of how much educators add to the richness of museum programming, it's fitting to thank them richly. Tenement Museum in New York offers a special way for families to gift teachers: "We are honored that you are thinking of sharing a Tenement Museum classroom experience with a teacher in your life! Our virtual field trips range in price from $150-$350 depending on the class size and program."

As parents fill out the requisite forms, teachers are identified, tours are created and scheduled, and everyone benefits. Parents learn about the museum, students experience a special trip, teachers are celebrated, and new concepts are learned. The data talks and reveals insights into:

Early data management system. Information like this is gathered throughout the museum; it also keeps brands vital in the present and future. *Department of Commerce and Labor. Bureau of the Census. 7/1/1903-1913. Alabama: BALDWIN County, Enumeration District 10, Sheet No. 5A.*

- Parents and their students
- Teachers and their students
- Zip codes
- Money they're willing to spend
- Reason for giving this gift
- Why certain teachers are special
- What parents have to say about school, education, the partnership, and anything else they want the museum to know

Inventive enterprises engender different dynamics, and in the parent-student-school nexus. originality is welcome. Data will tell how new ideas play out. Data guarantees that however an experiment plays out, knowledge will be gained.

LIBRARY

When searching for information, act on facts. The fact that so many museums have a library tells you something about consumer demand for a dedicated information center. When you realize the many audiences that use a museum library—scholars, researchers, academics, historians, scientists, writers, artists, designers, entrepreneurs, amateurs as well as professionals—act on that fact as you look for data.

Invite visitors to submit a form—simple or comprehensive—that gathers useful information such as:

- Their interest in the library/subjects of interest
- Level of expertise, such as elementary school student, graduate school, research scholar, professional, or informed amateur
- Interest related to a specific exhibit or exhibition
- Amount of time visitors spend in the library
- Geographics of library visitors
- Reasons for this visit

This information yields subtleties in audience profiles that usual categorization misses.

The scholarship component of Winterthur Museum, Garden & Library, in Winterthur, Delaware, is notable for its breadth of inquiry:

> "We encourage new and critical approaches to a broad range of scholarly topics, including: material culture studies, social and cultural history, social justice, museum practice, art history, literary studies, American studies, design history, the decorative arts, landscape architecture and design, consumer culture, and conservation studies covering global topics from the 17th to the 20th centuries. We also support fellowships designed for artists, writers,

filmmakers, horticulturists, craftspeople, and others who wish to examine, study, and immerse themselves in Winterthur's vast collections in order to inspire creative and artistic works for general, non-academic audiences."

Count the audiences in the above paragraph. Just as they seek information, they provide it for the museum.

THE STORE AS DATA COLLECTOR

Merchants through history teach us: You can't say "buy me" and expect customers to follow your command. You must offer something they want, and then assess why it is irresistible. So while museum stores are proven loyalty stops and money-makers, they also provide an opportunity to learn more about audience interests. Falmouth Museums on the Green offered an unusual holiday purchase: "The Very Unmerry Christmas Tour." This one-day experience, conducted by the museum director and research manager, journeys to a 1790s house that followed New England tradition and didn't celebrate Christmas until the mid- to late-1800s. It's a wonderfully creative and intensive project and you can imagine the data it must have generated.

- What new names were added to the list of store visitors?
- What new zip codes were added to that list?
- Who is attracted to bold new ideas?
- Is this a family or individual gift?
- What did they buy at the store?

It's an expansive addition to the traditional Christmas market because, like all new ideas, it appeals to different audiences: amateur historians and other kinds of curious people. Museums can't predict who will sign up for offbeat events, and that's the whole point; those who do sign add another column to your mailing list data set:

- Email addresses
- Experience shoppers
- Shoppers who are physically in town
- New idea buffs
- Families who enjoy history
- People with larger chunks of available time

Every time a museum offers Gifts for Mom, Fun for Kids, history stories, maritime tales, art supplies, architecture-related gifts, music, age-appropriate science games, and stocking stuffers, new data on museum users becomes available.

PARTNERSHIPS

Longwood Gardens, in its major redesign of landscape and buildings, not to mention programmatic activities, calls attention to the partners and suppliers whose audiences overlap with the museum's. A partial list of collaborations mentioned on its website:

- Challenge Program, a Wilmington, Delaware, nonprofit that provides vocational construction skills training to Delaware's young people
- A Brazilian landscape architect
- Landscape design studios
- Keeper of the Living Collections at a university arboretum
- Director of Science
- Director of Conservatories and Horticulture Design Horticulture Specialty Growers (aquatics and bonsai)
- Engineers of new state-of-the-art studios
- Crane operators that lifted three 25- to 30-foot-tall cedars and plunked them into their slots
- Gardeners who planted 43,000 square feet of sod
- Installation of trellis for twenty-seven espaliered magnolias

Each one of the individuals involved connect to an industry network of museum suppliers—a diversity of audiences. Every person has family and friends. Every supplier has its own contacts. Every professional connects with a universe of colleagues.

That's a lot of connections, and each one belongs in a database.

Partnerships and collaborations also result in business meetings and events, such as conference room meetings, lunches, and auditorium conferences; they all produce mailing lists and attendee rosters. Once having attended a business event, they can be added as names of those who will visit, buy memberships, donate, and sponsor. Look at the new information you can collect:

- Business addresses
- Names and titles
- Company names
- Ideal dates and days for business visit
- Specific interests
- Point person names and title
- Geographic range of attendees

Put a laptop on a coffee and donut table to collect their data.

Tamastslikt Cultural Institute, in Pendleton, Oregon, is notable for "still here" professionalism. This cultural history museum, rich in Native American

heritage, is not clinging to history with its state-of-the-art conference facilities. Tamastslikt offers a new 250-seat auditorium, a catering service from its established Kinship Cafe, and a selection of different-sized rooms. Native museums are important in spreading the tenet that Native Americans aren't history; they prosper today, and invest in the future. They'll probably get a lot of rentals—and data for further growth.

QR CODES

QR codes complement—not replace—printed messages. QR codes turn any flat surface into a deep store of information. It converts all these signs into data troves:

- Front desk handouts
- Mailings
- Hours on front doors
- Handouts at lectures
- Exhibit labels
- Cafe menus
- Store merchandise tags

Without disturbing the layout and design of a printed piece, this thumbprint-sized square opens a door to anything.

Here's what is captured by the several QR codes in Page Turner, a new quarterly e-magazine by the Georgia Writers Museum and the Atlanta Writers Club:

- Information about READBowl, a PK-8th grade reading competition
- Engaged readers who play a writers quiz and word game
- Viewers of TedX talks
- Advertising dollars
- Memberships
- Subscriptions orders

The audiences added to Georgia Writers Museum mailing list include readers of all ages, writers, Georgia-philes, teachers, children, and families who can now be targeted for programs, talks, store offerings, and donations. The QR code and the magazine reinforce each other in widening the museum's repute and augmenting its mission.

Technology has already morphed a print format to an e-magazine. The QR code adds other formats. Each format adds new audiences. The brand has not changed; the ways of experiencing it have.

QR codes in the service of exhibits is a wonder. Viewers in the museum and readers of print materials can see close-ups, colors, different angles, brush

strokes in paintings, details in fossils, and more. Information about the artist or creator, details in the science or history. And more. The informative QR code will tell visitors about related programs, books in the store, and complementary programs at other institutions.

PR releases of new exhibitions, with a click of a reader's camera, can show some exhibits, not just talk about them.

In solicitation mailings, a QR code opens up the array of giving options:

- Monthly or one-time
- Dedicate a gift in honor or memory
- Credit cards and other payment choices
- Spanish version of donation card
- Check box for receiving emails, rather than having to write in an email address

The insert donation card is an old format, easy to toss aside. For people unaccustomed to writing instruments, their mobile phone is always at hand.

QR codes expand a museum's physical footprint. In suburban Chicago, the local library gets a lot more foot traffic than the museum two blocks away. And the two institutions collaborated on a solution.

The Winnetka Historical Society, in a village of 14,000 residents, mounted a 2023 exhibition in poster format in the library lobby. Many would-be museum-goers saw it and, according to the librarians, stopped to read it. Here's the clincher: They were often accompanied by children. A QR code on the poster links to much more information about the down-the-street museum. It's one of several links between two institutions of learning; they have different but compatible audiences and are not so far apart after all.

When it comes to donations, Scan Me persuades gently to Give Me. It's immediate, and offers many more options than a newsletter item, or addition at the end of a ticket order.

These choices produce information that, when analyzed, offer different insights:

- A wider range of price options that give a clearer picture of what prospective donors are willing to pay
- Timing of payments (e.g., one-time, monthly, yearly)
- Designated memorial or celebration
- Translations into Spanish or other local first languages
- Appealing photographs (you can easily switch visuals to learn what best engages potential donors)
- Check box to receive emails

There's not room on an insert card or email announcement for all these choices, but QR codes expand options for everyone.

SOCIAL MEDIA PLATFORMS AND APPS

Here today, more tomorrow, outdated the day after. After you've internalized this reality, learn which platforms your audiences and other museums use, and try to discover what for. Follow your own posts. Learn what your fans and critics think. Social media pours out information hourly, some of it quantifiable, all of it worth discussing internally.

Here, in order of preference, are the top platforms globally today:

Facebook—has the most active users; ranks among apps that consumers spend the most amount of time on, according to Shopify
YouTube
WhatsApp
Instagram
WeChat—China's version of WhatsApp
TikTok—30 percent of Americans aged 18-29 get their news on TikTok (Pew Research)
Telegram
Snapchat
Kuaishou
Qzone
Sina Weibo
QQ — 574 MAUs
X (formerly Twitter)
Pinterest
Reddit
LinkedIn
Quora
Discord
Twitch
Tumblr
Threads
Mastodon
Bluesky

While looking at the content and followers of each platform, pay special attention to content creators; their intuitions, innovations, and dedication have the full attention of the marketplace that museums are a significant part of. The creators on YouTube, TikTok, Instagram, and whatever comes next supply information—data—on how the next wave of consumers, including museum consumers, think.

AI AND WHAT TO DO WITH IT

To get a grip on artificial intelligence (AI), generative AI, and their numerous newsmakers and analysts, follow the example of all workers in new endeavors: read, talk to others, listen, and discuss. There's a lot of information to gather before using this new way of collecting and analyzing data. To quote an AI researcher, entrepreneur, and author:

> "AI is useful. It is inventing and generating knowledge: the defining feature of our species, the engine of civilization and the basis of the economy. . . . AI can't and be judged on what is publicly available today. . . . Zoom in and some of the details are overblown. Zoom out, and you'll find that we're on the brink of significant change."

There will come a time when you can ask a chatbot for the data you need. However, your job continues to be essential; what do we need to know and why? As with even the simplest forms of information gathering, AI is most useful when museums can articulate and organize their questions flawlessly.

Data, whether from AI or a website questionnaire, is powerful and enticing. The museum's task is also formidable: knowing what to ask and why.

DATA CHECKLIST

Like branding, data should be integral to planning and executing new initiatives. While asking "Is this idea on brand?" also ask "What data will it supply?" Will it supply:

- More audience insights
- Characteristics of new audiences
- Stakeholders
- Trends of today
- Previews of the future
- Attitudes that yesterday were foreign to us
- Real numbers to be analyzed and acted upon
- Hypotheses (the what-ifs that drive curiosity and learning)

REFERENCES

"2022 Community Report," Frist Art Museum, https://fristartmuseum.org/wp-content/uploads/2022-Frist-Community-Report.pdf [accessed July 23, 2023]

"Abilene Zoo Welcomes You," email to mailing list August 8, 2023

"About Us," Fort Wayne Firefighters Museum, www.fortwaynefiremuseum
.com/about-us [accessed October 31, 2023]

"Ask Us," Winnetka-Northfield Public Library, www.wnpld.org/about/ask-us
[accessed December 3, 2023]

Bernhardt, Greg. "Top 10 Most Popular Social Media Platforms," October 18,
2023, Shopify, https://www.shopify.com/blog/most-popular-social-media
-platforms [accessed December 16, 2023]

"Blanton Collection Highlights," Blanton Museum of Art [accessed April 25,
2023]

"Boiseko Ikastola Is 25 Years Old," email to mailing list, July 24, 2023, https://
mailchi.mp/8db5bdaa6e4b/boiseko-ikastola-anniversary?e=8d4ebfec9d'

"Gather," Tamastslikt Cultural Institute, www.tamastslikt.org/explore/#gather
[accessed December 10, 2023]

"Gift a Virtual Field Trip," Tenement Museum, www.tenement.org/gift-a-virtual
-field-trip/? [accessed November 17, 2023]

"It's the End of Tornado Season in GA!" Message to a mailing list, May 23, 2023,
Tellus Science Museum

"Library," Crystal Bridges Museum of American Art, https://crystalbridges.org/
library/ [accessed December 11, 2023]

Miranda, Carolina A. "Newsletter: QR codes in museums can be a blessing.
They are also a curse," *Los Angeles Times*, January 22, 2022, https://www
.latimes.com/entertainment-arts/newsletter/2022-01-22/essential-arts-qr
-codes-in-museums-blessing-and-curse-essential-arts [accessed Decem-
ber 17, 2023]

Mobley, Katie. "Longwood Reimagined: New Moments, New Excitement"
(blog), October 25, 2023, Longwood Garden, https://longwoodgardens.org/
blog/2023-10-25/longwood-reimagined-new-moments-new-excitement
[accessed December 10, 2023]

Oladipo, Tamilore. "23 Top Social Media Sites to Consider for Your Brand in
2024," November 20, 2023, Buffer, https://buffer.com/library/social-media
-sites/ [accessed December 16, 2023]

"Page Turner," Fall 2023, Georgia Writers Museum, www.georgiawriters museum.org/page-turner/ [accessed November 8, 2023]

"Research & Scholarship," Winterthur Museum, Garden & Library, www.winter thur.org/research-and-scholars/ [accessed October 19, 2023]

Sample, Brooke. "Suing TikTok won't solve our social media problems," Opinion of the Week, *Bloomberg News*, November 18, 2023, from a mailing list [accessed November 28, 2023]

"Search our new digital archive," Winnetka-Northfield Public Library, https:// vitacollections.ca/winnetkanews/search [accessed December 3, 2023]

Shirky, Clay. "Creation Story," *The New York Times Book Review*, November 5, 2023 [accessed November 23, 2023]

Suleyman, Mustafa. "AI Is Now Cooking, But It Shouldn't Be Overdone," Opinion, *The Wall Street Journal*, November 8, 2023, www.wsj.com/articles/the -death-of-ai-is-exaggerated-efficiency-chatgpt-productivity-gain-951b1a26 ?st=sej7ezk6cgd7hqq&reflink=article_copyURL_share [accessed November 8, 2023]

"The Very Unmerry Christmas Tour, December 21, 2023," message from a mailing list, Museums on the Green, Falmouth Historical Society, "https:// museumsonthegreen.org/event/the-very-unmerry-christmas-tour/

"Your Gift Goes Further during Conner Prairie's Days of Giving!" Conner Prairie, e-mail to list, September 8, 2023

12

Video

Think of videos as anecdotes, used by writers or speakers to liven up a speech, chapter, lesson, or demonstration. Use videos to animate a report, handbook, or presentation. Insert videos for humor in a workshop. Lead off with a video to highlight human interest in a solicitation, awards ceremony, or appreciation event. For museums, videos corroborate the reality that created any object or exhibit in your physical space. Virtually, videos are the stories that keep museums alive.

The mere presence of a video adds to your brand's contemporaneity. Videos have a huge branding advantage: popularity. Look at all the museum websites that have YouTube icons on their home pages. Do not rely on just the allure of videos to bump up your brand. There are seven good reasons to bring out the video camera:

- Set your objects and exhibits in context, historical and physical
- Complement objects in exhibits
- Tell the story of intangibles, historic movements, projects not completed (buildings), organizations (American Red Cross)
- Show real people, speaking to real visitors
- Extend the museum into the home
- Show rental spaces
- Present niches and treasure

Of all the requirement of planning a video, the least important is a big budget. The most important is a connection to your brand:

- Connect every scene to the museum's mission, goals, history, or reputation.
- Use closed captioning.
- Select visuals that say museum, even with sound and CC turnout off.
- Supplement visuals with words when necessary.

- Hire real people, speaking naturally.
- Shoot the video on site, in an interesting part of the building or grounds.

SET YOUR OBJECTS AND EXHIBITS IN CONTEXT

Battleship New Jersey Museum and Memorial stands out as a museum that needs its context. Preserving and displaying the history of the U.S. Navy in World War II is an enormous job, even if the museum is the size of a battleship. How to portray the enormity of war, the complexity of a battleship, and the thousands of military people engaged in thousands of years-long tasks? There are several features of the Battleship New Jersey's portfolio of videos that organize its content and programs:

- **Understanding.** The stationary museum comes alive with scenes of ships at sea, sailors on the bridge, and engineers in the radio room.
- **Engagement.** Real people using real words draw in viewers with new vocabulary and interesting terms.
- **Action.** Because it is memorable!
- **Strangeness.** Because it ventures into exciting new concepts and engenders a "guess what I saw!" reaction.

Museums many times smaller than a battleship can follow the same guidelines, on much smaller budgets. For instance, the Battleship New Jersey keeps its videos short, another good rule to follow.

Context is more complex than one might think. Where does a museum's physical context start and end? For the Sonora Desert Museum in Tucson, Arizona, its landscape covers both dry mesas and green forests. The museum explained its locale with a video of an irresistible symbol: a porcupine. As the museum narrator stood with bare hands on a stand next to a ball of bristling spikes, the physiology of this native animal captures attention while viewers learn about attacking predators on dry land and escaping them up in the trees.

The Idaho Potato Museum also needs a context and backstory; most people don't appreciate the brown tuber. However, so much was built on the spud, including the state of Idaho and the American French fry, that there's a story needing to be told.

There are many industry museums—auto, air, furniture, and fashion, to name a few—and their contribution to American entrepreneurship is important. Idaho Potato Museum pays respect to its roots with videos. They are folksy and educational:

- One potato-farmer's piece of machinery
- A local narrator describing how it works

- A location on a street in Blackfoot, Idaho
- Brief, concise, and informative in three minutes
- Historic, a glimpse of potato farming in the 1940s and 1950s
- Visual
- Focused—the point is the success of Idaho potatoes in the American menu

Each detail of the video reinforces the brand of this down-to-earth museum. Videos excel at close-ups of details, and all museums have details worth discovering and explaining.

To John Updike, two-time Pulitzer Prize–winner and writer of one novel a year, his small-town American roots were everything. If one is not actually passing the dogwood tree in the yard of the John Updike Childhood Home, or climbing the steps to his bedroom where he imagined, video takes you there. An enterprising writer for the local paper photographed the entire interior of the National Landmark house, where the young writer's "artistic eggs were hatched." The tour of this Updike home really takes off on the second floor where, through the child's bedroom windows, a drone with a camera captures a bird's-eye view of his town. Videos support the large history of even the smallest historic house:

- The approach to the house—its neighborhood
- Trees, creeks, and hills—people are formed by their geography, especially in the sea-to-shining-sea United States
- Details in the rooms, explored by close-up camera shots
- Layout of the rooms—how people brought food from the kitchen, shared small spaces, and went upstairs to dream
- Windows—where the light entered, and curiosity went exploring

Museums that promote their regional affiliations can consider bird's-eye shots to underline the shared community, because drones are an option. Some information is in order:

- Threshold price is $350; at this price, drones work fine.
- If a drone hits a tree, both survive.
- To see how drones work, walk around your neighborhood when the local roofers are working. Many send drones up to assess the situation and are happy to give free information.
- Drones are built to be stabilized and support the camera against blurs.
- Price differences reflect the quality of the image, from very good to uber-professional.
- By experimenting with different camera angles and times of day, you can select the best drone footage.

COMPLEMENT OBJECTS IN EXHIBITS

With over 3,000 vehicles at its peak, LeMay America's Car Museum, in Tacoma, Washington, could rightfully boast of size and thoroughness. It brands, rather than brags, with this home page headline: "America's Love Affair with the Automobile and How it Shaped Our Society."

That brand story is echoed in the opening narrative of the video celebrating its tenth anniversary: "Visitors come from all over the world to learn how they [cars] shaped America's Culture."

The video runs sixteen minutes, and is concisely scripted to capture the automobile's history, technology, and influence on American culture.

Even small museums can translate a small collection into universal importance with:

- Objects. Select objects that visually represent your museum. A nineteenth-century mangle, an eighteenth-century harrow, a jawbone, ledger art. Use them to begin the broad and deep story that expands the image of your brand.
- Focus. If your objects are large, like a ship or architecture, focus on small details that add to performance. If your artifacts are small, like a sampler or harpoon hook, reveal the bigger picture they facilitate. Details in anything from sextants to apiaries shoulder big stories that your curators and educators know how to animate.
- Narration. A narrator can make small stories larger in impact. Audition for narrators who represent your singular brand and love digging out the singular fact. Select people who know the subject down to its details, people who talk easily with facts. Give them a topics outline, rather than a script; they will paint a big, original picture.
- Use local sites that add to your museum's store of information: cemeteries, parks, historic buildings, churches and temples of all denominations

Railroads and the Old West share a dramatic history. Colorado Railroad Museum, in Golden, embraces this history in a museum. Its videos capture the drama, as well as the dates and deeds. The videos time travel to rock-strewn mountain passes, boomtowns and their mines, titans of industry and workers on the rails, Congdon smokestacks and Westinghouse air brakes.

These videos support the museum's brand mission to "convey the rich history of railroading in the Rocky Mountain region" with a mix of simple resources:

- Photos
- Illustrations
- Maps that show trails
- Bios and photos of unsung people

- Contemporary newspaper articles of problems and how they got solved
- Historic headlines of disasters and rescues
- Photos of derring-do experiences
- Camera movement from one still image to another, giving the sense of action and progress
- Narration—the voice of someone who cares

Tall objects present obstacles to learning that video can reach without resorting to a ladder. You may have some of these in your museum:

- An Asian scroll
- A highboy
- A tall clock
- Sculpture
- Trees
- A cornice, arch, capital, dome
- Anything above the eye level of a child

Videos show tall objects top to bottom, often adding details of how they were created. A museum that honors the creation of a work, as well as its result, adds to its mission of interpretation. The video for an individual exhibit should be close captioned, rather than audible, and can be repurposed for use in email, social media, or QR codes.

SHOW REAL PEOPLE, SPEAKING TO REAL VISITORS

Value the human voice, in all its expressiveness. It speaks sincerely, idiomatically, in accents and expressions unique to the museum's place.

At Delta Blues Museum, in Clarksdale, Mississippi, visitors see lots of guitars, photos of the blues greats, and posters of their appearances. But nothing beats hearing Kingfish Ingram talk about the blues from his perspective as a Mississippi guitar player. Where else, besides a museum using video, can blues lovers all over the world hear a native son talk about the "Mississippi thing," "jelly roll king," "blues Clarksdale sound," and "catfish blues"?

The advantage of real people, talking real, is available to any museum. Hearing locals use the right terms, speak with the familiar colloquialisms, and talk to, not down, is delightful. Their enthusiasm echoes a museum's dedication to its mission. The ineffable image of a museum is reinforced by a congenial spokesperson. To prove, rather than promise, your commitment to diversity, the speakers you put on camera speak a thousand words. Here's your chance. Some examples in your community might be:

- Scientists talking about their research
- Military engineers demonstrating their equipment

- Farmers explaining effect of weather on crops
- Fishermen showing the aquatic environment
- Athletes explaining the physiology of workouts
- Longtime residents showing architectural details of their houses

TELL THE STORY OF INTANGIBLES

Some of the intangibles that museums address in their collections and exhibitions include historic movements, sports, and new buildings for their collections.

A point of view, so necessary to a museum's mission and brand, can be a point of contention at any time in the life of an exhibition. Video can present an opinion in a history-based, balanced forum that will enhance the museum's platform, not inflame it.

Consider the video about women artists' under-representation in museums, produced by National Museum of Women in the Arts. This video vividly presents its point of view in visuals and bullet points both reasoned and impassioned. It balances "brazenly inspirational women artists" with the shocking statistics highlighting the absence of women artists on museum walls. For museums wanting to present a fraught subject, video thoughtfully presents an argument:

- On-camera narration by real people, cast for reasoned performances
- Shots of real events
- Comments by diversely opinionated commentators
- Alternating shots of text and action, still photos and charts, maps and actual locations
- Solid data, telling enough so that museum commentary is unnecessary

An effective short video requires that an impassioned message must be edited down to a persuasive one. With a clear objective, simple story line, researched facts, and congenial narration, video can explain all sides of the issues. Good videos are miniature documentaries, and they must maintain that open-minded attitude.

How does a museum convey, on a website, the story, thrill, and tension of a sport? Consider the Museum of Racing and Hall of Fame in Saratoga Springs, New York. For museums that are dedicated to organizations, or concepts, or whose subjects—such as, horses—deserve more than people talk, for fully fluent portrayals of sports, turn to video. There's a lot of material to choose from.

The Saratoga Springs museum, based in a shrine to horse-racing, chose the daunting project of the totality of racing—from foal to finish line to hall of fame. Ultimately enlisting multiple horse owners, trainers, jockeys, and others, the video condensed the magic and hard work into a race-worthy time of just five minutes.

Videos are everywhere in the museum. They're already in good hands, and museums with strong brands will create more content to make the visit even better. *Photo AzmanL Release info: Model and property released*

For museums with less monumental goals, the key is still selectivity. What aspect of your museum would enhance your image and entrance viewers in five minutes? Some starter ideas for the first thirty seconds:

- Identify the objects that most people stop to ponder
- Request docents' feedback on which exhibits get the most questions . . . or giggles
- Select objects that inspire the most questions
- Find recent acquisitions that have interesting back stories
- Ask store assistants for observations of most popular items
- Interview curators for their proudest moments

Speaking of docents, one docent at a recent tour in a major art museum, carried a small tablet to show a video from another source that explained an artwork she particularly liked. That's another excellent use for a short video.

One-room schoolhouses look different, but the life of schoolchildren over one hundred years ago is hard to imagine. Harbor History Museum, in Gig Harbor, Washington, paved the way to comprehension with videos, The Virtual Schoolhouse series. The first video introduces Miss Bennett and the morning salute to the flag, Pledge of Allegiance, and "America the Beautiful."

"Are your fingernails clean? Take off your hat before you come inside." The school day begins, scholars.

For the next seven minutes, an actor playing Miss Bennett, standing at the door of the schoolhouse in Harbor History Museum's collection, shows today's children a classroom and details a life unimaginable to them without an enactment like this.

The schoolhouse clearly sets the scene for a 120-year-old school day. The message is well-written, the actor playing a turn-of-the-century schoolmarm plays her part well. The information is scripted with an interesting tidbit in every sentence. It reflects the brand mission of helping children appreciate the history of their community. It's a fascinating example of how to construct a video. Here's what, in seven minutes, your museum actor, set, and script might deliver:

- Walking in the woods with a scientist to search for and assess specimens for further research analysis
- Mixing colors on a palette, stretching canvas on a frame, buying brushes with a painter to appreciate how paintings happen
- Cleaning shipwreck finds with lab staffers to demonstrate the historical research of maritime museums
- One person, in the room of a historic house, facing the camera and describing the workday of a servant in a historic house

- Renovation and new buildings. If ever museums needed some wizard to see through the walls of a closed off construction site, it's a capital project in progress, and video comes to the rescue.

When the objective of a multi-year capital campaign was about to open its doors in New Orleans, video was an adept vehicle for disseminating the news and connecting it to mission and brand. The National World War II Museum produced a five-minute video that previewed the ambitious three-story Liberty Pavilion, and it had a unique slant: "The museum's vision is to continue the story of liberation, to tell what happens after a war is won, and it is a continuing process." This video, like all good videos, shows and explains not just the grand physical museum, but the mission that informs it.

PRESENT NICHES AND TREASURE

Throughout every museum there are hidden spots that the professionals and staff know and delight in. Collection storage objects. A quiet room, unused on tours. Successful places so well-run, they're taken for granted. A side door and patch of landscape. A tree. A cozy library. A curator's office. A researcher's lab. Video can "bring" people to these places, and shows another side of the museum's brand, in brief snapshots.

EXTEND THE MUSEUM INTO THE HOME

"At home" is here to stay, and it's different than "working from home." At home is where your visitors retell their day, ask questions, and do things together. Museums, wonderful places that they are, benefit from an at-home refresher project. Videos have the advantage of:

- Showing the museum from a different angle, from a couch, chair, or desk
- Engaging a different grouping of people
- Giving the option to visit at different times
- Building on a concept just summarized on sites
- Providing learning from a different platform

During the pandemic in 2020, Berkshire Museum, in Pittsfield, Massachusetts, hosted a "24-Hour Pajama Read-a-thon" and discovered a wonderful way to continue museum learning. It also has the video advantage of real people, holding a real book, and advocating something new: "How to Read a Book at Night."

All museums, any size or genre, could develop a "How-To" video using staff members on location at the museum. Select a visual that relates to the museum—a book from the store, an object being cleaned, a display in the assembling stage—and create a five-minute video story around it. Your

imagination reinforces your brand's reputation. Your spirit of adventure reinforces your brand personality.

SHOW RENTAL SPACES

Strangers! They are the big challenge in branding your rentals for weddings or business meetings. The attendees, though connected to the bridal couple or business, feel no attachment to the museum. It's just a venue. But don't let this lovely space fade from memory.

Wedding rentals provide branding opportunities in two important ways. At the planning stage, on the Facilities Rental page, camera shots of the various spaces acquaint brides, their families, and the wedding planners with the museum's spaces. Video reveals all angles of the rooms, adjacent galleries, and grounds. The panorama allows for not only close looks at table setups and long views out the big windows but forays into a hall of exhibits, the terrace, or a sculpture garden. Here, a little imagination will connect an appropriate object to the wedding or business meeting.

These facilities shots can be embedded in wedding or business invitations, announcements, and blogs. Repetition is good for branding. And pre-event, shots of the museum familiarize visitors with the venue, welcoming them in advance. Good museum branding begins when new people, such as wedding guests or conference attendees, feel comfortable.

As a wedding venue, museums can expect guests from afar. Crystal Bridges Museum of American Art in Bentonville, Arkansas, is accustomed to welcoming faraway visitors to its lush Ozark Forest setting. Its 360-degree pans of Frank Lloyd Wright lawn, Chihuly Reed Bridge, and Great Hall Ceremony, among many spaces, does a grand job of selling rural events. A camera icon superimposed on the photo indicates ideal places amid the greenery for photos.

Osceola County Historical Society, in Kissimmee, Florida, also has a small-town setting. Its video "Church" shows comfortable spaces and ordinary people looking un-posed happy. The video also includes a weathered wood house, a train depot, and railroad tracks leading into the future. This informal, homey site suggests a more casual destination wedding. Destination weddings don't have to be exotic.

Good museums relate to all visitors, and diversity also includes business audiences. They all have family and friends, and it is hoped they all will return at another time as visitors. With some video chronicling of your museum's objects and the meeting, businesspeople can make the connection between the meeting and the museum and take the museum part home. Make the video option available to the meeting planner. Place a video or QR code near the food tables.

National Nordic Museum in Seattle starts the branding of its rentals on its home page with a panorama video, including Fjord Hall, which is available for rental, with, one learns on its Rental page, "one-of-a-kind objects installations . . . that weave[s] together stories homeland and the Nordic experience."

Before planning a business video script and storyboard, bear in mind:

- Museums look different at different seasons; show the museum grounds in a season that matches the event date.
- Give travel times from known landmarks.
- Be clear about where to park, and provide a map to the museum and within the museum.
- Virtual workers may not know each other well. Museum exhibits, with the right narrative, make good icebreakers.
- Show images of some of the hosts of the event, so they know who to ask when they need anything.
- Explain how groups of attendees will interact around the table, or at the refreshment stands.

Select the most photogenic and brand-worthy objects for the video. These stars will serve as the video welcoming committee for the event and the museum. The objects will, of course, relay your museum's story, explain its collection, and reveal its singular personality. That's quite a task for an object, so select one—or its image—to also show at the event with an explanatory label or panel.

BRANDING CHECKLIST

This checklist is actually a pre-check. It will alert museums to difficulties before they happen and manage difficulties before they become headaches. Before the planning starts, ask if the video:

- Has a goal
- Shows a title card with the museum's name in the first few seconds
- Shows objects in the collection that relate to the Museum mission, vision, brand image
- Uses close-ups to show elements that a visitor otherwise couldn't see
- Casts real people in real settings, doing real museum activities
- Has an optimum run time (three to six minutes)
- Includes your neighborhood, town, region
- Tells a story that can be repurposed for other uses
- Shows diversity—of all kinds
- Ends with an action phrase such as "see you at the museum!"

Don't be shy about video. A summary thought comes from the Clara Barton Birthplace Museum: "Think only of the need and the impossible is accomplished."

REFERENCES

"Big Train Tours: Denver, Leadville and Gunnison No. 191 — Colorado's Oldest Locomotive," November 7, 2020, Colorado Railroad Museum, https://youtu .be/ct-Fzv-HPqs?si=67O_pflOBQFKFTn5 [accessed September 4, 2023]

"Bring 'Em Home: Operation Magic Carpet," Battleship New Jersey Memorial Museum, https://youtu.be/BydVUxUScCQ?si=i6EskocHSWJZwROF [accessed August 8, 2023]

"Christone 'Kingfish' Ingram About Big Jack Johnson," Delta Blues Museum, www.deltabluesmuseum.org/field-trip-tour-big-jack-johnson-with-ingram .aspx [accessed August 30, 2023]

Clara Barton Birthplace Museum, www.clarabartonbirthplace.org/claras-life/ #video [accessed August 10, 2023]

Davis, James W. Excerpted from "Aristocrat in Burlap," Idaho Potato Commission, "A History of the Potato in Idaho," Idaho Potato Museum, https:// idahopotatomuseum.com/history/ [accessed September 4, 2023]

"Fierce Women in Art," National Museum of Women in the Arts, https://youtu .be/zHair5dvGOs?si=3kEw3NV8Gq2xdfzb [accessed September 6, 2023]

"Foal Patrol—Thank You," Museum of Racing and Hall of Fame, Saratoga Springs, New York, https://youtu.be/AaQfhNRYm8o?feature=shared [accessed August 31, 2023]

Freyman, Alexa. "Drone Shots of Updike House Featured on Berks Nostalgia," *Berks Nostalgia*, September 17, 2022, John Updike Childhood Home, https:// johnupdikechildhoodhome.com/ [accessed September 6, 2023]

"Geology Collection," Twitter, September 1, 2023, Milwaukee Public Museum, https://x.com/mkepublicmuseum/status/1697353566342828338?s=61&t =t3Ul6X1s-tTHSV3P2dbyjA [accessed September 1, 2023]

"Going to School at the Turn of the Century," Midway School Experience, Visit to Midway 1: Lesson 1 with Miss Bennett, https://youtu.be/EszLJPuvFYk [accessed September 1, 2023]

"John Updike's Childhood Home, Shillington, John Updike Society," https:// youtu.be/OLZPIZN1_KM?si=qu2N1xlKTRR2-baC [accessed September 6, 2023]

LeMay America's Car Museum, https://youtu.be/BUGU9YJZVjw?si=SsrNnd ms-fTrggQX [accessed August 31, 2023]

National Nordic Museum, Rentals, https://nordicmuseum.org/asset/646cf9 a56b939/23_NordicMuseumRentals_Web.pdf [accessed September 10, 2023]

"The National World War II Museum's Liberation Pavilion," National World War II Museum, https://youtu.be/IFkaLX5WwSs [accessed September 6, 2023]

"North American Porcupine," Desert Museum, 2015, https://youtu.be/pQWEh Hsl-DA?feature=shared [accessed September 4, 2023]

Owls Head Transportation Museum. https://youtube.com/playlist?list=PLOtE qoVEoFqWZGZDxU_sBgMw-jeDLrVW9&si=ePbaNJaZqPMCdKeh [accessed August 31, 2023]

"The Potato Cinema," The Tour, Idaho Potato Museum, https://idahopotato museum.com/home/the-tour/ [accessed September 4, 2023]

"Romantic Venues of Pioneer Village," Rentals, Osceola History, https://osceola history.org/venue-rentals/ [accessed September 3, 2023]

"Tips for Readers: 24-Hour Pajama Read-a-thon at Berkshire Museum," You Tube October 27, 2020, https://youtu.be/zcGEhhi9NEA?feature=shared [accessed September 4, 2023]

"Ultimate Drone Buying for Total Beginners 2023," https://youtu.be/QThFesaR 1Vw?si=pQqoBBzCb4dsvS05 [accessed September 6, 2023]

"Venue Rental Image Gallery," Crystal Bridges Museum of American Art, https://crystalbridges.org/venue-rentals/image-galleries/ [accessed September 3, 2023]

Weddings, Facilities Rental, Crystal Bridges Museum of American Art, https:// tour.shiningstarinteractive.com/tours/RLaFfGNLQOI [accessed September 3, 2023]

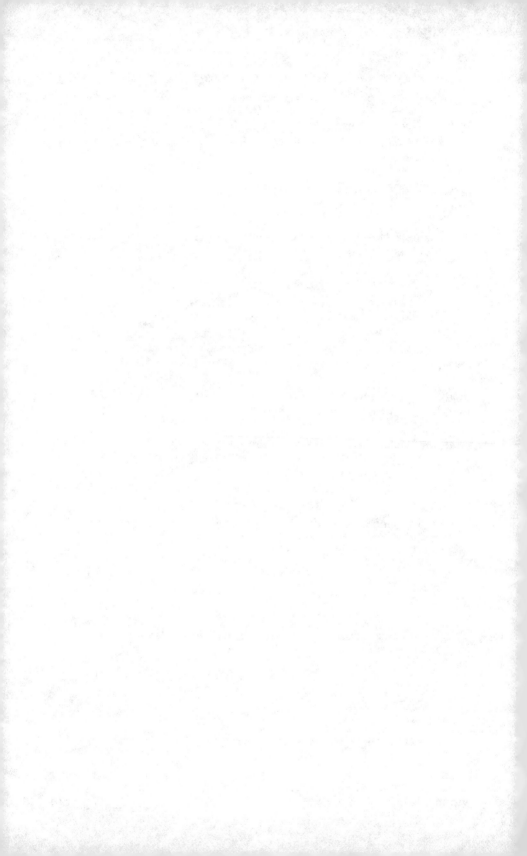

13

Volunteers and Board

Why are volunteers and board covered in the same chapter, let alone the same sentence? They're so different.

A board is a group, composed of individuals. Volunteers are individuals assembled in a group. A board acts; volunteers take individual actions all the time. A board is prestigious; volunteers are admirable. On websites, the board is named in About; volunteers are invited in Get Involved.

They're nothing alike, and that's what makes volunteering people valuable to your brand; they represent all facets of your museum and many work dynamics. They come at a job from all angles and head straight for the future. Do you appreciate them for giving their time? They aren't giving, they're making—making things happen.

This chapter looks at volunteers and board members in six shared brand personas:

1. Community loyalists
2. Symbols
3. Accountable people
4. Mirror of diverse audiences
5. Achievers
6. Teamworkers

COMMUNITY LOYALISTS

In reviewing a museum's image in its community, a main point to understand is: Who is the community! A community of scientists. The geographic region as a community. People who share a cultural community. Volunteers and board members frequently come from many communities, and they help project your brand in different ways.

The Basque Museum and Cultural Center, in Boise, Idaho, recruits volunteers to collect oral histories among Basque communities; they reside in five

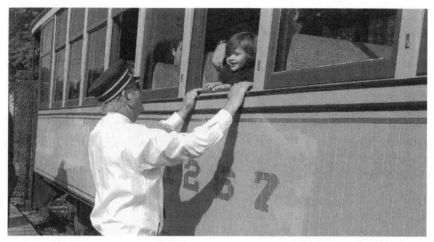

A volunteer at the Seashore Trolley Museum in Kennebunkport, Maine, greeting a visitor to streetcar #1267. When prospective volunteers wonder what the job might entail, photos show and tell. *The Creative Commons Attribution-Share Alike 4.0 International license.*

states in the American West where Basque immigrants settled and expanded over many generations. In Idaho, Montana, Washington, Oregon, and California, teams of Museum staff and volunteers from various organizations collected photographs and documents and interviews. "Komunitatea! [Community] The Story of Basques in Communities Throughout the West" is the culmination of this research.

The Basque Museum collection is the story of its people. The volunteers, behind the scenes and in front of the microphone, are building the museum, not merely serving it.

Oral histories require the work of interviewers, audio engineers, photographers, project managers, writers, researchers, archivists, and budget managers, among others, who build an enduring archive of information. It takes a highly respected brand to pull together that volunteer effort. When museums—of all sizes and genres—become repositories of oral histories, it's because people trust them with their stories. The volunteers who share in these projects not only honor the past, they enrich the future.

Diagonally across the Lower 48 states, there's another museum with its eye on community solidarity. Norton Museum of Art, in West Palm Beach, Florida, recognizes all the current trends that cluster in its visitor-popular, snowbird-heavy city, including mobility, family dynamics, work schedules, and concentration challenges, and here's what it asks of its museum guide volunteers:

- Engage visitors in discussions about art
- Enroll in a "thorough" training program
- Live in the area year-round

These are demanding requirements, and the last point deserves renewed attention. People move around and loyalty is geographic, too.

Here's how to look for—and earn—volunteer loyalty in new places. Start with the danger zones for your new loyal community:

- Job mobility
- Family structures
- Newcomer traditions
- Communication platforms that facilitate new enthusiasms
- The free-spirit zeitgeist

Then leverage those realities:

- Reach out to employers of relocated employees
- Promote volunteer sociability to new employees, many of them young and single
- Offer volunteer opportunities to parents/caregivers and children

- Remember that retired people often have children and grandchildren of volunteer age
- Search for groups whose cultural traditions you want to learn about
- Keep up to date with communications platforms
- Speak to the free-spirit zeitgeist with options first, strictness second

Many volunteers express loyalty to a community as a responsibility, or a worthy challenge. At Geneva History Museum, in Geneva, Illinois, two volunteers located some old headstones. The headstones were barely visible on the ground's surface. For years, the museum had wanted, but hadn't the resources, to search for them.

"It's a way to give back to the community," one volunteer said. The other, calling it "historical exploration," said, "It's about as close you can get to being an archaeologist without an archaeological degree."

Headstones, dearly beloved of historians, provide demographic data, names, and dates. They're records of the people in a museum's many audiences. When budgets aren't muscular enough but the volunteers are, cemetery research gifts your brand with a richer history.

Branding succeeds on loyalty. It spurs donors, motivates members to re-up year after year, and inspires tireless labor among volunteers and board members.

SYMBOLS

A name is a symbol. It could symbolize ethnicity, indicate the decade in which one was born, identify specific families, or blazon dedication to retaining a heritage.

There's another symbol that identifies a person: affiliation. Here are some of the board member titles that give a clearer picture of the Board of National Indo-American Museum, Chicago:

President, League of Women Voters; consultant, University of Chicago South Asia Outreach Educational Project; co-founder, first South Asian domestic violence shelter in the U.S.; professor of Civil Engineering, Northwestern University; vice president, wealth management firm.

Symbols add information about boards and volunteers that donors want to know. All museums can give symbolic strength to their board members with another kind of credential: their bio. After each name, list the member's interests that mirror the mission of the museum, for instance:

- Amateur historian
- Science teacher

- Influencer (good ones know their field and do their homework)
- Architect
- Collector
- Competitive athlete
- Musician

A bio should include one or two sentences about field of interest, but don't settle for the obvious. Board members need a story.

ACCOUNTABLE PEOPLE

"Looking Ahead" looms large in today's museum world. Cognizant of their collections' past and present, museums always look to the future. News flash: The future is tomorrow and so is the due date for new ideas. In New Jersey, Newark Art Museum is throwing open the gate to new thinking and including volunteers with board members in its expectation for new ideas: "Our trustees and volunteers are as diverse and varied as our collections, advancing our mission and guiding our path forward."

Museums of all sizes and genres depend on those who are in face-to-face jobs and on the board to think of the future. Face-to-face workers, like volunteers, see the audience and are smart enough to understand what they want, need, and will love. Board members, with their years of expertise and achievement, know a thing or two about future planning. Here are some discussion prompts for your first volunteer and board meetings:

- What did you learn yesterday that surprised you?
- What worked before that won't work now? Why not?
- What annoys you most about our museum?
- What do you admire about one other museum you've visited recently?
- If you haven't visited another museum recently, do so tomorrow.
- What did the seven-year-old in your life do in school yesterday? This is the future talking. We'll help you find a child if you don't know one.
- Who do you know in any of your other milieus that had a good idea recently?
- Have you ever said, "We've never done it that way?" Good. Do it tomorrow.

Accountability falls to different people at different times. Sometimes the finance people have the final say. Or the techies. Writers who write the final document, after the committee has all weighed in, may get the last word. Listen to the new people—part-time, hybrid, or gig workers find solutions often missed. As for the recently retired, they won't take vacations forever, so recruit them. Working types always want to work more, and their experience fills gaps.

On applications or interviews, ask which skills they could bring to the museum. These are skills to look for, because they know how to re-envision your brand:

- Writing
- Photography
- Technology
- Science
- Research
- Manager
- Accounting
- Education
- Construction
- Healthcare
- Law
- Finance
- More

Heed that "More." Be ready to add new abilities as they appear on the horizon and at your door.

The above skills list is labor-intensive. Consider it a checklist, or wish list, for the volunteers you can count on. They are accustomed to responsibility and accountability and will like being counted on again.

If someone is truly accountable, they put their phone number where their mouth is. African American Museum, in Dallas, in an initiative unusual for any museum, lists the extension and email addresses of its president and chief executive officer, director, and chief operating officer. Want to talk about enterprise? Give this team a call.

MIRROR OF AUDIENCES

What is seen in a mirror is not a replica but an ideal. Volunteers and boards, ideally, will look like the audiences you *want*, not just the audiences you have now.

Eiteljorg Museum, in Indianapolis, shows the face of its brand on the Volunteers page with nine large, well-staged photos of the people who volunteer, and what they do when on the job. Would-be volunteers can see the personality of the museum they want to support. They see different aspects of volunteering. Photos of people in action take some time to peruse; they keep applicants engaged longer than a list of responsibilities would. Engagement helps reinforce the brand's values that you want volunteers to share.

Become a Volunteer pages say, in words, that volunteers play an essential role. Now, prove it. Bring them up front, from behind the scenes, to the spotlight.

About Us tells website visitors that board members are part of the community, not overseers. Prospective board members, doing due diligence in checking out the museum, get a fuller picture of the brand they want to invest time in.

Small museums may have a small audience, but Mai Wah Museum, Butte, Montana, has a big way of expanding volunteerism among its own. At the bottom of its website home page is an open invitation: "The Board of Directors meets the second Wednesday of every month at 7 PM. Send an email to address above if you would like to attend."

For Mai Wah, this is probably a familiar public. They can trust the success of the museum with people who know it through its online presence. It's a double smart way to invite volunteerism because, at the very least, new people are urged through the front door where they can learn about the museum's collection, mission, and way of doing business.

Two Maine museums, similar but with two different sets of needs, describe their volunteers quite differently: Cole Land Transport Museum, in Bangor, asks prospective volunteers in its online application: "Do you have an interest in helping to raise the aspirations of children?"

Less than two hours up the highway at Owls Head Transportation Museum, another volunteer application asks for skills and experience: "whether your passion is vintage cars . . . working in our archives, handling admissions, flying planes. . . ." They say:

> "It became apparent from day one that volunteers were . . . a collective resource of experience, skills, vision and commitment . . . from retired clam diggers to the vice chairman of a Fortune 500 Company."

To show the "people from all walks of life" that museums should aim to enlist, Owls Head museum also produces a video in which individual volunteers talk about their work and prove that, like their audiences, volunteers carry a diversity of skills and motivations in their backpacks.

ACHIEVERS

If you need someone to do a big job, ask a busy person. This time-proven axiom applies to the high-energy people handling the myriad responsibilities given to volunteers and board members.

Pensacola Lighthouse, in its guide for volunteers—a scroll down of seventeen website pages—is a master class in details, sturdiness, and preparation for exigencies of maritime weather, like lighthouses themselves. Volunteers who mastered the knowledge of Pensacola Lighthouse are stalwarts. Here are some of the duties outlined in the guide, examples of how this Florida museum communicates its brand:

- Always remain on the catwalk when visitors are present.
- Learn how to use the wind and lightning meters.
- Know the procedure in case of an emergency. . . you may be asked to fill out an accident report.

- Answer questions like: "Why does the lens turn and why is the lighthouse painted two colors?"
- Unlock the two large deadbolts ... and place the rubber wood chock against it.
- Stay in constant contact with the base ... do not leave your radio inside.
- Be vigilant and assertive.
- Watch for narrow head space in two areas marked by orange, and make sure small children are between two adults.
- Offer a chair if a visitor appears distressed or disoriented.
- Allow climbers to the top who are afraid to descend the stairs to sit down the stairs or climb down backwards as if on a ladder.

Board members of any museum need to know about the deadbolts and wind gusts, so to speak, of their institution. Details matter when they are part of a museum's brand. Is it asking a lot of a volunteer to learn so much? No, volunteers want to spread the exceptionalism of your institution. Granted, it's asking a lot of any museum to write it all down. Be assured, when you can write a definitive document for volunteers—and board members—you understand your brand well enough to maintain it.

The National Churchill Museum in Fulton, Missouri, also lists rigorous expectations. It's strict, straightforward, and forward-looking, like the museum's brand and the man whose name is on the door. The museum expects volunteers to:

- Attend orientation and training sessions
- Know your duties and how to do them promptly, correctly, and pleasantly
- Cooperate with staff and fellow volunteers while maintaining a team attitude
- Be punctual
- Wear your uniform shirt and name tag at all times
- Keep all communications with the public focused on the museum

And here's the kicker:

- Voice your opinions and contribute suggestions for improvement to museum staff

Good museum brands salute the past and then march to the future. Junior boards smash outdated board stereotypes of old, conservative guys-in-ties. The young are socially programmed to reach out and try new routes. In Alabama, Friends of Birmingham Botanical Gardens Junior Board seeks "to increase awareness and involvement among their peers. They aim to

increase diversity." Just diversifying age-wise spurs new patterns of strategizing, budgeting, pricing, programming, meeting agendas, and, everlastingly, technology.

What doesn't change with new board models are obligations and responsibilities; boards represent a museum's brand values and reputation only when they share its commitment. A subhead on the Volunteer page might read:

Commitment to the mission and goals of our museum includes:

- Membership in the museum or its auxiliaries
- Participation in committees, including all regular meetings and signature events
- Fundraising through personal donation, business donation, or at Birmingham Botanical Gardens, "memberships purchased"
- Specified number of volunteer hours

Another caution about achievers: They don't come from the usual places; it's in their nature to take the road not taken. So, when Newport Mansions, a preservation society for the gilded age homes in and around Newport, Rhode Island, welcomed international students from Romania, Moldova, and Kosovo, it likely discovered resources richer than their visa application list of skills in special events, housekeeping, and tour guiding. Could these hard-working, curious students volunteer knowledge of methods and cultures unfamiliar to New Englanders? Museums like Newport Mansion Preservation Society might need to stretch their concept of volunteerism, just as the exchange visitors stretched their horizons.

The U.S. J-1 visa program, or Exchange Visitor Visa, publishes a comprehensive list of the duties and requirements, for both applicants and host employers. It is rigorous. Work Study students must be enrolled in a higher education program in their home country and in the U.S. might work in fields, including:

- Agriculture
- Arts and Culture
- Education, Social Sciences, Library Science, Counseling and Social Services
- Hospitality and Tourism
- Information Media and Communications
- Management, Business

They might work in positions at:

- Resorts, restaurants, or amusement parks
- Architectural firms

- Scientific research organizations
- Graphic art, publishing, or other media communications
- Computer software firms

And they might contribute immeasurably to your brand.

TEAMWORKERS

Volunteers and board members are plural, parts of corps or a board. They serve with other people, often around a table in one room, or side by side on a project. Not everybody thrives on teams, but volunteers know they must learn that skill.

Here are two different museums that address the "teams" part of teamwork quite differently.

Cable Natural History Museum, Cable, Wisconsin, in its instructions for Community Science projects, considers a team as the unseen Wisconsin Statewide Community Science Project and the citizen volunteers who follow its printed, specified methods. The volunteers' responsibilities are spelled out:

"Use the Pollard Walk survey method: Observe butterflies within an 18-foot radius—18 feet to your left, right, front, and above you. Walk at a slow rate of less than 1 mph—the pace can be compared to the "here comes the bride" walk. The Pollinator Garden route should take at least 15 minutes to complete."

The volunteers understand they are not working as individuals but as part of a government effort.

At Bakken Museum, in Minneapolis, teammates are everywhere in the requirements section of Volunteer at the Bakken:

- Collaborate with a team of Bakken staff and counselors to best support and build skills and interests of campers.
- Have the ability to work as a team member and accept responsibility.
- Work with a team of Bakken staff and mentors to expand and develop the interests and skills of young student inventors.
- Collaborate and cooperate with museum staff and other volunteers.
- Work as a team member and ambassador for all things Bakken.
- Learn new ideas and develop new strategies to teach them.
- Resist taking over students' projects, allowing them to work through the invention process.

"Resist taking over children's projects" ranks as the most charming sentence ever written in a rule book. They are the future, we're told, and we must get on board.

BRANDING CHECKLIST

In all communications, verbal and written:

- Are volunteer and board member given the same orientation session?
- Do they understand the distinct mission and future goals of the museum?
- Are volunteers and board members included in, when appropriate, staff reports on their current projects?
- Are they advised how to engage visitors that they encounter at the museum?
- Are they notified of the facts of any honors, or problems, that occur, and given suggestions on what to say publicly?
- Are they reminded that they represent the museum wherever they are, in any situation?

REFERENCES

"Board Members," National Indo-American Museum, www.niam.org/about-us/board-of-directors/ [accessed June 25, 2023]

Coxe, Trudy. "International Students Join Us for Summer," Headlines of the Week, e-mail to mailing list, Newport Mansions, The Preservation Society of Newport County, www.newportmansions.org [accessed July 8, 2023]

Girardi, Linda. "Work at Old Geneva Cemetery Uncovers Headstones from City's Early History," *Beacon News*, May 24, 2023, https://genevahistorymuseum.org/work-at-old-geneva-cemetery-uncovers-headstones-from-citys-early-history/ [accessed June 25, 2023]

Harrison, Linda C. "Volunteers, Art Ball, and a New Gallery Opening," April 14, 2023, Newark Art Museum, https://newarkmuseumart.org/2023/04/14/volunteers-art-ball/ [accessed July 11, 2023]

"J1 Student Visa," Visa & Immigration Center, International Student, www.internationalstudent.com/immigration/j1-student-visa/ [accessed July 8, 2023]

"Junior Board," Birmingham Botanical Gardens, https://bbgardens.org/junior-board/ [accessed July 9, 2023]

"Komunitatea," The Basque Museum and Cultural Center, https://basquemuseum.eus/see/current-exhibits/komunitatea/ [accessed July 9, 2023]

"The Mai Wah Society," www.maiwah.org [accessed June 22, 2023]

"Our Team," African American Museum, https://aamdallas.org/about/ [accessed July 9, 2023]

"Resources for Survey Volunteers," Wisconsin Statewide Community Science Project, Cable Natural History Museum, www.cablemuseum.org/statewide -community-science-project/ [accessed May 19, 2023]

"Video Archives," Owls Head Transportation Museum, https://owlshead.org/ page/videos [accessed June 27, 2023]

"Visual Orientation for Volunteers," Pensacola Lighthouse and Maritime Museum, www.pensacolalighthouse.org/images/forms/Visual_Orienta tion_for_Volunteers_FINAL.pdf#page3 [accessed May 18, 2023]

"Volunteer," Cole Land Transport Museum, www.colemuseum.org/volunteer/ [accessed June 27, 2023]

"Volunteer," Norton Museum of Art, www.norton.org/get-involved/volunteer [accessed July 10, 2023]

"Volunteer," Owls Head Transportation Museum, https://owlshead.org/page/ volunteer[accessed July 11, 2023]

"Volunteer at the Bakken," The Bakken Museum, https://thebakken.org/volun teer [accessed June 24, 2023]

"Volunteer at the Eiteljorg," Eiteljorg Museum of American Indians and Western Art, https://eiteljorg.org/give-and-join/volunteer/ [accessed April 19, 2023]

"Volunteers Make the Difference!" America's National Churchill Museum, www .nationalchurchillmuseum.org/museum-volunteers.html [accessed February 25, 2023]

14

Store and Cafe

The museum store and cafe, revenue sources and brand enforcers, have reinvented themselves with savvy new ways to extend a museum's brand. As new audiences visit museums, each comes with different expectations and idiosyncratic schedules. Yet, the store remains a constant presence, online and on-site, and cafes experiment with new kinds of modus operandi. To maintain a significant place in the museum's floor plan, they have adapted and flourished.

Single shelf or sprawling emporium, counter or table with a vase in the middle, the store extends knowledge, and the cafe embraces sharing it. Some of the brand benefits are:

- Support of mission
- Part of the community
- A quasi-gallery
- Resource material for professionals and amateurs
- Toys and games that develop early interests in science, history, art, and culture
- Year-round continuity
- R&R—a place to reflect and recapitulate

SUPPORT OF MISSION

Different museums envision a panorama of visions, and they all focus tightly on their missions. However, they also dare to widen their approaches to supporting those missions. It gets exciting!

In Massachusetts, New Bedford Whaling Museum, like seaports all along America's eastern seaboard, isn't just about whaling. Its portfolio is the sea, the waters that connect us all. Its store isn't just about merchandise.

Included with the online store's images of individual book covers, readers find a short history lesson:

Every time a visitor stops in the store, your brand is reinforced. Curiosity, knowledge, inspiration, enjoyment sit on shelves and tables waiting to be touched. You can't get that close and familiar in the galleries. And these tangibles can be taken home. *Wiki Commons*

"Buried deep within the logbooks, journals, and manuscripts of America's whaling heritage are paintings, drawings, and representations of the whale hunt rarely, if ever, seen by the public. The book highlights those unique artworks that capture the essence of whaling and its culture. This comprehensive examination of whalemen's art will be the standard reference text for years to come. The author's meticulous research is based upon a study of marine history and art spanning two decades."

Books like this are invaluable for scholars, professional and amateur, who come to museums to research their field. Making them available for purchase is an added benefit.

Any museum store, of any size or genre, can translate three-dimensional knowledge onto the pages of books. Subject matter is limitless; size is whatever the budget can bear. As repositories of information, stores complement museum galleries, archives, libraries, tours, and websites. They:

- Augment a museum's mission in a take-home format
- Maintain relevance by being ownable, not just viewable
- Enrich brand identity by making it tangible for all audiences

Museum of Contemporary Art Chicago says what everyone knows but maybe forgets: "Every purchase supports the exhibitions and educational programs at the Museum of Contemporary Art Chicago."

Stores are good for the museum, as well as the shopper. The branding benefits abound.

- Interactive process strengthens memories.
- Purchases recall the museum visit for a long time
- Interaction between shopper and staff gives a human face to the experience
- Store surveys the entire museum
- Talking with other shoppers reinforces familiarity, the comfort of belonging.
- A purchase passes through a few hands, spreading the museum name.
- Ownership confers a special attachment to objects.

In California, Morro Bay Natural History Museum takes the same approach and moves it to a pop-on box: "We need your help. Help us reach the millions of visitors on the Central Coast by donating today! Support continued educational programming, conservation, and volunteering efforts!"

Support for volunteerism is notable. All museums need it. Say so loud and often.

Added to the initial motivation to buy, the store entices the visitor with brand-themed items like a Rattlesnake Bar (aka chocolate); scarves with sea otter print; Life Cycle of a Monarch Figures (including individual caterpillar, chrysalis, and butterfly); or children's books like *Bonnie Barnacle Finds a Home*.

If your museum budget doesn't allow for that level of merchandising, some thoughts for online and on-site stores:

- Select the items most closely connected to your mission and show them first on the web page
- Write counter cards that make the connection
- Use logo and mission imprinted gift cards and shopping bags

On the scale of mug to original artwork, the Tenement Museum store purchase ranks near the top: a personal guided tour for a group of 2–75 friends, staff, clubs, college class, alumni group. Gift tours range from $390-2,500, depending on virtual or in-person, length of tour, and whether it's during or outside of regular museum hours.

And it's totally about mission. Pricey, yes. Targeted, to gift-givers with special recipients. Worthy, indeed, both in value received and benefit to the museum. Never underestimate the amount of money people are willing to spend, especially for something they value. Your museum has value, and different audiences will always value it according to their own inner scorecard.

High-priced items usually go on the top shelf in museum stores, or inside locked vitrines. Given the layout of your museum, you might consider offering them if:

- Space is available and appropriate
- Complete descriptions are written on high-quality shelf or table cards
- Staff can explain them, in detail, including how to ship or pack them
- Items reflect your collection, exhibition, mission, or vision
- Staff, from director to volunteers, are comfortable with the idea
- Supplement programming, such as a video, expert talk, or workshop, might benefit the museum beyond the store

In Texas, Abilene Zoo knows that its mission of being a place of learning includes learning for everybody. And its gift shop gives away a special gift for people with sensory disabilities and difficulties in new and busy environments. In collaboration with KultureCity®, a national nonprofit leader in providing "sensory accessibility and acceptance for those with invisible disabilities," the museum gift shop hands out:

- Noise-cancelling earphones
- Fidget tools
- Written cue cards

These items bring peace of mind for the "invisible disability" sufferer and companions and community-wide access to a museum whose mission is "the

joy of discovery" and preservation of wildlife. KultureCity uses its resources "to revolutionize and effect change in the community for those with sensory needs, not just those with autism." It works with public and private groups.

Here's one more example of museums' forward-looking collaborations with institutions that can strengthen their missions.

The Museum of Work and Culture, part of Rhode Island Historical Society, has an outsized presence in the history of colonial America and beyond. It displays brand-unique exhibits of early mills. Its tours are in French as well as English. The store carries distinctive Woonsocket merchandise and books on early life in the community. Labor history books showcase a market segment still in need of attention, a valuable addition to American business history. Moral: A store in a small museum, surrounded by another museum, in a small city of a small state can wield a big brand.

Small museums thrive when they:

- Focus on a local specialty
- Select small segments of knowledge to explore
- Leverage the store to publicize its brand identity

PART OF THE COMMUNITY

On first glance at the online store of Erie Canal Museum, in Syracuse, New York, one sees a building whose windows reflect water. And then, scroll down! What appears are books on canal side commerce, the Foodways Project, maps of waterway systems, DVDs on the Canal in American history, and a book of Erie Canal ballads—"Low bridge, everybody down."

Information has always been available at museums, from exhibits and labels to lectures and tours. And museum stores are intended to be an extension of the museum experience. Here's a bright example of information to own, information to share at home, and information to sing out loud.

Museums of any genre or size can offer the gift of information. Museums' vast trove of information is already available in archived documents and artifacts. Monetize them with:

- Framed maps
- Professionally printed oral histories
- Photos
- Songbooks

And devote separate pages, apart from apparel, to list them.

Corporate gifts are a natural for museums that are integral parts of their community. For the busy person charged with filling the business gift-giving assignment: Drayton Hall, Charleston, South Carolina, makes it one-click easy

with gifts like culinary Charleston gift boxes, Southern BBQ gift boxes, magnolia wreaths, and magnolia trees. Other museums can adapt the concept for corporate gifts in their region.

Now that gifts are within the sights of a business gift-giver, expand the occasions from "Holiday Gifts" to other business appropriate occasions. Gifts for:

- Speakers
- Workshop leaders
- Employee community service
- Business partnership projects
- Education programming initiatives
- Restaurants and hotels

RESOURCE MATERIAL FOR PROFESSIONALS AND AMATEURS

For museums of all genres, attentiveness to scholars presents a glorious challenge: how to aid their research. While other parts of a museum get big chunks of budget and scholarship attention, the store operates tidily with just a slice of resources. Books prove their usefulness quickly, especially when they permit brief browsing; they will remind readers of the museum's merit for a long time afterward. Readers, writers, and educators gravitate to bookshelves, and the store at Planet Word rewards "the wordsmith in everyone."

Planet Word, whose store is called Present Perfect, recognizes that amateur scholars can be schoolchildren as well as adults and that, perhaps more importantly, children can harbor nascent professional interests: "You can browse books full of wordplay ... Present Perfect offers plenty of curated, one-of-a-kind items to pique the interest of writers, readers, performers, conversationalists, kids, and word nerds."

As tools for branding, books in the store are always within reach, easy to grab, peruse, and purchase. Who doesn't like books? The connection to museums' identity and mission is often evident in the title. Tighten the link with:

- Shelf cards that connect the title and author with the museum's collection
- Printed suggestions from the staff to provide personal connections
- Paper bookmarks—survivors of an earlier era—are portable logos
- Answers to questions from store volunteers trained to extend the learning in the galleries
- Special attention to the youngest amateurs, the children starting out
- Interaction with shoppers; let them know they've found their special place

Open the page of this North Dakota online museum store and get a quick lesson on who lives in North Dakota. There are cookbooks for German cookies;

a cookbook for Germans from Russia; books on the fur trade, blizzards, medicine, railroads, Custer and Teddy Roosevelt; and 119 books on Native American culture and history. And a book on researching Germans from Russia, plus a journal with cover photos of rodeo riders and a nurse in a hospital ward during the 1918 flu pandemic. Just part of the North Dakota heritage, this visual booklist says volumes about the State.

Museum stores are built of visuals, and the onsite visitor sees items, not words. Smart of the online store to furnish the same view!

This vast inventory underlines another benefit of the store: continuity through all seasons. It doesn't take a bookshelf on blizzards to remind everyone of North Dakota's weather. There will be periods when personal visits are down and a well-stocked store keeps the museum brand robust and helpful.

CONTINUITY

Once cool weather comes to a village and folks return to school and indoors, how will thoughts return to farm and barn, cider festivals, and lambs? In Pittsfield, Massachusetts, the store at Hancock Shaker Village says it well: "While you can't take home one of our Baby Animals, we have the next best thing—a wide variety of Shaker inspired gifts, books . . . and much more." By the way, the name of the store is Shaker Mercantile. If just one child asks what "Mercantile" is, the museum has scored a brand benefit.

Cold weather also affects the schedule of visitors to Conner Prairie in Fishers, Indiana. Before the 2023 holiday season began, its store offered gift tickets to spring classes, announcing: "registration now open." There's a note of urgency, because holiday shopping is an urgent endeavor, and this prompt starts the continuity many museums need through winter lulls. Smart to look forward to new spring offerings! Tickets wrapped as a present are tangible items that stay around the house as reminders.

Small museums, especially in cold climates with short seasons, put a lot of stock in their stores. The merchandise at Verendrye Museum, in Fort Pierre, South Dakota, looks intriguingly informative. It's a kind of collection, a type of exhibit:

- Note cards with illustrated stories of original country schoolhouses, written by a museum member
- Cookbooks whose recipes are combined with memories
- Maps of a long-ago territory, beguilingly named the Fort Pierre to Deadwood map and Pine Ridge Indian Trail Map

Volunteer store assistants talk like local historians, and the banner on the store page invites another kind of exploration: "For the other sites that comprise the museum—1906 Stanley County Jail, 1900 Sansarc Country School Museum, Fort Pierre Depot Museum—there are store items complementing

their stories." The store is so important to the mission of the museum, the Store page is headlined: "The Verendrye Museum in Fort Pierre is named for Louis and Chevalier Verendrye, two French brothers who explored the upper reaches of the Missouri River."

In all seasons, toys and games bring the museum experience home, and when it's a jigsaw puzzle from The Whale Museum, in Friday Harbor, Washington, the whales stay around a long, long time. Puzzles of more than a dozen whales and dolphins range in complexity from twenty pieces to 1,000. It's hard to forget the museum that occupies the whole family in a tabletop puzzle. That's continuity.

QUASI GALLERY

If this isn't a maxim, it should be, "There's always space for the store." Find a nook or closet, add a counter and some display units, and make sure your space:

- Has a view of the galleries
- Inhabits an actual room of a historic house
- Houses artifacts, furniture, science apparatus, or some other identifiable aspect of the museum

Then stock objects that truly reflect your museum's collecting philosophy and exhibit goals.

The Driehaus Museum in Chicago tucks its store into two rooms on the third floor of a Belle Époque mansion, at the top of a winding grande-dame of a staircase. The rooms are wood paneled and vintage wall-papered, and there are deep windows and a carved fireplace. The merchandise comprises ballroom-quality beaded purses and drop earrings. One can learn from this suite of rooms. A floor stand by a tall window holds this framed sign: "This small room at the southeast corner of the third floor originally served as Mrs. Nickerson's Sewing Room. The walls above the wainscoting were originally decorated with . . . 19th century wall covering patented in England."

It's a historic room, curated and labeled like the rest of the museum, and with the added attraction of period objects and books for sale: a gallery and store in one!

Walking down the stairs, views of other belle rooms come into view. The trip to the store engages the visitor in a vertical tour and ties the rooms and hallways of the museum together. (There's also an elevator.)

Even the most incidental stores, a few shelves and a case, aid branding by selling objects that a visitor can take home and think about at leisure.

R&R—A PLACE TO REFLECT AND RECAPITULATE

Local produce and dishes connect museums to their surroundings, and another local resource can be added: people. In addition to a farmers market on the plaza of the Museum of Contemporary Art Chicago, there are local chefs that the chef at Marisol turns to—a tip of the toque to the museum's Chef Collaboration Series, which joins forks and knives with local culinary talent by highlighting their signature dishes.

Examples are dishes inspired by the cuisine of Kerala, the southwestern coastal state of India, and Southern comfort food, created by chefs from various cultures, using different techniques, and catering to a range appetites. This cross-over of styles befits a museum whose personality is venturesome and whose milieu is urbane.

Food is so universal, such a popular subject of conversation, art, drama, and literature, that any museum can benefit from connecting to it. Many already do with:

- Farmers markets
- Cooking demonstrations
- Street fairs
- Farm-to-table blogs
- Lectures on meals in historic house kitchens
- Programs on the science of food
- "Dishes my grandmother taught me"
- Regional recipe books

Planet Word's restaurant continues its spot-on use of language, right down to the forks and empanadas.

The name, Immigrant Food+, clues one into its devotion to learning, including from food. Sustenance from other cultures, traditions upheld, joy of getting together—it's all on the table. The website text explains: "Satisfy your hunger for knowledge—and food—at Planet Word with Immigrant Food+'s international menus that honor the gastronomic contributions of immigrants!"

The special shout-out for immigrants is noteworthy: They are the link to cultural diversity, and the inspiration for its scale. Menu items don't talk down to the diners; of course, many diners are themselves immigrants or visitors from other countries. A menu example: "Mezzo Dip Trio, Three Dips: harissa hummus, feta/oregano shankleesh, and walnut/red pepper Muhammara, served with warm na'an,"

Here is worldliness and togetherness. Museums that provide that kind of sociability for its community give a big boost to brand loyalty.

Good food and drinks, staples of hospitality, are emerging as museum exhibits. Often, they relate clearly to the museum, and sometimes they're

simply part of the exhibition. At Chicago Botanic Garden, in suburban Glencoe, Illinois, a snack and hot drink pop-up add even more glam to the glitter of the annual holiday season "Lightscape," a lightshow so amazing, it's the one thing that can equal the splendor of the beautiful garden.

Feeding visitors is not required of museums; it's an extra, a pleasant extension of the visit that provides a place to sit, refresh, and compare notes on the experience: "Feeling cozy? Sip on Santa's Magic Potion, a smooth mix of eggnog and Irish crème, or try The Grinch Cocktail, with a splash of spiced rum. Holiday mocktails are on the menu, as well as light fare, kid-friendly snacks, and a s'mores station."

For smaller museums, a holiday event may be the time and place to try a pop-up cafe; and it offers a way to include local businesses.

There are many benefits to even a small snack commissary:

- Extension of experience
- Place to discuss and remember what was seen
- Fun of different mealtime food
- People-watching—an exhibit everyone should see as often as possible
- QR code access to exhibit creators' bios, notice of upcoming talks and workshops, tickets for events, community news, little education tidbits for children

BRANDING CHECKLIST

From aisle to scanner, bookshelves to locked cases, every square foot of the museum store is a brand reinforcer. Does your store, could your store, engage in these branding activities:

- Staff interacts with shoppers
- Mirrors let shoppers try things out
- Staff recommends book of the month on a counter card or shelf card
- Local artwork is noted, with brief bios of the artist
- Current or upcoming programs are posted in the store
- Museum-related magazines and journals are displayed or offered for sale
- Gift memberships, event tickets, and classes appear as merchandise, online and onsite
- One copy of exhibit-related book allows for perusing
- Laptop is available to encourage comments and email addresses
- Appropriate book content is excerpted and printed on counter cards
- "People on Your Gift List Who Would Like This" suggestions are posted, in store or online
- Holiday-specific items get subject line treatment in emails
- Enticing holiday tie-ins are created by imaginative staff

- Recycling bins and paperless receipts meet expectations of many shoppers
- Local program announcements, especially when brand-appropriate, show your commitment to the community
- Venue used for author readings and signings
- Staff says "thank you for visiting"

REFERENCES

"Abilene Zoo Becomes a Certified Sensory Inclusive Zoo," Abilene Zoo, https://abilenezoo.org/news/abilene-zoo-becomes-a-certified-sensory-inclusive-zoo/ [accessed October 29, 2023]

"Corporate Gifting from The Shop at Drayton Hall," The Shop at Drayton Hall, email to list, November 26, 2023.

"Donate," Morro Bay State Park and Museum of Natural History, https://centralcoastparks.org/portfolio-item/morro-bay/ [accessed May 10, 2024]

The Driehaus Museum Store, https://driehausmuseum.org/shop [accessed October 6, 2023]

"Games and Puzzles," Whale Museum, https://whalemuseum.org/collections/games-puzzles?goal=0_4afc0d8ef6-d7772d49fd-92929474&mc_cid=d7772d49fd&mc_eid=b2f776b929 [accessed October 6, 2023]

"Gift Shop," Planet Word Museum, https://planetwordmuseum.org/plan-your-visit/#present-perfect [accessed October 6, 2023]

"Gift Shop Items," Verendrye Museum, www.verendryemuseum.com/about-the-museum/gift-shop-items/coins-prints-maps-more/ [accessed June 10, 2023]

"Host a Group Visit," Tenement Museum, www.tenement.org/host-a-group-visit/ [accessed October 26, 2023]

"Immigrant Food+," Planet Word Museum, https://planetwordmuseum.org/ [accessed June 25, 2023]

"Lunch Menu," Planet Word Museum, https://planetwordmuseum.org/wp-content/uploads/2023/06/IF_PW_Lunch-Menu_612.pdf [accessed June 25, 2023]

"Make History and Register Now for Our Spring Classes: Tickets on sale soon for Conner Prairie's Solar Eclipse Festival!" (e-mail), October 26, 2023, info@connerprairie.org

"Marisol Chef Collaboration Continues," Museum of Contemporary Art Chicago, https://marisolchicago.squarespace.com/news/marisol-chef-collaboration -7x744?utm_source=MCA+General+List&utm_campaign=1f57f542f9-E MAIL_CAMPAIGN_2023_08_01&utm_medium=email&utm_term=0_fa4a 052a8d-d57e357590-[LIST_EMAIL_ID]&mc_cid=1f57f542f9&mc_eid=71c 48a0813 [accessed August 3, 2023]

"MCA Store," Museum of Contemporary Art Chicago, https://mailchi.mp/718fb019ddca/dont-wait-to-shop-only-1-day-left-for-member-double -discount-185828?e=71c48a0813 [accessed October 13, 2023]

"Museum Store," Erie Canal Museum, https://eriecanalmuseum.org/store [accessed October 25, 2023]

"New Arrivals," North Dakota Heritage Center and State Museum, https://north-dakota-state-museum-store.shoplightspeed.com [accessed October 25, 2023]

"New at Lightscape 2023," Introducing new festive cocktails and cuisine, message from a mailing list, Chicago Botanic Garden, October 25, 2023, https://www.chicagobotanic.org/lightscape [accessed May 10, 2024]

"O'er the Wide and Tractless Sea: Original Art of the Yankee Whale Hunt," Books, New Bedford Whaling Museum, https://store.whalingmuseum .org/products/the-art-of-the-yankee-whale-hunt?pr_prod_strat=use_de scription&pr_rec_id=ce2b203ce&pr_rec_pid=9824840457&pr_ref_pid =142388235&pr_seq=uniform [accessed November 16, 2023]

"Shaker Mercantile," Shaker Hancock Village, https://hancockshakervillage .org/ [accessed August 21, 2023]

The Shop at Drayton Hall, Drayton Hall Museum, https://mailchi.mp/dray tonhall/corporate-gifting-from-the-shop-at-drayton-hall?e=7ea4ba1771 [accessed October 28, 2023]

"Woonsocket Merchandise," Museum of Work & Culture, Rhode Island Historical Society, https://www.shopmowc.com/ [accessed July 21, 2023]

15

Logo

Logo. Mark. Brand. Symbol. Signature. They're all visual reminders of a brand one can trust. Many synonyms have evolved over the eons of human creating. Evolution isn't going to stop, so logos need regular re-evaluation. Visuals are powerful. The information culture adores images. Words still count—if they don't count up to too many—but visuals connect and communicate more quickly. Ideally, words and logos work together in irresistible synergy.
It's not only what logos say but where they say it. It's not what they promise but to whom.

This chapter will discuss all the aspects of your museum that need your logo to communicate what you stand for; it covers the touchpoints that connect with all the audiences you want to know. The following list includes many areas where a museum's brand would be strengthened by the logo. For your museum, they're a reminder: Is a logo important here in the future? Will it better distinguish our museum for the audiences we want to reach?

In strategizing where to make your mark, caution: Don't change the logo. Change where it appears such as:

1. Website
2. Logo line
3. Signage—front to back
4. Partnership materials
5. Tour—self-guided or docent-led handout
6. Front desk
7. Ephemera
8. Store
9. Social media platforms

WEBSITE

A quick identifier is necessary when viewers are linking from searches. Photographic banners, at the top of home pages, quickly communicate a sense of

the museum, helping to place a museum in context. Photos of your museum and its surroundings give an image no other leisure organization has. A photo of your town or regions also helps put your museum in context. Now add your logo and make that home page your home. Photos plus logo put your museum brand on the mental map.

Look at the home page of the Mark Twain House & Museum in Hartford, Connecticut, which has a large menu of programs, classes, and talks. It moves around a large, multi-garret, multi-wing house that bulges with variety.

Visitors to the home page of RISD Museum, at the museum of Rhode Island School of Design in Providence, experience an aerial overview that dramatically approaches a venue. There's no global celebrity in this museum's name, rather, its global reputation for greatness is heightened by photography. Add the logo to brand it.

In Aberdeen, South Dakota, Dakotah Prairie Museum offers exhibitions and teacher programs, family events, and a college scholarship fund. Its home page is a collage of photographs to immediately communicate breadth of ideas and a museum's contemporary role in its community. The home page also headlines this message: "Helping to Preserve the Future of Our History." In a glance visitors see what the brand stands for. Add the logo to clearly identify the brand's name.

The clues to deciphering this nineteenth-century cradle logo of Susan B. Anthony Birthplace Museum, Adams, Massachusetts, are photos on the website's home page. The images are significant, because there's another Susan B. Anthony Museum in Rochester, New York. Here are the telltale images of the Birthplace Museum:

- "Votes for Women" sign
- Susan B. Anthony relaxed in a chair
- New England two-story clapboard house
- Garden
- Kitchen
- Schoolroom
- "Organize, Agitate, Educate" headline

We see Susan B.'s priorities immediately, and they are borne out on other pages. The shop carries books under the heading: "Discover Books About Suffrage, Our Feminist Foremothers, & Historic Movements."

The Events tab is based on "events, and daily life during the years 1820–1920, from Susan B. Anthony's birth to the passage of the 19th Amendment which bears her name."

The Learn tab says: "Facing History Objectively: Research difficult issues including racism & restellism during suffrage times." (Madame Restell was a

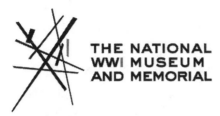

Wikimedia Commons

Public domain

Wing Luke Museum of the
Asian Pacific American Experience

Public domain

TWO
MISSISSIPPI
MUSEUMS

MUSEUM OF MISSISSIPPI
MISSISSIPPI CIVIL RIGHTS
HISTORY MUSEUM

Public domain

Public domain

The beauty of logos is in their versatility. Put them everywhere there's a flat surface, on virtual pages and print, posts and podiums, letterhead, signs, store bags, and tags.

self-proclaimed physician and the widely known Fifth Avenue Abortionist from 1839 to 1878.)

If your museum's brand is a famous name, don't rest on its laurels. It's easy to lose the person amid programs for school trips, Fourth of July celebrations, and e-newsletter announcements. As for donation requests or partnership talks, your brand is all important, and absent the Famous Person, your logo must be on call all the time. Make sure that brand mark appears everywhere, large, and with a logo line if needed for clarity.

SIGNAGE AT TALKS, WORKSHOPS, AND FUNDRAISING EVENTS

Consider the circular logos of Planet Word Museum in Washington, DC; Louis Armstrong House Museum and Center in Queens, New York; and the Museum of Work and Culture in Woonsocket, Rhode Island. They couldn't be more different. The roundness of a planet, the round vinyl record, and the round gear of industry demonstrate how quickly a logo can communicate many different ideas.

All three museums have strong identities strengthened by excellent writing in all communications.

Planet Word has Word names for many of its spaces. Lexicon Lane is a room where visitors can solve puzzles. Present Perfect is the name of the museum store.

The Museum of Work & Culture "presents the compelling story of immigrants who came [to find work] in the mill towns along the Blackstone River. Visitors recreate this journey . . . to the workday world of Woonsocket."

Louis Armstrong Center names its events—which honor a historic figure and his relevance today—Armstrong Now.

And when significant museum happenings occur, a well-placed logo saves many communications disasters:

- Talks and lectures where the paid speakers spend an hour of attendees' time plus untold hours of staff planning time—and the talk doesn't reflect the values, goals, or personality of the museum.

 - Put your logo on the podium and next to the e-newsletter announcement

- Workshops where learners of all ages expect to learn something from museum experts—but it's not clear whose experts are actually conducting the session.

 - Put your logo on a sign at the door, and on print handouts.

- A fundraising gala where money is the goal, and trust in the museum is key—and the museum's identity is drowned out by food, music, entertainment, and drinks.

 - Put your logo on the napkins and the goodie bag.

PARTNERSHIP MATERIALS

Partnerships are based on mutual values. Whatever your museum's needs, the best partner is one that understands your goals and appreciates your vision. Sharing applies to space allocated for logos. Partnerships are mentioned in programs, solicitation material, and events like the above-mentioned fundraising event. Make sure your logo enlarges, or reduces, to the size of your partner's logo.

TOUR—SELF-GUIDED OR DOCENT-LED HANDOUT

Tours spotlight several effective branding tools: your collection, staff expertise, and diverse audience. They're all used in the Bruce Museum tours. Bruce Museum says: "Experience the highlights of the Bruce Museum exhibitions . . . no reservations are necessary, but capacity is limited."

The Bruce brand is Art + Science. Its logo is a technical drawing of a palette. It's logo line says, "where art meets science"—and its tours promise fulfillment of that.

For any museum that offers guided tours, its logo belongs several places:

- At the front desk or wherever tours begin
- On printed handouts
- On the docent's badge

For self-guided tours the logo should be evident on:

- Printed handouts
- A label near exhibits on the tour
- The podium where devices are handed out
- The lanyard that holds a device

A guided tour gives museums valuable face time with visitor. A self-guided tour allows visitors added time to focus and think about the objects. Make sure visitors know who is giving them this opportunity. Use the logo.

FRONT DESK

Everyone passes the front desk, entering with expectations and exiting with memories. With a logo on the counter, they'll be clear on where they are. With a logo on brochures or calendar printouts, they'll remember where they've been. Museum visitors, like all people, go to many places, tightly scheduled, and you can make this leisure trip last a little longer.

At Harbor History Museum, in Gig Harbor, Washington, many community groups come and go, including a monthly literary club and school groups. They're there to learn in a special place. A logo on the front desk identifies that special place.

Harbor History Museum is specific about its specialness, starting with its wave-like logo: "Our vision is to be a premier South Sound resource and destination that is recognized as the community memory bank, preserving and sharing our regional heritage and its connections to the world."

Every museum, in all kinds of communities, can benefit from hometown advantages. If your museum welcomes community members—of course it does!—use your logo as part of the hometown welcome, with the front desk a place to start. Other welcoming places for your logo:

- Front desk handouts
- Entrance fee stickers
- Ticket stub
- Front lobby book table
- Coat and bag storage

EPHEMERA

Ephemera is defined as (1) something of no lasting significance—usually used in plural, or (2) *plural*: paper items (such as posters, broadsides, and tickets) that were originally meant to be discarded after use but have since become collectibles. The latter definition rules. Museum archives avidly collect, protect, and use them. In Grahamsville, New York, Time and the Valleys Museum has an exemplary branding tool in its not-ephemeral map connecting visitors to its mission, "connecting Water, People and the Catskills."

The map is downloadable, a guide to the waterways that for centuries have provided water for New York City. Time and the Valleys Museum bears an unforgettable name, a singular mission, a tantalizing vision, and the map folds them all into one place. This guide to the Catskills region covers scenic routes and water learning. At the top of the map is the museum logo—a stopwatch—with a face of water, sky, and land.

All museums produce ephemera, and many have the archives to preserve them. Here are some places for your logo to go . . . if only home with the visitor, to linger in physical memory for a few more days:

- Lecture programs
- Board meeting agendas
- Volunteer packets

STORE

The store is one gallery everyone visits. And the store *is* a gallery, where visual reminders of your museum's collection and exhibitions are displayed and monetized. It's a winning place for your logo. The store buyers know two important

things about branding: what items relate to your mission, and which will go home with a happy purchaser.

Even merchandise that isn't bought is ogled. Depending on the prospective buyer, books are examined, games and toys coveted, and *objets* studied, especially if they have table cards adjacent. Stores provide an introduction to the museum and memory making. They're social places where visitors can compare notes along with "do you think my mother would like this?"

The most important store places for your logo are table cards and shopping bags. Table cards explain the relevance of an item to the museum collection or exhibition. It's a way for the store to extend the experience of the museum visit. However, shopping is a generic experience. All stores are shopping places. Identify the museum.

Shopping bags are more than utilitarian paper containers; they also contain your name for everyone to see. They're paid advertising, paid for by the purchaser. Purchasers enjoy owning this proof of their cultural leisure activity. They trust that a gift recipient will appreciate the provenance, if not the geode or bookmark itself.

SOCIAL MEDIA

X (formerly Twitter) and YouTube remain the two most robust platforms for museum communications.

X serves as an excellent podium for your logo. There's space for it on every post you send. And these posts go farther all the time.

YouTube has a name, a logo, and a reputation that everyone with a camera should learn to master. Whatever material you put on video platforms, make sure your logo is in the opening title and the first scene. It's your museum's video. It was produced by your museum, with your script, quite probably with your staff, and certainly with your objects. Not to mention your objectives. If you can superimpose the logo, like speaker names, on other scenes, do so. Certainly, at the end of the video, along with all the other credits, credit the museum by name and logo, big.

A reminder about social media. It's designed to show and tell and be reposted. Very quickly, your words will be commented on and interpreted by people you don't know, with their hashtags and their logos. You can't control this, of course, but you're the original speaker with the trusted logo, so make that first impression—your post—identifiable. Make your point immediately, along with your name and logo. Museum Name. Event. Date. Logo. In St. Petersburg, Florida, The Dali Museum offers an example: "Dalí Alive 360° is officially opening this Thursday, August 3! Be prepared to step into an immersive, 360-degree experience showcasing Dali's artwork."

In Texas, here's how Abilene Zoo writes an X post:

"Happy World Lizard Day! Here at Abilene Zoo, we have nearly 20 different species of lizard!

"Look and listen to this bumblebee dart frog. The sounds are shaking the frog's side!

"A special thanks goes out to Lowes for donating some Christmas Trees to use for enrichment purposes. Our addax are really engaging in thrashing those pine needles clear off."

Zoo animal news. Animal information. Logo.

LOGO LINE

Sometimes called the signature, or slogan, the words under the logo clarify what the brand stands for. The best logos in the world need a logo line. Even the name and illustration of Mark Twain, which appear on its home page, need verbal accompaniment. The human learner sees quickly, and reads slowly, absorbs quick impressions and mulls reasoned explanations.

Mark Twain's face is famous. But two museums devoted to Mark Twain—Mark Twain's Boyhood Home in Hannibal, Missouri, and Mark Twain House & Museum in Hartford, Connecticut—bear his image in their logo. Their respective logo line clarifies which museum is being communicated.

The mission of Mark Twain's Boyhood Home & Museum is "to demonstrate the relevance of his stories and ideas to citizens of the world."

Mark Twain's House & Museum has as its home page banner headline "A house with a heart and a soul."

Even the most recognized names need clarification of their values, and there will be many to choose from. Museums can start by:

• Talking to staff and volunteers—how they explain the museum's singularity
• Listening to children on school tours and the questions they ask; they're searching for your special abilities in their own words
• Walking the galleries and eavesdropping on visitors; hear how the public interprets your exhibits

Not many museums are known by their nicknames. It's an honor when the community considers you a friend. The History Museum at the Castle, Appleton, Wisconsin, has an origin story to explain it:

Founded in 1872 as a Pioneer Association, this 150-year-old cultural institution has deep roots in its community and a building that's a former Masonic Temple; ergo its logo, an illustration of a medieval fortress door with an easily imagined rampart and surrounding walls. The museum today is "affectionately known as the History Museum at the Castle."

If your museum has a story behind the name, that could become your signature line. It works like a logo to quickly identity you by your credentials,

and your stature in the community. Use your logo and nickname origin story to identify history-bearing materials such as:

- Tour handouts
- Programs for talks
- Education proposals
- Lead-in to videos
- Volunteer training material
- Solicitation material

Logos aren't a museum's brand; the brand has been built and nurtured over years of faith and credence on the part of the museum, its stakeholders, and the public. The logo is short reminder of that. It goes everywhere.

BRANDING CHECKLIST

If a consultant tempts or encourages you to redesign your logo, don't do it until you ascertain first whether your current identification mark:

- Appears on all your communications, in all media
- Reflects your mission, vision, values, personality
- Has a good, explanatory, or clarifying logo line
- Can accommodate a new logo line
- Meets the approval of your staff, board, volunteers, and suppliers
- Looks good in black and white, reduced or enlarged in size
- Makes a strong statement when paired with a partner's logo
- Resembles, or is distinct from, logos of similar organizations
- Conforms with the practices of designers and graphics professionals
- Retains its meaning and impact with future programming or expansion
- Communicates your intended message to all audiences, domestic and international
- Will be costly and time-consuming to change

REFERENCES

"A House with a Heart and a Soul," The Mark Twain House and Museum, https://marktwainhouse.org/ [accessed May 10, 2024]

Abbott, Karen. "Madame Restell: The Abortionist of Fifth Avenue," *Smithsonian*, November 27, 2012, www.smithsonianmag.com/history/madame-restell -the-abortionist-of-fifth-avenue-145109198/ [accessed August 7, 2023]

Abilene Zoo @AbileneZoo 1/7/23 X (formerly Twitter) [accessed August 14, 2023]

Abilene Zoo @AbileneZoo 8/3/23 X (formerly Twitter) [accessed August 14, 2023]

The Dali Museum @TheDali 4d X (formerly Twitter) [accessed August 5, 2023]

"Delaware Water System Driving Tour," www.timeandthevalleysmuseum.org/wp-content/uploads/2020/10/Delaware-System-Driving-Tour11x17.pdf [accessed August 14, 2023]

"Exhibitions, Tours, and Events," Bruce Museum, https://brucemuseum.org/whats-on/exhibitions-highlights-tour/ [accessed August 14, 2023]

"Helping to Preserve the Future of our History," The Dakotah Prairie Museum Foundation, https://dacotahprairiemuseum.org/ [accessed July 29, 2023]

"Home," The Susan B. Anthony Birthplace Museum, www.susanbanthonybirth place.org/ [accessed August 1, 2023]

"Louis Armstrong House Museum," https://www.louisarmstronghouse.org/armstrong-now/ [accessed May 10, 2024]

"Museum of Work and Culture," The Rhode Island Historical Society, https://www.rihs.org/locations/museum-of-work-culture/ [accessed May 10, 2024]

"'Organize, agitate, educate': Susan B. Anthony," The Susan B. Anthony Birthplace Museum, http://www.susanbanthonybirthplace.org/ [accessed August 1, 2023]

"Our Mission," Harbor History Museum, https://harborhistorymuseum.org/our-story [accessed July 31, 2023]

"Our Mission," History Museum at the Castle, www.myhistorymuseum.org/about.html [accessed August 1, 2023]

"Planet Word," https://planetwordmuseum.org/ [accessed May 10, 2024]

"RISD Museum," https://risdmuseum.org/ [accessed May 10, 2024]

"Shop Unique & Memorable Suffrage Gifts," Susan B. Anthony Birthplace Museum, https://susan-b-anthony-birthplace-museum.square.site [accessed August 7, 2023]

16

Discussion Groups

Discussion groups, long popular with libraries, are needed by museums wanting to reenlist audiences. These groups have a genius for bringing people together, giving disparate gatherings something in common to talk about, and inviting newcomers inside a museum for a sociable and intellectual hour. With their range of possible subjects, neighborly facilitators, and short commitment of time, discussion groups agree with the way people live today. And how they refresh a brand! They're relevant, sociable, with stimulating topics and interesting people to meet.

This chapter lays out the steps for building a discussion group.

PLANNING

When planning a discussion group, one that will forward your brand, these are good steps to follow:

1. Decide on the framework.
2. Select the books, films, or topics to be discussed for the first year.
3. Identify the kind of facilitator that meshes with your community and be prepared to train that person or persons.
4. Learn how to conduct a discussion group.
5. Allow time for two kinds of follow-up.

FRAMEWORK: GETTING STARTED WITH STRUCTURE AND ORGANIZATION

After a museum decides on a discussion group and has justified the time of staff and return on investment beloved by the financial people, the next step is its framework and how it supports the brand.

Types of discussion, book, film, or topic. Books suggest readers; films are visual; topics could be current, historic, science-oriented, or biographic. Each museum should question what new audiences might be attracted to any

discussion group. Study carefully the many people in your community. Whoever you think your audience is, it will change tomorrow. At the most basic, it gets older.

Location. On-site, virtual, a different location. Where might your audience want to travel? Consider new audiences, and the time they must allocate for a new venture. It's good to have them inside your space, so select the actual room, gallery, or terrace that lends itself to talking together. Forget the theater; it's too formal. What about the lobby, which is more informal?

In Massachusetts, the Art Lovers Book Club at Attleboro Art Museum holds discussions about artworks, the artists themselves, and artists' workplaces; it meets in the museum's gallery or its art studios, places where art is at home. It's a connection to the books being discussed, and connections are smart branding.

Art Institute of Chicago offers a walking discussion group: a 1.5-hour gallery discussion and tour in which there is "no pre-set itinerary; the interests of the program participants will determine the artworks we visit. Participants will be invited (though not required to) to briefly introduce themselves, and museum staff will respond with artworks for the group to view and discuss."

Time and date. Whatever has proven appropriate or convenient for other events doesn't necessarily work with a new concept. For new audiences in the age of rethinking everything, think about new work-from-home schedules, new kinds of workweeks, and new concepts of 9-to-5 and weekends.

Materials needed by group participants. Will they buy or borrow a book, rent a streaming movie, download attached handouts, rent videos, or use online resources of other institutions? All these are easily available now.

Peripherals. What is added to the discussions? Maybe you'll show the book, printouts of movie reviews, or a related object. Perhaps it's wise to hand out discussion questions before the talk begins. At the end, you might have a suggested reading list. Distribute a sign-in sheet, preferably with a space for email addresses. Measure attendance.

Announcing the discussion group. Where to publicize a new program is a brand consideration. Audiences interested in Calendar Items differ from those checking your Events. Discussion groups deserve a higher tier, like their own tab. People who open an email follow different motivations than people who follow Twitter, Instagram, and Facebook. Your museum already intuits its audience, but the past is no guarantee of the present or future, so don't forget the next new platform. And influencers appear elsewhere besides YouTube.

Audience metrics. Of all the measurements of success, one is foolproof: how many showed up. Analyze with colleagues later how involved the group participants were in the discussion; how many wanted to see a trailer for the next movie; if they wanted to know the name of next month's book. Ask what genre of book or movie they enjoy. Find out what kind of topics they like to explore, such as history, science, philosophy, science, travel, recipes, civic issues, business, the arts. Backing up a bit: At the beginning of the session, ask each to say why they came to this book-movie-topic discussion group. Repeat that question at the end. Send a follow-up email thanking them for attending.

People involved. This loaded question accompanied every meeting in the history of the world; in a new project it affects one's brand. A staff member is necessary to start and run a project. After that, a museum has a choice of organizational men and women. These are people who schedule, brief the speakers, train staffers, write the announcements, set up chairs, turn on lights, open the doors, design a sign for the entrance, and stand by for tech support. Outsiders may help and volunteers are hoped for. Everyone is your face to the public, and this assists or detracts from your brand.

TOPICS FOR DISCUSSION GROUPS

First and most important, discussion groups must revolve around a museum's brand: its collection, exhibitions, new acquisition, its schedule of talks and programs. To pass muster, these groups must suit a museum's long-term strategy and enhance its brand.

Look for group topics among your existing programs to see what has already drawn audiences. Talk to the people who run these groups. You may find they have a point of view that expands to a monthly or quarterly discussion group schedule in one of these sources:

Tour guide manual. Ask curators and educators what aspects of an exhibition, or individual object, they want to interpret. There's a topic for a discussion group to interpret.

Volunteer training programs. Read what the museum's website communicates to its volunteers. Ask the volunteer coordinator. Some museum volunteers can fix engines, clean salvaged maritime wreck objects, tell stories, explain the traveling box contents. Those are some topics a different constituency might enjoy discussing.

Lecturer topics. Good lecturers select unusual, untried topics to talk about. Any scheduled talk would benefit from a scheduled discussion group. Q&A is entrenched as a mini discussion group at the end of a lecture or presentation.

Socrates Address by Belgian artist Louis Joseph Lebrun, 1867, Sotheby's Auction House. Socrates, arguably the best discussion leader of all time, asked good questions. It's a time-proven format. *Wiki Commons*

Illinois Holocaust Museum & Education Center expands the concept technologically by encouraging members of the audience in its hologram talks to ask the presenter questions. What's fresh and new is that the presenter is a hologram, sharing the personal recollections of a Holocaust survivor. After the short, pre-recorded talk, a docent at a podium asks for questions from the audience.

> "High-definition holographic interview recordings paired with voice recognition technology enables Survivors to tell their deeply moving personal stories and respond to questions from the audience, inviting visitors to have a personalized, one-on-one 'conversation.'"

It's a bit of magic, a lot of technology, and a modern forward-looking technique for developing curiosity about the past.

New books in the museum store. Look at the title, jacket flap, table of contents, and images. All are sources for a discussion topic. If the page count is under three hundred, the book itself leads to a discussion.

Cincinnati Art Museum looked for books and found a discussion topic, "See The Story," which targets people who love to read and people who love art. Facilitators work in pairs drawn from Cincinnati Art Museum staff and librarians from the Public Library and Hamilton County. From 2023, one discussion centered on a book about Pablo Picasso's cook. Just imagine! Aren't you curious? "See the Story" is a brand name for today, a new hybrid of learning. That's what discussion groups are all about. Talk to the public library in your community.

Website. Small museums often put their creation myth and ensuing story online. Their archives contain more stories, in photo, diary, letter, recipe, and map documents. If gallery walls could speak, they couldn't tell a fraction of the stories these documents hold.

Teachers' lesson plans are accessible on many websites under Education, generously available for anyone to see. Most are for grade school classes, but as adults know, young people's minds are an excellent place to find unimaginably clever ideas.

Here are some topics, for instance, from Mission San Luis de Apalachee, in Tallahassee, Florida:

- Life on the Spanish frontier
- Music at Mission San Luis
- Spanish Friars and religion's effect on the Native Americans of Spanish America
- Trading partners

- Traditions of the Apalachees
- Seventeenth-century science

Demonstrations. Programs and workshops often consist of how-to demonstrations, anything from glass blowing to beehives to boatbuilding. Get the story behind the demo and you have a discussion waiting to be held.

Newport Mansions tried a more down-to-earth event in the summer of 2023, a "more intimate, educational tasting experience." The museum admitted in print that "The Annual Newport Mansions Wine and Food Festival will look a little bit different this year." Sounds like an informal discussion of two topics usually seen as elite gourmet. Museums everywhere are taking a deeper, broader assessment of their communities and seeing ways to adapt.

Archive. This incredible resource, continually replenished by the museum and the community, is a gift to discussion groups. They often contain books and films for discussion. Digitization makes many things available.

Online designer/art director. Talk to your visual people; they see stories others don't. It's their nature. Ask what ideas they get from the pages they design. They also have visual resources that can be developed into book, film, or topic discussions.

Yoga class. Yoga instructors like to verbalize their disciplines. Sometimes, they have refreshing insights that add to a museum's reputation for learning. Many classes are outside, in nature, which might relate to your brand.

If it's a crazy idea, rattling the boat and mixing the metaphors, it's a topic for discussion. And a step forward to a renewed brand image.

FACILITATOR

A group facilitator can come from many places: museum educators, docent tour guides, or the museum bookstore. Professional facilitators are great if they understand the museum's brand reputation and personality and complement your style. Facilitators have personalities, too. Take a cue from the many types of tour docents.

Georgia Writers Museum enlists a local college professor of English to lead book discussions on Georgia writers. Professors excel at comparing and analyzing, and drawing out insights from their classes. Ask a professor whose research area jibes with your museum's collection goals to talk about that topic. Professors can talk about anything!

Authors might be willing to lead a discussion—length negotiable—as part of their tell-and-sell book tours. Make sure the discussion centers around a topic from the book, not the authors themselves.

The hike leader at Swannanoa Valley Museum Hiking Club is a ready-made discussion group facilitator. He presides over the club's monthly hikes, each of which has a name like Pinnacle of Blue Ridge, Grey Eagle Rock, or Garden of Eden. There's a manual where written material could provide topics to explore intellectually. There's already a close-knit group of dedicated hikers. Museums with cooking, quilting, or aviation clubs have groups already assembled; the addition of a discussion group with sharing of knowledge enlivens the museum brand.

For book club discussion topics, look at the bookstore shelves. Swannanoa often stocks books for its neighbor, the Swannanoa Library, and its book club.

Museum of Fine Arts of St. Petersburg has a brand name for its discussion and a named facilitator. "Coffee Talks" is a well-established, regular discussion group held at the museum. The facilitator is part of the brand name. A regular leader engages and retains discussion group members (and museumgoers) by promising a familiar format everyone already appreciates. It's stimulating, sociable, and comfortable. No matter how far and wide the topics range, the leader and format are known quantities. A good place for a museum to be.

Not all museums have the luxury of a named host; however, any named facilitator, even an occasional one, adds familiarity with and connection to the museum. Good branding for all.

Wherever you find a discussion leader for your group, be prepared to train them. They aren't lecturing, or teaching a class, or selling books. They're facilitating, and it's a skill. Train museum people; look internally for good listeners and encouragers you didn't know you had.

HOW TO RUN A DISCUSSION GROUP

People who come to talk in a discussion group that's part of your museum are invaluable branding consultants. Here are some guidelines:

1. Ask participants to introduce themselves and say why they're there. Why are they participating in this group discussion? A good leader will welcome the differences around the table, or across the Zoom screen: They break the ice, show the names and faces to have real personalities. Introductions prompt the leader to explore the different viewpoints. And it's a good ice-breaker; people like talking about themselves. The discussion leader starts off, telling why they're interested in this discussion topic; it's a model for others.
2. Look out—and listen up—for the differences in your group. The usual diversities are now joined by mixed race families, adult stand-ins for a parent, work schedules, family responsibilities, education, immigration,

and the military. There's no end to the embarrassing faux pas a facilitator can stumble into. Be aware of this and, perhaps, talk less and listen more.

3. Use name cards. People love their own names. They want to be recognized as Anna Marie, Patience, Hyunjung, Shanida. Ask for the correct pronunciation, by all means. You can't embrace diverse audiences if you can't pronounce their names. Also ask James, Patricia, William, and Margaret what they want to be called. For virtual discussions, participants may need instruction on how to change "2nd laptop" to "Leslie"; if possible, take time to show them or ask if someone in the group can explain. If you can provide a list of instructions for virtual help later, it's a way to involve them with the museum even more.

4. Prepare a list of good questions. Chances are, you won't use them all. Some leaders provide written handouts before the session; it's a way to keep the talk vivid longer.

5. Congratulations if your group is continuing. You have a loyal audience, so welcome them back and welcome newcomers warmly. You have probably already modified your approach a bit, based on what you've learned from your audience. Thank the group for discussions that prompted any modifications.

6. During the discussion, jot down some questions you can position as "good comments that deserve a fuller discussion." It fills gaps, if necessary. Also, this notetaking forces the leader to listen to how other people think. Listen for the quiet asides and look for the wrinkled forehead of confusion. The leader can always say: "Interesting point, let's explore it a little more."

7. Danger zones to finesse: Responding to questions you don't know the answer to:

 • Admit you don't know and ask the group for help.
 • Cutting off people who talk too long. Find a pause and interject: "Wait. That's interesting. Let's discuss that."
 • Responding to people who have special knowledge about an object or display. Say: "Do you mind taking a few minutes to tell the group about that?"
 • Assuming all attendees have college degrees. Don't assume that. They won't, and it doesn't matter. It's a common faux pas that embarrasses everyone.

8. Realize that we're in a hybrid world now. Virtual discussions are here to stay. They enhance every aspect of the museum; they don't replace anything. Leave a few minutes for simple tutorials with the group. Show how to use Chat, Q&A, and the raised hand symbol. Realize that different people use different devices, of differing generations. They haven't mastered good lighting or camera angles. Not everybody has a home office.

Do politely ask everyone to put barking dogs and other noisy mammals in another room.

9. How to listen carefully. Good listening continues after the discussion group goes home, take a few minutes to reflect on what you heard. Jot down two or three points; they're your agenda of the discussion to be held later with the rest of the staff and volunteers. Some museums leave a notepad for that purpose.

Set aside a regular time for "What Went Right, What Went Wrong" meetings. It's good for operations and great if you're reassessing your brand image and brainstorming some implementations.

A discussion leader in the Midwest recounted a newcomer from Massachusetts apologizing "for my funny Boston accent." It was an aside, but the leader realized the insecurities some people have about their own accents.

Read the T-shirts: Big Mike, Sunnyvale Swim Team, Grandma Spoken Here. They're insights into what's important to your audience. Discussion groups are where visitors connect what's inside the museum with what's outside.

Get to the discussion group early and listen to the group's chit-chat. It's how they talk when they're not in a formal setting.

Remember this about discussion group participants: They're already inside your museum, already familiar with it; they will reveal your brand to you if you listen carefully.

AUDIENCES METRICS AND FOLLOW-UP

It's not over when it's over. After every discussion group you have two more tasks:

(1) Count heads and keep track of how many people attended. Small group or large, size doesn't matter as long as you analyze how a discussion group adds to your brand positioning and growth for the future.

(2) Send a thank-you-for-attending email. Of course, you have captured their contact information. Of course, you will add to your database their date of attendance, number of repeat attendances, and where to reach them with future events and programs.

BRANDING CHECKLIST

Do your discussion groups:

- Extend your influence into the many unrepresented segments of your market, such as background, age, work-life balance?
- Nurture curiosity in your collection and mission?
- Uncover ideas and processes that you've never tried before?
- Cause the planning committee to yell, "but we've never done it this way before!"

REFERENCES

"Arts Lovers Book Club," Attleboro Arts Museum, https://attleboroartsmuseum .org/art-lovers-book-club/ [accessed July 5, 2023]

"Coffee Talks with Nan Colton: Living in the Sunshine," Museum of Fine Arts St. Petersburg, June 14, 2023, https://mfastpete.org/event/coffee-talks-living -in-the-sunshine/ [accessed June 15, 2023]

"Meet Virtual Holocaust Survivors," Interactive Holograms: Survivor Stories Experience, Illinois Holocaust Museum & Education Center, www.ilholo caustmuseum.org/exhibitions/survivor-stories-experience/ [accessed July 1, 2023]

"Mission San Luis de Apalachee: A Teacher's Guide," A Florida Heritage Publication, Florida Department of State, 1998, https://missionsanluis.org/ media/1732/02-teachers_guide-sm.pdf [accessed June 19, 2023]

"Newport Mansions Wine and Food Festival," www.discovernewport.org/ event/newport-mansions-wine-%26-food-festival/56143/ [accessed June 19, 2023]

"See the Story Book Club," Cincinnati Art Museum, www.cincinnatiartmuseum .org/events-programs/adults/see-the-story-book-club/ [accessed June 30, 2023]

"Slow Looking: Museum Matchmaker Edition" (discussion group), Art Institute of Chicago, May 19, 2023, www.artic.edu/events/5613/slow-looking -museum-makeover-edition-may-19 [accessed April 11, 2023]

"Swannanoa Rim Explorer Hike Series," Hiking Programs, Swannanoa Valley Museum & History Center, www.history.swannanoavalleymuseum.org/rim -hike-explorer-series/ [accessed June 30, 2023]

"Writing Memoirs," Georgia Writers Museum, https://georgiawritersmuseum .org/writing-memoirs/ [accessed May 10, 2024]

17

Architecture

Your building is your biggest logo. You know what image it sends, but that's just your side of the story. What do others see?

It is all a matter of perspective.

This chapter looks at museums' physical structure from the point of view of visitors—tourists, locals, schoolchildren, ticket holders, scholars, donors, partners, staff, volunteers, and suppliers. That is the brand message they will get. From parking lot and bus stop to the front desk and beyond, that big logo makes a massive impression. We'll talk about the:

- Building
- Approach
- Virtual approach: website home page
- Place in the community
- Campus
- Volunteer room
- Facility rental spaces
- Space to reflect

Building architecture can be old or new, traditional or astounding. Or just plain plain. Museums of any size or genre find ways to evolve their spaces as their collections and interpretations evolve. However your building looks, help it look like yours. Show it off, talk it up, with pride.

BUILDING

It is when one considers small museums that brand identity needs reinforcing. Small never means insignificant. It plays a large role in the history of your region. It may represent an important niche in architecture history. The people who lived there might have been world builders. Your space is all important, so tell why: "The Hacienda de los Martinez is one of the few northern New Mexico

style, late Spanish Colonial period, 'Great Houses' remaining in the American Southwest. Built in 1804 by Severino Martin (later changed to Martinez). . . ."

Invite closer inspection: "This fortress-like building with massive adobe walls became an important trade center for the northern boundary of the Spanish Empire." It seems as if it's a major stop in the march of history.

Explain architectural choices: "Doorway heights within the Museums are consistent with historic architecture." Add some personality: "Watch your head!"

Every building has architecture. Museums are fortunate to know the provenance of the building, and that expresses your brand. Here's how to enhance it:

- Look for architectural details and explain them, which adds to the brand history
- Ask locals for their description of the building, which engages people
- Discover the intended use of hidden spaces; exploration shows forward movement
- Learn about the architect or builder; people are part of your brand

"Buildings might try to hide their past, but 'ghosts' supply hints to the secrets."

The blog of Adirondack History Museum, in Elizabethtown, New York, reveals the visual history of an architectural landmark and it gives your brand a backstory, a special richness.

In the case of an old Yankee courthouse, where abolitionist John Brown's casket once spent the night, the story was about windows, an enlightening subject for architecture buffs.

Architectural history is important to your museum's brand because it is your own and yours alone. It's part of your looks and personality, your strength and eccentricities. Researching and writing about a museum's history instills self-pride in staff and volunteers, as well as members and the community. And a blog is a serious place to tell the story.

In a world of "starchitecture" and rooms with views, a museum with a more basic design is cause for renewed look. Definitely renewed in the case of The Chinese American Historical Museum (aka the Ng Shing Gung Museum) in San Jose, California. It was built in 1888 as a community center teaching Chinese calligraphy and literature. It doubled as a "hostel for travelers who did not belong to any of the local family associations." Now that's a unique slice of American history not found in other museums!

The two-story, Chinese-style building now sometimes—rarely—seen in old-city back streets in China has an ornate shrine on the second floor. But the original California citizens grew up and moved out, and the Immigration Act kept new people from moving in, and the building was torn down. Now it's

Museum of the American Arts and Crafts Movement, in St. Petersburg, Florida. Your building is the biggest brand you have. Grand or humble, new or seasoned, it joins the community and welcomes it inside. *Margot Wallace photo*

been replicated, board by board. Preservation, interpretation, and a volunteer corps trained to retell the story is another way for buildings to bear their brand.

Does your museum have a story underneath the floorboards or between the lathe and plaster? Look for the splinters and dust.

When a building is two years in the future, that's a good time to start practicing your brand message. All anyone sees is bare bones, and they want to know how they'll be fleshed out. Meanwhile, everyone is looking and wondering, and not just passers-by but visitors, members, staff, capital campaign donors, and reporters.

The mission of a work-in-progress should be clear. Milwaukee Public Museum declares its mission in the context of a new building like this: "A New Place to Gather and Learn."

It goes on to explain the Wisconsin geography and geology, ecosystems and cultures that inform its collection and interpretation philosophy. There's an image of the proposed building, and a detailed description of galleries, classrooms, and amenities, capped with a roof garden. All geared to gathering and learning. It's clear the museum knows its brand and vision going forward and can document it.

Look at the branding ideas that emerge when a museum explains a multi-year capital project:

- Augmented learning ideas
- New audiences to meet and welcome
- Featured exhibits and interpretations
- Expanded exploration of the museum's place in the social and natural ecology
- View of the future

If you have a celebrated profile, plan, concept, and architect, share it. It's interesting and it brands you as forward-thinking.

The Guggenheim Museum in New York had a very large architectural concept, which was described in an e-newsletter:

"Part UNESCO World Heritage Site, the Solomon R. Guggenheim Museum is a one-of-a-kind building designed by Frank Lloyd Wright.
Did you know . . .?
. . .Spiral ramp is 1/4 mile long.
. . .Design initially had two ramps, but the second was so steep, it was almost a slide!
. . .Interior walls of rotunda are tilted outward at 97 degrees, to emulate an easel's tilt."

For museums much smaller than a Guggenheim, if your museum has architectural details that show the hand of an artisan, talk about them. The details to be learned about a quoin or a mullion appeal to people who expect to learn

something new inside. Your architecture's history augments your brand's durability and heritage.

APPROACH

Here's a novel concept for selecting an architect for museum remodeling and expansion: Respect the existing building, an acknowledged beauty, and adapt to the present and future.

The winning design changed the way visitors approach the building, through a garden that "puts you in the presence of art before you set foot in the museum."

The existing structure, elegant on the inside, was fortress-like, because it was situated in a corner of Dallas filled mostly with parking lots and garages. Over forty years, the neighborhood had become a robust art district with two other museums and a sculpture park. The new building faces outward, toward the community.

Another category of "Approach" was the Dallas Museum of Art's process for selecting an architect. It paid a $50,000 stipend plus expenses to six finalists for their final presentations. Finalists were brought to the site to examine the current structure together, to interact with their competitors. A community of professionals, if you will, brought together physically and quickly intertwined emotionally to further the cause of museum architecture.

Connecting to the neighborhood is a goal with a concrete plan in Cincinnati. The redesigned Cincinnati Art Museum built the grandest of staircases connecting the neighborhood of Walnut Hill with the front door. And then named it the Art Climb. It connects physically with a clear route from the street and parking lot to the museum's front door. It connects intellectually with art spaces all along the steps. Good reasons to pause one's climb!

Brands survive and flourish when they find new ways to reach and communicate with their many audiences, whose diverse traits include how they navigate to a museum, and how easy the path is made for them. New ideas are honored most when they delight rather than daunt.

Most people see museums long before they enter them, if they ever actually overcome intimidation and do enter. The Buffalo AKG Art Museum, formerly known as Albright-Knox Art Gallery, broke down several walls to approach the public and encourage everyone to approach its new persona. Buttressing its new we-the-people name is a people-friendly courtyard, covered but not hidden from Buffalo weather by a crystal dome that rises from a crystal-like architectural sculpture. The tree-like, sky-like "Common Sky" was collaboratively designed by an architecture firm and an artist who joined in dedication to the AKG brand, old and new.

This old-new museum pays attention to words. It is renamed after the city, not two elite founders. The new courtyard is specifically "not a lobby." You

don't have to pay to gather in the courtyard for programs, a restaurant, and a play area.

The parking lot has been covered over with grass, becoming the "Great Lawn," while cars now park warm and dry in an underground structure.

The Buffalo AKG Art Museum exemplifies a brand redesigning itself for its people: how they live today and how they respect their past.

VIRTUAL APPROACH: WEBSITE HOME PAGE

Before visitors set forth on the road to your building, they approach it via your website. They view the home page and see the journey becomes meaningful.

Dana Adobe & Cultural Center tells visitors it preserves a National Landmark adobe house that depicts the history of California's Rancho Era, its peoples, and the land.

It shows visitors a wide landscape photo of the house. The appealing building declares itself at the beginning of a website exploration, a virtual approach that signals the museum's heritage.

An oversized ladybug and a tall statue share the home page of Milford Museum in Milford, Delaware. And then the ladybug moves resolutely through every succeeding page. The sturdy red brick building, commanding statue, and industrious insect give clues to the collections inside, including Milford's legacy industries: "shipbuilding to canned goods to wooden spoons." Ladybugs, by the way, are omens of good luck, so imagine the worthy experiences to be found inside.

In Iowa, Sioux City Art Center credits its "model partnership" with the City of Sioux City for its dynamism. Its mission is "to enrich our region's quality of life by bringing the excitement of the visual arts to our community." Its home page shows the bold architecture of a museum in a big city, and signals to visitors, virtual or otherwise, the heart and intent of this institution.

Museums on the Green, plural, is a collection of buildings that star on its website. The home page visual shows a lighthouse situated on water, and every tab links to another building. The sprawling campus in Falmouth, Massachusetts, promises a lot of history, plural.

CAMPUS

When buildings multiply, and their surroundings expand, a campus is formed, and this spread enriches a museum's brand in many ways. One important value of a campus is the multiple perspectives that relate the history of the people and their community.

The re-created buildings of Fort Casper Museum at Platte Bridge Station vividly describe life in Caspar, Wyoming, in the 1860s. To see the sparse equipment-filled rooms reveals the fact behind the legends of transcontinental telegraph lines, the soldiers' mess hall, a blacksmith shop that "served the needs" of those traveling on the trails, and the sutler who ran the general store

and social center of the fort. Photos of the replica buildings, with brisk text, appear on the museum's website, creating a virtual new annex for the 150-year-old museum.

For other museums, wished-for buildings exist only in archives. Fortunately, local historical societies and museums maintain unequaled documents of the lives of their communities, down through history and up to the present. Small museums can make these documented buildings larger than life in several ways:

- Blogs with stories of the buildings and their uses
- Photos of people who lived, studied, and worked in the buildings
- Maps of where the buildings stood
- Ephemera from buildings as visual starting point for short videos
- A QR code next to photos of buildings that links to an on-camera narrator

Museum brands increase in robustness and reputation when they connect to their larger campus and community.

For example, the nine buildings surrounding Empire State Aerosciences Museum in Grenville, New York, add up to a stronger brand because each structure interprets the collection differently, and the paths leading to them tie their stories together. The campus includes Schenectady County Airport and its runways, and holds hangars, aircraft, a museum for artifacts and documents, and classrooms for school groups to learn about aviation history. Its view of the active runways adds the singular appeal of an airport where Charles A. Lindbergh's plane landed shortly after his famous transatlantic flight. Aircraft for World War II were built here, and rocket and jet engine research took off here.

Maybe your museum's surroundings also have landmarks, not famous perhaps, but notable:

- Street where it resides
- Neighborhood with its own personality
- Village green
- Historic downtown
- Statue of a local hero
- Cemetery with a history

No landmarks readily available? Create a campus: Add benches from supporters with their own stories, and now you have a park with a background Research your plantings, which, of course, are regional, and tell your nature-loving audiences about your environmental activity. Point out a path that other generations trod; exploration continues outside your galleries.

Added elements surround a museum with context and connections. They visualize history and nudge curiosity. Each pause on campus increases contact hours with your message.

The terms "campus" and "grounds" augment your brand in more ways than expanding it. They give a museum—traditionally thought of as a building—a neighborhood. In the case of Forest Lawn Museum, a building surrounded by a cemetery, the community is not just the past but the present and future, as prescribed by Forest Lawn's founder in his Builder's Creed: "our park should be 'a place where artists study and sketch; where schoolteachers bring happy children to see the things they read of in books.'"

To that end, Forest Lawn Museum displays its permanent collection and rotating exhibits, and schedules free education and art programs. It also honors its Southern California climate, flora, and fauna. On the website's Visitor Guidelines pages, a thorough description of its particular environment includes:

- hills
- lighted pathways after sunset
- gardens
- regularly tidied individual grave tributes
- wild animals
- required supervision for children under 16

Most museums have surrounding territory. Describe it and expand your place in the community:

- Paths paved with New England cobblestones
- Entrance framed by Georgia pines
- View of the lake from the terrace
- Function rooms overlooking the city

Nobody intertwines architecture and campus like Crystal Springs Museum of American Art. Its property in northwest Arkansas lies amid rolling landscapes of woods and springs, bridges and ravines. Trails through this verdancy are part of the architecture. Architect Moshe Safdie designed the campus and the structures on it "to provide views of the surrounding landscape and play up the interaction between architecture, art, and nature."

Architecture is the heart, soul, and intellect of the museum, which offers videos on Frank Lloyd Wright as well as Safdie; a summer camp session for budding architects; and a blog series on Architects of Nature. The architecture-themed blog includes articles like "Avian Builders and the Complexities of Birds' Nests" and "The Busy Building of Beavers."

PLACE IN COMMUNITY

Sometimes a museum campus is the old neighborhood.

Louis Armstrong Center at the Louis Armstrong House Museum opened in 2023. It's an accessible archive for the audio and video recordings, documents, and objects of sixty-year career. And it is brand-fitting that it was recently relocated to the street where Louis lived. As a review in *The Wall Street Journal* says of the museum:

> "It stands out as well as fits in, just like Armstrong did.
>
> And it makes a larger point. Jazz often lives and grows in residential spaces far from elevated venues. . . Protecting these spots reinforce jazz as a culture marked by individuals, families and communities, each with their own story."

The community is part of your brand.

In another neighborhood, the Driehaus Museum, a Belle Epoque mansion in an upscale part of Chicago, stands firmly by its mission to tell all sides of a not-wholly-gilded age in Chicago's history. A major construction project offered the Driehaus an opportunity to talk about its place in history—Chicago's and architecture's—not its gilt and glitter.

Projects that renovate glamorous spaces, as well as administrative floors, are seductive for brands intent on being smart, as well as beautiful. Driehaus uses "re" words like reinforcing and revitalizing to mark its place in a dynamic, changing city. Driehaus not only expanded its built spaces but wrote about them, sharing that the project will reuse former office space for a learning center, art and maker studios, outdoor terrace on the top floor, and a world-class performance space. They said it would be "a more active and visible part of the community" that is revitalized and "reinforces and celebrates Chicago as a great architectural city and artistic center."

FACILITY RENTAL SPACES

As new buildings arise, and old buildings renovate, rental spaces emerge as architectural delights. It is not just about the fees; now the museum is a special exhibition in itself, one whose visitors appear in droves to attend a wedding, party, or conference. Legions of new audiences, meeting and greeting and eating while they enjoy everything you can offer. Offer some exhibits, some learning, some new perspectives, maybe even trail walks, like Shaker Village of Pleasant Hill, in Harrodsville, Kentucky.

Here's how National Nordic Museum in Seattle describes one of its several rental spaces: "The museum is designed around a linear Fjord Hall that weaves together stories of homeland and the Nordic experience . . . including a PA system, dramatic lighting, and one-of-a-kind art object installations."

Other museums with different architecture might include:

- Views of the harbor, the river, the hills, the city
- Terrace seating with music
- Hard-hat tours
- Neighborhood tours such as gardens or landmarks
- After-hours access
- Libraries for business and scholarly meetings
- Classrooms for education meetings

VOLUNTEER ROOM

Museums can offer hospitality to their volunteers, too. A small gesture like a volunteer break room gives these hard workers a chance to exchange experiences and see their skills at work. Even a small space provides a professional atmosphere where one can find their badges, name tags, and a daily comment log: a laptop where volunteers enter comments from visitors and on-the-job observations for everyone to see. It's a setting to show videos of volunteers sharing their stories.

From inside its walls, Owls Head Transportation Museum, Owls Head, Maine, says:

"Volunteers: People from all walks of life find another home at the museum."

A home away from home. That's one of the nicest things ever said about a building.

ROOM FOR REFLECTION

The smallest room in a museum is one most will have to create on the spot. It's the space where a tour ends, before anyone leaves the tour. This space takes up about one hundred square feet, depending on the number of people in a group. It takes up about 5 minutes of time. In this space, the tour guide asks:

- What will you remember about this tour?
- Is there one object or work that you liked best?
- Did anything need more explanation?

As each person reflects and then shares with the group, new ideas leap out, different perspectives seep in, and more lasting memories are made.

BRANDING CHECKLIST

Thinking about your building, all its small and large details, have you:

- Put signs or labels near the ones that add to your brand's heritage?
- Mentioned them on your website as stops to look for on a visit?
- Written a blog about their significance?
- Added them to a tour?
- Announced their importance to your revitalized exhibition space?
- Created a talk or workshop around them?
- Added related merchandise to the store?
- Told volunteers and staff about them?
- Utilized them for donor events?

REFERENCES

"Architecture," Crystal Bridges Museum of American Art, https://crystal bridges.org/architecture/ [accessed August 30, 2023]

"Art Climb," Cincinnati Art Museum, https://www.cincinnatiartmuseum.org/visit/art-climb [accessed May 10, 2024]

Blumenfeld, Larry. "The Louis Armstrong Center Review: Jazz's King in Queens," *The Wall Street Journal*, July 18, 2023, www.louisarmstronghouse.org/our-new-center/ [accessed September 17, 2023]

"Buildings Tell History Tales, Essex" (blog), Adirondack History Museum, May 10, 2023, www.adkhistorycenter.org/blog.html#!/blog/posts/Buildings-tell-history-tales/222 [accessed July 22, 2023]

Byrnes, Mark. "How Buffalo's Art Museum Hopes to Win Over the Working Class," *Bloomberg News*, July 20, 2023, www.bloomberg.com/news/features/2023-07-20/albright-knox-art-gallery-reopens-as-buffalo-akg-art-museum-after-oma-renovation?cmpid=BBD072123_CITYLAB&utm_medium=email&utm_source=newsletter&utm_term=230721&utm_campaign=citylabdaily [accessed July 22, 2023]

"Chinese American Historical Museum (CAHM)," Chinese American Historical Museum, https://chcp.org/Museum [accessed September 31, 2023]

Dana Adobe & Cultural Center, www.danaadobe.org/ [accessed September 16, 2023]

"The Driehaus Museum Embarks on an Exciting New Project," Murphy Auditorium Renovation, https://driehausmuseum.org/construction?mc_cid=1038e379f8&mc_eid=b97d54fadb [accessed May 19, 2023]

"Fort Grounds," City of Caspar, Wyoming, www.fortcasparwyoming.com/cms/One.aspx?portalId=89189&pageId=89943 [accessed September 15, 2023]

"Get to Know the Guggenheim Building," email to list, Guggenheim, August 19, 2023,

"History of ESAM," Empire State Aerosciences Museum, www.esam.org/history [accessed September 17, 2023]

Lewis, Michael J. "The Dallas Museum of Art Picks a Winner," *The Wall Street Journal*, August 3, 2023, www.wsj.com/articles/the-dallas-museum-of-art-picks-a-winner-9d3eedf0?reflink=integratedwebview_share [accessed August 3, 2023]

Milford Museum, www.milforddemuseu.org [accessed September 16, 2023]

"Museums on the Green," Falmouth Historical Society, https://museumsonthegreen.org/get-involved/membership/ [accessed September 16. 2023]

National Nordic Museum, https://nordicmuseum.org/asset/646cf9a56b939/23_NordicMuseumRentals_Web.pdf [accessed September 10, 2023]

"A New Place to Gather and Learn," Milwaukee Public Museum, www.mpm.edu/future [accessed August 23, 2023]

Sioux City Art Center, https://siouxcityartcenter.org/ [accessed September 16, 2023]

"Summer Camps for Kids," Crystal Bridges Museum of American Art, https://crystalbridges.org/families/summer-camps/ [accessed August 30, 2023]

"Tailored Experiences," Shaker Village, https://shakervillageky.org/meetings/ [accessed September 17, 2023]

"Taos Historic Museums—E.L. Blumenschein Home & Museum and La Hacienda De Los Martinez," Taos Historic Museums, www.taoshistoricmuseums.org/ [accessed April 12, 2023]

"Video Archives," Owls Head Transportation Museum, https://owlshead.org/page/videos [accessed June 27, 2023]

"Visitor Guidelines," Forest Lawn Museum, https://forestlawn.com/about-us/visitors-guide/ [accessed July 27, 2023]

18

Publications

Publications are brand fuel: a sustainable source of forward thrust for your institution. You already have a brand; the challenge is to keep it. Publications announce your museum. Explain its workings. Paint its visions. They endure and renew. They are obtainable.

Of all the attributes of a good brand, publications shine when it comes to your:

- Reputation
- Permanence/stick-around factor
- Being forward-looking
- Being a community asset
- Building membership
- Donor assurance
- Scholarship and expertise (Deep research, variety of topics, thorough research—these are parts of publications that prove museums' expertise.)
- Inclusiveness (Just look at the Table of Contents. Diverse titles appeal to diverse audiences. More people see what your brand stands for, and what they can learn from it.)

As museums renovate their programs, exhibitions, and learning experiences, publications must be re-entered in their plans. Journals, newsletters, magazines, annual reports, scholarly papers, books, and archived material in a range of innovative formats give imprimatur to your brand, in innumerable, audience-specific ways. Museums' good reputation is in many hands, as it should be.

REPUTATION

Foxfire Museum, in Mountain City, Georgia, occupies over twenty log buildings and overlooks miles of hiking trails. It foregrounds the work of Appalachian artisans and their culture. A large list of titles puts their work onto the bookshelves

The man who published *Poor Richard's Almanack* appreciated the versatility of the printed word, as does the Franklin Institute today with transcripts for its podcast. The museum's yearlong series, "The Science of Music," is available in printed form, researched article-like episodes; and it sticks around online. Benjamin Franklin, also a great brand, is smiling. *Wiki Commons*

and nightstands of readers everywhere; and additions keep them there. Books are tangible ways to keep a reputation alive when the tangible museum requires visitors to hike there.

The Foxfire Books are anthologies of articles from the *Foxfire Magazine*, stories of "the trades, crafts, and livelihoods of the Appalachian pioneers." Cookbooks, how-to titles from winemaking to hog-scalding, and works by local writers fill out the catalog. Foxfire Museum oversees a heritage spanning a lot of years and topography, and its books keep the territory covered.

The *Lincoln Herald* is one of the longest running peer-reviewed journals about Abraham Lincoln and the Civil War. It has been published regularly since 1915 by the Abraham Lincoln Library and Museum in Harrogate, Tennessee. The issue of fall 1988, Vol. 90, No. 3, lists these features:

- "Dancing Attendance in the anti-chambers of the great: A Texas Unionist Goes to Washington, 1863"
- "What Was Abe Lincoln Doing in Pre-War Japan?"
- "Not So Strange Bedfellows: Thomas Ewing II and the Defense of Samuel Mudd"
- "Romantic Glimpses of Abraham Lincoln"
- "Faces Lincoln Knew: Photographs from the Past"

This remarkable achievement of longevity and intense investigation is a model of publication authority. It confers distinction on the institution that makes it possible. It would be hard to equal it, but as a role model for scholarship it has lessons to convey:

- Any subject can be explored more deeply, more often.
- Frequency carries authority.
- Strength of message is more important that size of messenger.
- Dig into your institutional memory and you'll find a subject as rich as Abraham Lincoln.

The Abraham Lincoln Library and Museum, with its unparalleled brand, might be tempted to rest on the laurels of the 16th president. No! It's too good a museum, and it knows good museums don't have the luxury of resting; they revise and refresh and revisit, or disappear.

PERMANENCE

Don't write off the magazine. It has staying power. It sticks around. It embodies the countertop effect of printed pages inside an attractive cover. The book, by the way, formerly known as a codex, has been around since 260 B.C. In 2022, Americans purchased 788.7 million copies, in print form.

The *Quarterdeck Magazine* reminds professionals and aficionados of the lure and lore of boats. Just to look at the magazine covers and main stories in its 50th year celebration underlines the branding bounty a publication brings to its museum:

- "The Columbia River Jetties: Battling the Columbia for Over 125 Years"
- "Maritime Archaeological Society"
- "World War II Merchant Ship Losses: Columbia River Built, Owned or Operated"
- "Exploradores! The Spanish and Northwest America"

The multiplicity fostered by the North Dakota State Museum is a large one—the totality of a state's heritage and culture plus the connections it fosters going forward. The museum publishes a journal for this, a regular account/record of its people and their pursuits. It looks very much like a big, beautiful magazine.

From 2015, for example, the cover stories looked at James Cash Penney (J.C. to the rest of the world) and his stores, and Northern Plains quilts and American Indian identity.

Speaking of quilts, consider the publishing activities of the National Quilt Museum. When it comes to permanence and stick-around value, one can't beat handmade quilts themselves. They represent everything a museum represents: heritage, ingenuity, community participation, interpretation, learning, respect for history, and striving for the future. And the National Quilt Museum has a publication as unique as its collection—A Block of the Month Club. (Blocks, for the quilting uninitiated, are the 12-inch by 12-inch squares that comprise a bed-sized covering.)

Look at the branding advantages of this regular, enduring club:

- Monthly consistency
- Membership
- Creativity
- Sharing of ideas and challenges
- Geographic scope
- Cross-culturalism

This club's output represents and refreshes the museum every day. Its publishes on its website and a social media platform. The world of publications is changing; a good lesson for museums that are forever.

Publications have expanded from print to microfilm to digital archives to websites, so why not to video? Many museums already save their ticketed virtual programs to YouTube for future viewing. Tenement Museum has a particularly good brand reason for it. The museum's brand is stories about

immigrant life on the Lower East Side of New York City from mid-1800s to 1930s. The museum is a basement to top floor virtuoso renovation of a tenement building whose exhibits are apartments where immigrants lived. Their stories are told and enacted and discussed in tours and programs. Videos are a brand-appropriate way to save these stories.

Other museums can use video-hosting platforms for:

- Lecture series
- Monthly book clubs
- An address from the director for annual reports
- Video "articles" for online magazines or newsletters
- Demonstrations of findings or methods in research projects

In the case of video-hosting platforms, the countertop effect has been saved to your desktop.

EXPERTISE

The name of this publication assures the depth and breadth of its expertise: *Holocaust Encyclopedia*.

Encyclopedic knowledge means something when its variety of formats, as well as the content, is varied and easily attainable. *Holocaust Encyclopedia* is:

- Well organized, for browsing or intensive research (the home page leads with a Search menu bar)
- Accessible—all in on one site, with hundreds of articles translated into eighteen languages
- Diverse in its methods of information delivery such as "digitized collections, critical thinking and discussion questions, lesson plans, oral histories, and videos"
- Continually developed "to ensure that it not just meets but exceeds our users' needs and expectations"
- Inclusive, with a focus on the worldwide information user rather than the information supplier

The lessons from encyclopedic publications are, by definition, organized in ways that museums of any size, genre, and mission can borrow:

- Focus—often stated in the first page Letter from the Director
- Table of Contents—articles titled creatively and clearly
- Visuals—photographs, illustrations, and charts provide evidence of research and significance
- Credit—Giving credit is deserved and essential. Authors, editors, photographers, illustrators, chart and map makers, graphics designers,

advertisers, and underwriting supporters all share in the responsibility for content.

- Variety of content—museum publications are broad minded and broad in application of mission
- Amenable to feedback and comments
- Audience-focused—that means many diverse audiences

LONG COPY

Magazines, journals, newsletters, books, blogs—online, in print, as video—show far-ranging inquiry, love of curiosity, and evidence of industry. They take fortitude to write, competitive drive to publish, and excellence if they are to continue. As you review your various publications, use this key to measure length of your articles, announcements, and posts: The standard number of words of an authored article, edited for mainline media publication is 800.

Use your own definition of "mainline" and "article." Think strategically about the abundance of platforms to choose from. Ask your writers how they like to tell your stories.

COMMUNITY ASSET

The Chinese community in Butte, Montana, has a museum to mark it, research it, and keep it robust. Mai Wah Museum serves a large diaspora that spreads across the American West. The museum conducts research, as well as tours. This is not a Chinese immigrant history museum but, rather, a past-to-present-into-the-future museum. It is based on ethnic Chinese in America; that's its brand and it publishes copiously to uphold its current significance. Titles of some publications indicate its interwoven culture:

- "The Butte Chinese: A brief history of Chinese immigrants in southwest Montana," by George Everett. 24-page illustrated booklet.
- "Guide to Butte's Chinatown Archaeological Dig Exhibit." 24-page full-color booklet.
- "War of the Woods: Chinese Wood Choppers and Unlikely Allies, 1885–1900." Video produced by University of Notre Dame (1:01:38).
- "Chinese families thrived in Butte's early days." Video produced by KLFX News, Butte, profiling the family that founded the Mercantile Store (1:51).

What the museum doesn't publish itself, it posts on its Publications page. If looking for a good role model, consider the publishing benefits Mai Wah Museum advances:

- Considers culture as a present attribute rather than a historical one
- Talks to a multistate audience

- Promotes publications from other sources
- Honors the past's achievements
- Uses multiple formats

ANNUAL REPORTS

Annual reports are published for a variety of reasons and stakeholders. They report on financials, new initiatives, and progress. They assure continuity, from roots to new growth. People play an important role in these reports, as they do in the life of the museum. With so much ground to cover, museums should be praised for staying focused on mission and vision. So, congratulations, Burke Museum, for resolutely standing for "In community."

This is the through line connecting all activities, participants, and plans in the Burke's Annual Report. It connects collection and people, forming the community of scientists and visitors, donors and volunteers, and many more of many cultures.

Significantly, there are two side-by-side "in community" paragraphs, one from Burke Museum Association, one from Native American Advisory Board—two communities with a common goal.

Dearborn Historical Museum celebrates its community by introducing some of its volunteers:

"I have lived [here] since I was a child . . .attended Dearborn Porcelain Artists meetings there for many years with my mom . . . volunteering with my grand-daughter . . . at museum functions like Halloween and 'The Teddy Bear Picnic' . . . [is] a great way to bridge the generation gap and teach her the importance of volunteering and just have some fun together."

"I'm gaining real world experience for my future career . . . [and] also I have gained a community that I am so excited to be a part of."

"I was placed here by my job after I was hurt at work . . . I like it . . . because of the non-judgmental vibe and the close community atmosphere."

"After rebuilding the 1922 Model T engine, my friend [fellow volunteer] . . . and I were actually able to get it to run!"

Any museum wanting to underscore the benefits of volunteerism could well use these as examples.

SCHOLARSHIP AND EXPERTISE

Scholarly articles and their publication magnify the reputation of the museum that publishes them. This tangible proof of inquiry and relevance is visible for amateurs and professionals alike; online or bound in a book or magazine,

everyone can read about exploring minds at work. The Hagley Museum and Library, in Wilmington, Delaware, looks in both directions in its ongoing mission of promoting American industry, ingenuity, and entrepreneurship. *Hagley Magazine* tells its stories in a format that honors both news and long-form investigation. A Fall 2018 issue reported a Hagley exhibition on U.S. patent models that traveled to the National China Museum in Beijing. A Winter 2022 article told another chapter of its extensive, long-term oral history project, Black STEM Pioneers in Delaware.

Hagley is a big museum, with a finely honed brand, and its research is useful to scholars and professional researchers of American and international business. Focus, however, can be achieved by museums of any size and genre; publishing their findings adds to their credibility. Magazines have a reputation for largeness. Blogs have a reputation for frequent updating. Journals are comprehensive. All publication formats offer a range of benefits to museum brands:

- Continuity
- Permanence
- Authority
- Variety of voices
- Editorial review
- Visual confirmation

Some scholarly communities that are great at scholarship might be tentative when writing about it. The magazine of Georgia Writers Museum serves this body of like-minded individuals very well. The Table of Contents of *Turn the Page*, lists how one quarterly publication offers professional help to its community:

- Tips to help you start writing
- The business of being an author
- Reading other writers' work
- Scheduling your time and place

INCLUSIVENESS

Augusta Museum of History, in Georgia, publishes a two-to-four times a year newsletter, with a magazine-like cover and a dozen pages of news and research articles. Its title is Archive, and the archive online goes way back. A standout standing feature is a show and tell of its collection. Over the years its subtitle has changed—Accessions, Acquisitions, Collection—while the subject remains clear: the importance and variety of its objects, each depicting an aspect of Augusta culture. There's "Medicine chest ca. 1820," "Ty Cobb Christmas card ca. 1940," "Fire Department ledger 1846-1867," railroad maps and instruments,

a Pullman porter's cap, and a locomotive engineer's hat. By the 2020s, a tab with home page placement titled "Collections" includes four-color photographs of objects in categories such as Archaeology, Fine Arts, Clothing & Textiles, Documents & Manuscripts, and Weapons.

Inclusiveness includes a lot of topics: inclusiveness is burgeoning. The Clark Art Institute, in Williamstown, Massachusetts, gives pride of place—the home page—to a long list of publications: art books, an annual journal or report, and a provocative series titled "What We May Be." The latter is a collection of talks by museum professionals at a series of colloquia hosted by the museum's education department. A partial list of topics suggests the aim of this publication:

- "What Does Inclusion Exclude?" (disability)
- "Autism Programming"
- "English Learners" (inclusion versus exclusion)
- "Taking It to the Streets"
- Programming for Older Adults
- "Being Explicit" (programming for LGBTQ+ and youth of color)

Inclusiveness is a very broad and inclusive field, and there is no one path to diversity.

Here's an exercise. Find three objects in your collection that concern people—

- Different from you
- Born before 1920
- From towns larger than yours, or smaller
- With rural backgrounds
- With families larger than eight people
- More religiously observant—or less—than you
- Who check a different "Race" box than you do on a questionnaire
- Whose family dynamic is different from yours

Once you see the differences, spot the exclusions, and recognize the inclusions, you may find some daringly incisive stories for your publications. Their relevance is part of your brand. Get your mailing list in shape!

History gets beckoned/lured into the present with a click on a QR code, jumping off the pages of *Tru Magazine*, a publication of Truman Library Institute, in Kansas City, Missouri. Historic film footage and photographs of President Harry S. Truman abound and are staged on the printed page throughout the publication. For history scholars and researchers, and amateurs, too, the combination of print and interactive formats is an engaging way to explore the past and follow it into the future.

DONOR ASSURANCE

Donors are a necessity and a mystery. How can something so essential be so hard to fathom?

Because donors have so many varying priorities, publications are great ways to please all of them. You have so many stories to tell.

Blogs are particularly effective in reaching many minds. Blog writers have their own interests, perspectives, and styles. There's a blog topic for everyone. They don't have to be deep, although many are superb research reports. They don't have to last all year—a blog of six entries shows depth and consistency without getting tedious.

Blogs like those from the Guggenheim Museum tantalize and then move on to the next intriguing piece:

- Can Art Aid the Climate Crisis?
- How Does Art Travel
- Discovering the Story in a Speck of Paint

Canvass your staff, volunteers, and interns. Encourage them to look outside their silo to see what museum details interest them. Ask them to write about them. There are probably a few writers-in-waiting eager for this extra challenge. Rising to challenges is what museum people do.

Conner Prairie looked outside itself, to its audiences, for the title of its 2022 Annual Report: *Impact Report*.

If this were a branding tool, rather than an authoritative accounting document of a 501(c)(3) organization, it would be perfect. It includes its audiences in its identity. Annual reports add heft to a museum's brand image; they summarize what the museum does to earn its brand. Conner Prairie's document takes an outward-looking tack; in showcasing success, it proves it by how its audiences and other stakeholders benefited over the past twelve months.

MEMBERSHIP BUILDER

When does a newsletter become a publication? When the content is less about news and more about permanence. A little less current attention and a lot more about history and legacy.

The Kentucky Historical Society monthly newsletter is sent to a mailing list. It covers a wide range of topics, and it appeals to many kinds of audiences, in many walks of Kentucky life. It's not just a messenger of a museum's activities; it is a repository of them. A look at the topics covered in the August 2023 newsletter shows the heft of this publication that raises it from a mere letter:

- Walking Tour of Civil War Frankfort
- Kentucky Ancestors: Family, Genealogy and Recipes

- Women at War

You could argue that annual reports only go to members, not the general public, but the publication issuing from Boise Art Museum is more than a report; it's a full-fledged performance:

- Beautiful four-color format—showing a wide selection of activities and programs
- Speaks a brand position of "a special place in the west"
- Evidences a strong, creative organization
- Looks like a place to join, not just visit

The Annual Report website page shows the covers of the past nineteen reports. Each is well designed with art as the focus. This is a museum that has been around. Click on a cover and you'll see a museum that's also going places; it's a scrolling stroll through a whole year's worth of initiatives and productivity. This is a big, highly visual publication that serves as a branding tool for a museum whose board president said: "We . . . look forward to the future of the museum; it was here before us, and we intend to position it, healthy, vibrant and relevant, to far outlive us."

IN PRAISE OF PUBLICATIONS

If an idea, a story, a challenge, a solution, or a vision is published, it becomes part of the public knowledge. The endeavor of publishing earns the respect that comes to open inquiry. That's the brand advantage of museum publications, whether newsletters, catalogs, magazines, academic papers, or books. Printed or online, they regularly reinforce your values, transparently. With consistency, they demonstrate what you stand for, what you want your audiences to remember. Visible, tangible, and fulsome, publications are keepers.

BRANDING CHECKLIST

The huge category of publications produces a simple list of brand benefits. Ask yourself if your museum needs:

- The authority of a regular, edited message
- Regularity of communication
- Tangibility in addition to your building
- Variety of voices
- Evidence of curiosity
- Intense explorations
- A past, present, and future

REFERENCES

"August 2023 KHS Insider Monthly Update," Kentucky Historical Society newsletter, message from a mailing list, August 8, 2023

"Become a Member," Augusta Museum, www.augustamuseum.org/Virtual ArchiveNewletter [accessed August 23, 2023]

"Block of the Month Club," National Quilt Museum, https://quiltmuseum.org/botm/ [accessed December 28, 2023]

"Business of Authoring," Contents, *Page Turner*, Georgia Writers Museum, https://www.georgiawrtiersmuseum.org/page-turner [accessed May 10, 2024]

"Catch Up on the Rest," Virtual Tenement Talk Series, Three Cheers for Three Historians, Member News, Tenement Museum, message from a mailing list, November 15, 2023

"Celebrating 50 Years of *The QuarterDeck*," Columbia River Maritime Museum, www.crmm.org/celebrating-50-years-of-the-quarterdeck.html [accessed August 5, 2023]

"Chinese Families Thrived in Butte's Early Days," KLFX News, January 10, 2023, https://www.kxlf.com/news/local-news/chinese-families-thrived-in-buttes-early-days?fbclid=IwAR2uTTyjlCW62AjhN6scOSeEpCzTPW1hOJsiAd2Ds3JFuABSOV-z99sHWao [accessed October 16, 2023]

"Connor Prairie: 2022 Impact Report," www.connerprairie.org/wp-content/uploads/2023/04/Impact-Report-2022.pdf

Foreman, Amanda. "The Enduring Technology of The Book," *The Wall Street Journal*, August 3, 2023, /www.wsj.com/articles/the-enduring-technology-of-the-book-889a846c [accessed August 5, 2023]

"Foxfire Books," Foxfire Museum, www.foxfire.org/shop/category/books/ [accessed August 1, 2023]

Hagley Magazine, Hagley Museum and Library, www.hagley.org/about-us/publications [accessed January 3, 2024]

Holocaust Encyclopedia, United States Holocaust Memorial Museum, https://encyclopedia.ushmm.org/ [accessed December 9, 2023]

Guggenheim, https://www.guggenheim.org/blogs/page/4 [accessed July 17, 2023]

"In Community," Annual Report 2023, Burke Museum, www.burkemuseum.org/news/2023-burke-museum-annual-report [accessed November 11, 2023]

"Lincoln Herald Archive," https://cdm15995.contentdm.oclc.org/digital/collection/myfirst/id/3981/rec/3 [accessed [accessed January 2, 2024]

"Maps & Blueprints Collection," Augusta Museum of History, www.augustamuseum.org/collectionsearch.asp?cat=Maps [accessed August 23, 2023]

North Dakota History Journal, 77(3/4), Article number: 009817, https://north-dakota-state-museum-store.shoplightspeed.com/north-dakota-history-journal-volume-77-3-4.html [accessed January 2, 2024]

North Dakota History Journals, North Dakota State Museum. https://north-dakota-state-museum-store.shoplightspeed.com/journals/north-dakota-history-journals [accessed October 25, 2023]

"Publications," Abraham Lincoln Library and Museum, www.lmunet.edu/abraham-lincoln-library-and-museum/publications [accessed December 31, 2023]

"Publications," Mai Wah Museum, https://www.maiwah.org/learn/publications-press/ [accessed May 10, 2024]

"Publications & Press," Mai Wah Museum, http://www.maiwah.org/learn/publications-press/ [accessed October 7, 2023]

The QuarterDeck, 21(2), spring 1995, Sea Stories, September 16, 2022, Maritime Museum, https://issuu.com/maritimemuseum/docs/v21n2_spring_1995_ocr [accessed August 5, 2023]

Rustad, Amy. "Letter from the Board President," Annual Report, May 1, 2021–April 30, 2022, Boise Art Museum, www.boiseartmuseum.org/wp-content/uploads/2022/12/FY2022-Annual-Report-for-EMAIL-WEB.pdf [accessed December 30, 2023]

"Three Historians Walk Into a Saloon: 1882," Virtual Tenement Talk, live-streamed Nov 9, 2023, Tenement Museum, https://www.youtube.com/watch?v=jUpEitVU-ZY [accessed. November 15, 2023]

Tru Magazine, Spring-Summer 2022, Truman Library Institute, www.truman libraryinstitute.org/about-us/tru-magazine/ [accessed November 6, 2023]

"Virtual Archive Newsletter," Augusta Museum of History. www.augusta museum.org/2022-Archive-Newsletters [accessed January 2, 2024]

"Volunteer Profiles," Dearborn Historical Museum, https://thedhm.org/volun teer-profiles/ [accessed December 29, 2023]

"War of the Woods: Chinese Wood Choppers and Unlikely Allies, 1885–1900," https://youtu.be/1sRo_gHb-Rw?si=X3GF7eQhwZXc9d3l [accessed January 2, 2024]

"What We May Be," Publications, The Clark Art Institute, www.clarkart.edu/ museum/publications/what-we-may-be [accessed November 27, 2023]

19

Archives

Archives support a museum's brand by placing its collection, exhibits, and interpretation in context. Whether large or small, your archive is your history, your personality, your identity—and it has changed with time. No matter how old your archive, position it for the present and the future. It already represents your brand, and now it must be seen in context with your expanded audiences, community, programs, and strategies.

Just look at what an archive can accomplish:

- Makes available what's not on view
- Allows for contemporary interpretation and demonstrates relevance
- Expands your audience to visitors and viewers you would not have imagined originally
- Shows the depth and breadth of your vision and values
- Let's you speak in more than one voice, echoing the diversity of voices you listen and talk to today
- Provides different formats for all kinds of learners, of all ages, backgrounds, and cultures
- Serves as an outlet for donors, community members, scholars, and local historians who want to contribute
- Extends your brand as a community resource

Objects "not currently on view" can be moved into view when they've been preserved in an archive. In a historic house, for example, they represent the real people who lived there, tending to its historic architecture and furnishings and daily life. They tell the story differently, heard in the letters and diaries, invitations, and news clipping in your archives; new dimensions of your brand arise. Bloggers and researchers may have to hammer them into coherence. Or you may find ready-to-show first-person contemporary narratives like this one from Martin House in Buffalo:

Looking for material for a blog, video, or research project? Check your archive. *Luis Alvaz This file is licensed under the Creative Commons Attribution-Share Alike 4.0 International license.*

"A 1939 edition of an A.M. Leonard & Son trade catalogue, viewed in the [image collection archived at Martin House] . . . indicates that the catalogue was the personal copy of George Henry Fellows (1877-1972). Fellows . . . was employed as a Martin House gardener between the years 1913-1916. He lived in the Gardener's Cottage with his wife Euphemia Seatter McKay (1876-1957), [who] also worked for the Martins, serving as a governess and upstairs maid. While living in the cottage, they raised their baby daughter Jane (1913-1999)."

KNOWLEDGE WELL BEYOND THE SPACE AND TIME

Exhibitions are assiduously assembled, curated, and labeled. Archives are also well organized. Combining the qualities of both augments your brand and its mission.

The Abraham Lincoln Library and Museum, in Harrogate, Tennessee, assembles its voluminous archive in a branded knowledge-machine: the humble newsletter. How appropriate! First published in 1915, just 50 years after Appomattox, history stays fresh because the newspaper is still published four times a year. Abraham Lincoln remains relevant and, as his brand demands, so do museums sharing his name. *The Lincoln Herald*, all 30+ pages of it, conveys the limitless newsworthiness of the man. He is with us still, has been for a long time, and according to the terms of a 2023 yearly subscription, will continue to be throughout time and place.

Many museum brands revolve around history-changing personages, encyclopedic collections, or maintenance-intensive exhibits such as video, installations, and site-specific works. They can keep the brand vivid beyond the limitations of space and time with exhibitions of walls with ongoing publications.

If your museum has access to a service that's only tangentially related to your collection or mission, consider it carefully, especially digital material. An online presence can be a boon to your brand.

For example, among the archives listed on Kentucky Historical Society website is:

Findagrave.com

Cemeteries are under-appreciated (or just plain unknown) repositories of history. Even a casual exploration of a graveyard offers insights into a place and an era. Unlike many documents, they list dates, birthplaces, and family members—and the names are correctly spelled. Pure gold for researchers and historians, as well as visitors. For example, among the resources available on the Find a Grave site: "Search 554,728 cemeteries in 248 different countries."

FORMATS FOR ALL KINDS OF LEARNERS

The Tenement Museum in New York holds an epically large archive of objects and documents. The museum occupies the actual site of the apartment building home of immigrants from across Europe, Asia, and Latin American who lived there from the 1860s to 1930s. They left a lot of stuff, and when the building was explored and cleared for renovation, the stuff became a singular archive. Imagine the faces in the photographs, the voices who sang the sheet music, the cultures who created one hundred years of cookbooks, the family discussions around school report cards, the details found in business ledgers and seamstresses' patterns, these items communicate in words, pictures, and activities that the viewer/visitor can almost join.

All learners are different. For readers and viewers, talkers and participants, Tenement Museum's archive is a godsend. Its expertise at researching, documenting, analyzing, and organizing has resulted in material for all learners.

Here are some examples of archived material from a wide range of museums, all sources for the learners who will pore over them:

- Maps
- Posters
- Newspaper articles
- Fabric scraps, buttons, and patterns
- Oral histories
- Photographs
- Job applications
- Genealogy records
- Shipping manifests
- Leases
- Municipal plats
- School yearbooks
- Sports memorabilia
- Society columns
- Immigration papers
- Diplomas
- Medical instruments

Do you have any of those in your archive? Think of the diverse audiences that might learn from them.

Helping other institutions and individuals with their preservation and digitization projects shows how your museum does it. In Ohio, Massillon Museum shares its own expertise with others. Here are some of the areas of expertise it shares with preservation learners:

- Faces of Rural America Project Toolkit with instructions on holding a town hall community event to gather oral histories
- Preserving Garments & Textiles
- Care and Storage of Moving Picture Film
- Case Study: Digitizing Photo Negatives
- How to Develop an Internship Program

This information—which is on Massillon's website—demonstrates the hard work that goes into managing an archive. Its authoritativeness and generous community spirit are hallmarks of an expansive brand.

Your archive expands your audience to visitors and viewers you could never have imagined originally.

Brands are made when the marketplace buys into them. You can depict and articulate your brand mission and goals; others will feel their personality, like their values. It's a challenge making your identity appreciated unless successive audiences identify with you.

For example, the Driehaus Museum, a Belle Epoque mansion, gives ever-changing audiences stories to captivate them. Driehaus Museum creates videos on topics from the architecture of fireplaces to children's story hours to the art of entertaining. Each attracts a different, new audience. Each aspect of the museum connects in a fresh way. Archived programs, one hour long and available on YouTube, provide a third-party endorsement; they're also available to people who haven't visited the museum, or people who can't.

Look at the many audience segments appealed to by video:

- Adults and children
- Parents and caregivers
- History buffs
- Music lovers
- People who appreciate closed-captioned video
- Overworked, attention-challenged, leisure-oriented souls seeking intelligent diversion

For museums based in historic houses, attracting diverse audiences is a challenge. But the architecture and backstory are so compelling! Driehaus wisely mines its history for stories of its era, its city, the people who created for the period, and those who visit today. One of its stories, a video, talks about entertaining in the Golden Age of late 1800s Chicago. It was elegant, but everyone loves a great party.

The Driehaus calls its collection of articles, past programs, and scholarly papers Blog. It's a term everyone understands, where Archive might be too academic. The big difference is that archives preserve years of deep research,

but the underlying purpose is solid: preserving years of research for the ongoing use of viewers, into the future.

Listening to people, you learn more and connect more meaningfully. From these voices, we hear about how daily life was really lived. We need to listen to spontaneous laughter, pregnant pauses, and funny colloquialisms. Here are some things to listen for and interpret:

- What words they use and turns of phrase
- Accents
- Emotional moments
- Details that people have on the tip of their tongues
- Anecdotes
- Humor

As archival material, oral history documents that inform a museum's collections and interpretations add context and relevance that are living examples of your brand—which is invaluable. Your visitors and viewers like you and respect you, and enjoy being with you, but think of the human connections you make when they can hear the people whose objects you show.

"Pass the Word," a project of the Kentucky Oral History Commission, is featured on the Kentucky Historical Museum website, and its list of stories gives an idea of the understanding/value/richness it adds to any museum's brand message. Some examples:

- Women in Government
- Immigrants in Bowling Green
- Versailles Main Street
- World War II Veterans
- John J. Johnson's experiences with the desegregation of schools in Franklin, Kentucky

Any museum, of any size, can collect oral histories. You start with the small step of interviewing one person, such as:

- An older relative with a historical perspective
- A local tradesperson who understands what keeps communities working
- Elected officials who know the laws and the hurdles
- Volunteers at other organizations who talk among themselves
- Military people, present and past—likely a huge, under-represented constituency in your community
- Interns who undertake these projects and who will talk about their hopes and challenges

Here's a valuable archive item, available to most museums: yearbooks. Dacotah Prairie Museum is a small museum with an admirable archive of high school and college yearbooks. These contribute the invaluable voices of the young and hopeful, with their special lingo and syntax, their remarkable outlook on the world from their community. There's a Wish List tab on Dacotah Prairie Museum's website for missing editions. In addition to the site being a good example of archive-enhancing items, it suggests a method for adding to them.

When a small, local museum seeks its brand, it may look at the inscriptions in old yearbooks. All those handwritten congratulations, serious jokes, wonderful hopes, and big plans—they say a lot about your community and your museum's role in representing it.

COMMUNITY RESOURCE

Museums are part of the communities with which they share a zip code. It's inevitable. Museum buildings, with their sign out front, are recognizable parts of the landscape. That landscape, habitat, locality—call it what you will—reinforces your identity.

Enter Archives, a hospitable repository for the community's unique, varied history. No collection or exhibition can encompass the organic growth—past, present, and evolving—of a community. There are many ways to share the personality of a community.

Using your archives as an information source for the community is one. Archives document the laws and regulations, deeds and censuses, business papers and family albums of a community, proof of the evolving environments that give a community its singular sense of place.

In Virginia, Historic Alexandria plays an ongoing role in the community with the Office of Historic Alexandria's Descendants Survey. It's an online resource that asks: "Are you a descendant of a person buried at Contrabands and Freedmen Cemetery? Please submit the Descendants Survey to help us better assist you with documenting your family's story." The museum already administers the Freedmen Cemetery Memorial, which is a visible and visitable, site. However, it's the online Descendants Survey that brings history into the present and future, by involving today's constituents. It's current, relevant, and relatable. It commemorates more meaningfully this burial place for about 1,800 African Americans who escaped bondage during the Civil War. Museum and community share a history.

Archives material that reflects its community's brand bolsters the museum's, too, by:

- Documenting a community's roots
- Shining a light on the depth of a community's other cultural assets
- Providing a place and context for the histories of diverse groups whose stories aren't told by objects and collections

- Giving a bricks-and-mortar tangibility to history
- Explaining the context for a community's changing history
- Preserving the documents that can put the smallest detail into consequential context

DEPTH AND BREADTH

Beyond the museum lies a wider world that resists displaying and labeling. At the Columbia River Maritime Museum, in Astoria, Oregon, archived material resides in the Reference Library. This resource speaks of ships and seas and exploration and has a focus that reinforces its brand. Its tab occupies the top row of the website. The Reference Library collects "the history of the Columbia River and the Pacific Northwest." At the core is the Ted M. Natt Maritime Library, which has holdings "from the earliest explorers to current day . . . first printed map of the Columbia River, journals, manuscripts, over 20,000 printed volumes, 30,000 historic photos, and over 1,000 charts and maps . . .relating to the maritime history of the Pacific Northwest."

All museums have a deeper history than shown in their galleries. Today they have expanded their breadth due to their new audiences and available platforms. Here's how to leverage your library and reinforce your brand:

- Signage in library that connects material to brand mission or identity
- Paragraph on website identifying the library as an extension of your collections, exhibits, and personality
- Open Library Day connected to community event
- Library presence—a librarian, intern, or even just a handout—at the front desk
- Instagram or X (formerly Twitter) post or email sent with some regularity (even if it's weekly or monthly)

And more maritime matters. There's a lot of water in the United States, and museums on their shores celebrate their historical, scientific, and social aspects. In the Adirondack Mountains, Lake Champlain, and Lake George regions, the Ticonderoga Historical Society exhibits "the contributions of our region to the history of New York and the United States while preserving and promoting our unique cultural history."

The Steamboat History pages provide information designed to present the history of steam boating in the Lake Champlain valley. The viewer sees Steamboats: The Early Years, Commerce, Tourism, Captains. Four perspectives, different eras, and multiple interests, from navigating instruments to the people who commandeered and steered them.

This is more than an archive; it's a lot of material, from many species of documents, organized into a series of pages, and copiously illustrated with maps, and images of ships, their men, and their tools.

DONOR AND COMMUNITY PARTICIPATION: SUPPLIERS AS WELL AS VISITORS

Once the concept of an archive is known and understood in the community, its fulsomeness is irresistible. It connotes limitless possibilities, for keeping and giving. An archive can look like familiar library shelves or an art gallery's storage racks. Add virtual archives and you can add these to your collection: slides, videos, songs, oral histories, author readings, hologram-type responses, demonstrations, and every angle on a subject from extreme close-up to bird's-eye views.

That said, it's no wonder that museums large, small, and smaller are repositories, willingly or just smilingly, of community in-kind donations. Many donations will find a place in galleries, helping to demonstrate your goals and identity. However, their main advantage resides in the archives where professionals, amateurs, scholars, and interns can:

- Learn their background from the donors
- Study original formats, materials, size, and location
- Examine objects at leisure, up close, uncrowded, in quiet
- Compare other archived material, or personal collections
- Hear real voices, sound effects, and music
- View motion and different angles, observe body language, and see the weather and topography
- Talk to staff, many of whom work best behind the scenes and have years of accumulated familiarity with the material and context

If a museum is lucky enough to consider visible storage, with all its advantages and many disadvantages, that's a wonderful archive. If it's available as a tour, museum professionals can learn the reactions and input of visitors.

The Center for the Chesapeake Story (Chestory) Collection at Calvert Marine Museum, in Solomons, Maryland, has a collection of written documents and media assembled over many years by a local songwriter and artist, scientist, and educator whose collection goal was environmental literacy through interdisciplinary material. The archive includes songs, audiovisual material, and lesson plans. On-site and virtual archives welcome an audience as large as the Chesapeake region. When a museum's brand includes the concept of "region," area donors are invaluable sources. Archives can help connect donors and friends with your brand as suppliers, not just visitors.

OUTLET FOR DONORS

Archives aren't just old treasures from storage attics; they need regular refreshment from new contributions. When a small museum gets a large donation, it's an opportunity to select items from the new, add them to selected items from the existing, and give them a fresh interpretation.

Cable Natural History Museum, in Wisconsin, combined the existing in an entrance hall display demonstrating "the varied identifying behaviors of minerals." It's a smart introduction to the museum that's all about Northwoods nature, for visitors who don't know all about it already. That's just about everybody!

Here, in the physical introduction (the hallway) to the museum, is a curatorial introduction to "minerals and all their complexities—colors, crystal structures, and unique stories of formation."

For any museum, an exhibit that blends existing archives with additions is a windfall because it demonstrates how:

- Collections are formed and constantly re-interpreted
- Donations are integrated into the museum's culture
- Ongoing research and interpretation are implemented
- Curators figure in collecting, selecting, and exhibiting

Relevance is manifested in museum's collection and vision. Honor the old and welcome the new. Old and new demands communicating to ever-new, ever-changing audiences. That philosophy applies to all aspects of museums, and small institutions are agile enough to make the point in many ways.

LOCAL HISTORY

In Michigan, Holland Museum gives its archives full credit for building community pride. It delivers its message in a lecture and a YouTube recording. It promises continuing chapters of the story. It highlights the endurance of its identity in the community: "This program is part of the Holland Museum 'Tales from the Archives' series which explores local history topics supported by the Holland Museum's collection and archives."

Institutional history is a popular project, and here are some ideas for implementation:

- Assign it to a college intern; and provide enough supervision for the project to qualify for college credit
- Get input from local filmmakers, student and professional
- Engage local historians and scholars
- Add it to your Volunteer/Contribute page

BRAND CHECKLIST

- Is our archive well communicated on-site, online, and in all communications?
- Does our archive have a unifying theme or focus?
- Does our staff understand how our archive reflects our brand?
- Have we asked out staff how they might use the archive?

REFERENCES

"The Art of Entertaining," Driehaus Museum, https://youtu.be/Es6oAnTRYzw [accessed June 11, 2023]

"The Chestory Virtual Archive," Calvert Marine Museum and Chesapeake Education, Arts and Research Society (CHEARS), https://chears.org/environmentalliteracy/CVA/ [accessed June 4, 2023]

"Contrabands and Freedmen Cemetery Memorial," Archives and Records Center, Office of Historic Alexandria, www.alexandriava.gov/FreedmenMemorial [accessed May 29, 2023]

Find a Grave, www.findagrave.com/cemetery [accessed May 23, 2023]

"From the Collection: George Henry and Euphemia Fellows," Martin House History, February 16, 2023, martinhouse.org/george-and-euphemia-fellows/ [accessed June 12, 2023]

"How To: Collections Toolkits," Massillon Museum, https://massillonmuseum.org/collections-toolkits [accessed June 13, 2023]

Kreb-Mertig, Mollie, "Marvelous Minerals," Cabinet of Curiosities, Museum E-Newsletter, June 2, 2023, Cable Natural History Museum [accessed June 2, 2023]

The Lincoln Herald, Abraham Lincoln Library and Museum, https://www.lmunet.edu/abraham-lincoln-library-and-museum/documents/Lincoln_Herald_Advertisment_for_website.pdf [accessed June 11, 2023]

"Oral Histories," Pass the Word, Kentucky Historical Society, https://passtheword.ky.gov/about-us [accessed June 13, 2023]

"Our Collections," Tenement Museum, https://www.tenement.org/about-us/our-collections/ [accessed May 10, 2024]

"Reference Library," Columbia River Maritime Museum, www.crmm.org/reference-library.html [accessed June 10, 2023]

"Steamboat History," Ticonderoga History Museum, www.tihistory.org/copy-of-steamboats [accessed June 11, 2023]

"Tales from the Archive," Holland Museum, www.youtube.com/watch?v=T2A9RRREb3k [accessed June 13, 2023]

"Wish List," Dacotah Prairie Museum, Brown County, https://www.brown.sd.us/dacotah-prairie-museum/about/wish-list [accessed June 9, 2023]

Epilogue

This book ends, not with a summary, but a look ahead. There's a lot going on in the future. New platforms appear regularly, others fall from grace, and many old ones return. Globally, everyone gets into the arena, and museum audiences will continue to migrate to what's new. At the beginning of 2024, these were the social media platforms most used by museums and their arts and leisure competitors:

Facebook
YouTube
WhatsApp
Instagram
Facebook Messenger
WeChat
TikTok
Snapchat
X (formerly Twitter)
Pinterest
LinkedIn
Reddit
Quora

One might add to this list soapboxes such as email and websites. This book has integrated platforms into every chapter where they have a strategic use for branding.

Strategy matters more than ever. Today, the platforms available to museums are digital, online, and, of course, inside museums themselves, anywhere from which you talk to your many and varied audiences. Each platform benefits your brand if used strategically. Good brands, in all fields of endeavor, only climb on a platform when they have something that will enhance and expand their mission. Some platforms are more effective than others. As a general rule, don't talk unless you have something to say.

As a branding tool, the various platforms should be evaluated, and then used because they deliver the messages you want to send, those under your control. These communications inform, share knowledge, and expand the exhibits that can be seen in the museum to a wider range of viewers. They

demonstrate the museum's expertise, widen the reach of the museum in space as well as time, bring new voices to the public, and explore the worlds that are opening every day. Viewers will share them, and comment, and you should heed the conversations. But, you needn't participate in all of them.

Some of the more adventurous projects recently undertaken by platforms include translations for speakers of languages other than English; audio tours for sight- and mobility-challenged visitors; creative lessons for young learners; close-up inspections of objects; behind-the-scenes work integral to the museum's mission; information for scholars and professionals; and programs that include the community as part of, rather than a setting for, the museum.

The best platform for branding remains the tangible museum, because that's where your mission, goals, and values are best arrayed. Your audiences are already there. They're involved with you and each other. Your collection is on view, up close, with labels. Programs play out, workshops are working. People, in all their variety, get together. There is time to reflect at tables and bookshelves and feel the ineffable buzz of activity.

There are many platforms to further the museum, and further is a good place to go.

Index

About the Author

Margot Wallace is an author and researcher whose fifth book, *Writing for Museums: Communicating and Connecting with All Your Audiences*, was published in fall 2022. She has spoken on museum branding and writing for museums at museum conferences throughout the country and internationally. A retired marketing professor, she now develops discussion groups for Osher Lifelong Learning at Northwestern University, including three courses based on museum blogs and digital exhibits.